THE ART OF PHOTOGRAPHING CHILDREN

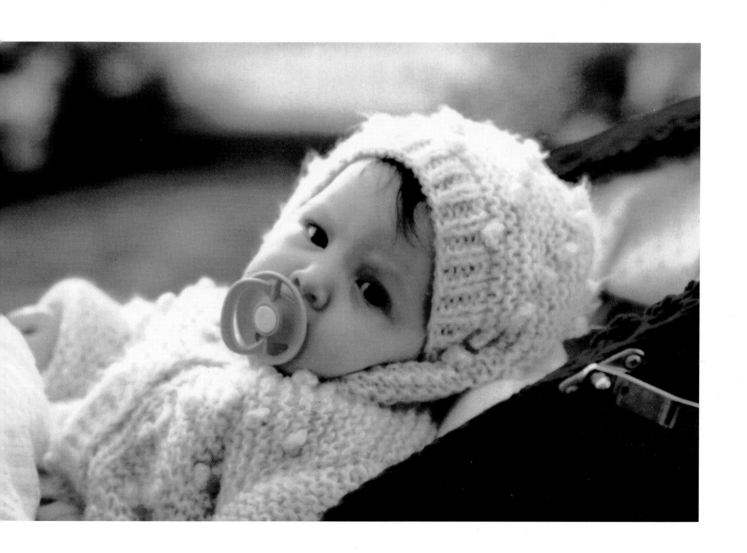

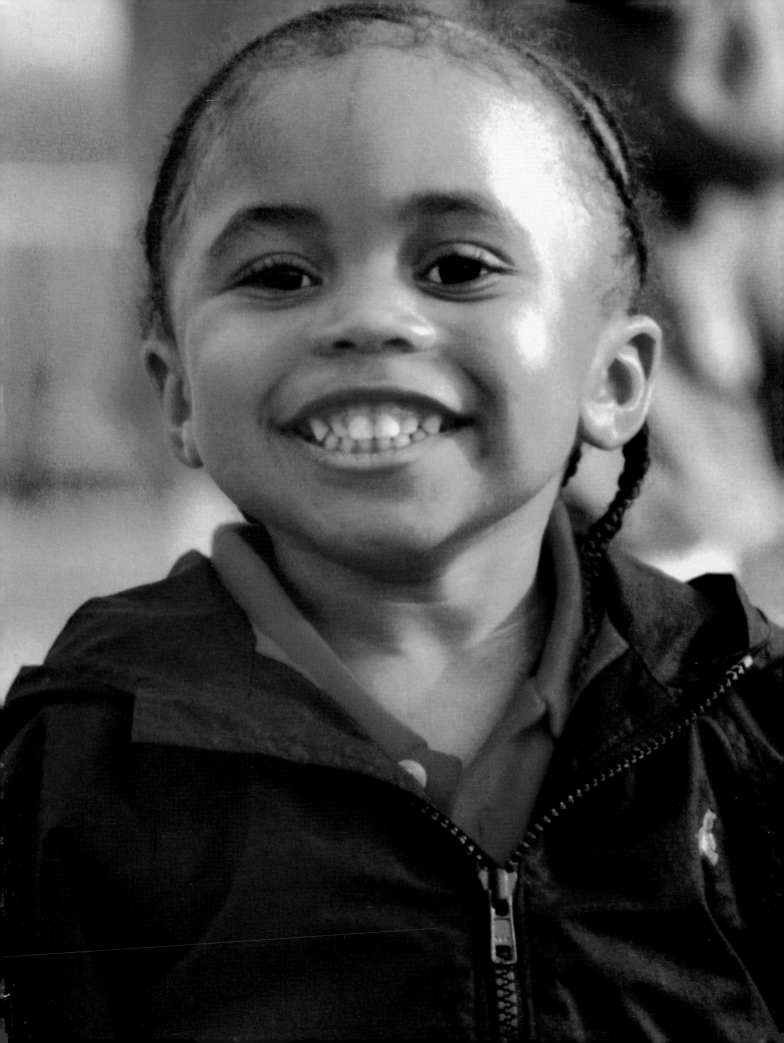

The Art of Photographing Children

TECHNIQUES FOR MAKING BETTER COLOR, BLACK AND WHITE, HANDCOLORED, AND DIGITAL PICTURES

Cheryl Machat Dorskind

AMPHOTO BOOKS

AN IMPRINT OF WATSON-GUPTILL PUBLICATIONS/NEW YORK

THIS BOOK IS DEDICATED TO MY MOTHER, ROSLYN MACHAT, WHO COURAGEOUSLY FACES CHALLENGES WITH A GENTLE SENSE OF HUMOR.

ACKNOWLEDGMENTS

Photography/digital technology is in a state of constant change. Thanks to the resourceful knowledge of these very kind people, I have managed to stay current: Dan Steinhardt of Epson USA, Gwyn Weisberg of Adobe Systems, Inc, Debra Boring at Auto FX Software, Karen Drost at Jasc Software, Brian Williams at Nikon USA, Inc., Paul Bruckner at LaserSoft Imaging, Joseph Paglia at Eastman Kodak Company, Inc., Wacom Technology Co., Wendy Erickson at Ilford Imaging, Inc., Jay Brenner of Brenner Lennon Photo Productions, and Calumet Photographic, Inc.

While researching the history of photography, I was fortunate to meet some very smart people. Thank you Maja Keech at the Library of Congress, Linda Briscoe Myers of the Harry Ransom Humanities Research Center at the University of Texas at Austin, Karen Schoenewaldt, of the Rosenbach Museum and Library, Paula Galasso at the George Eastman House, Dan Silverstein at Getty Images, and Christine Granat at Memorial Hall Museum.

Thank you to Victoria Craven for encouraging the creation of this book and to Michelle Bredeson for her gentle queries and her kindness. Thank you gallery artists, Tina Manley, Bruce Berg, Gayle Tiller, Jeff Marcotte, Ross and Juli Zanzucchi, and Dani Blackwell for their beautiful photography and their willingness to share.

Thanks to my husband Glenn, whose crazy wisdom and poetic tongue are always enriching, and to my daughters, Nicole and Joelle, who challenge me with their wit and insight and comfort me with their laughter and affection. Thanks to Doris and Robert Dorskind for their love.

Finally, a special ovation to the children and parents who grace the pages of this book: thank you, thank you, and thank you.

First published in 2005 by Amphoto Books, an imprint of Watson-Guptill Publications, a division of VNU Business Media, Inc. 770 Broadway, New York, NY 10003 www.wgpub.com

Library of Congress Cataloging-in-Publication Data

Machat Dorskind, Cheryl.
 The art of photographing children : techniques for making better color, black and white, handcolored, and digital pictures / Cheryl Machat Dorskind.
 p. cm.
 Includes bibliographical references and index.
 ISBN 0-8174-3547-6 (alk. paper)
 1. Portrait photography—Handbooks, manuals, etc. 2. Photography of children—Handbooks, manuals, etc. I. Title.

TR575.M317 2005
778'.925—dc22
 2004015632

Senior Editor: Victoria Craven
Editor: Michelle Bredeson
Designer: Leah Lococo
Production Manager: Ellen Greene

Manufactured in the U.S.A.

First printing 2005

1 2 3 4 5 6 7 8 9 / 13 12 11 10 09 08 07 06 05

Contents

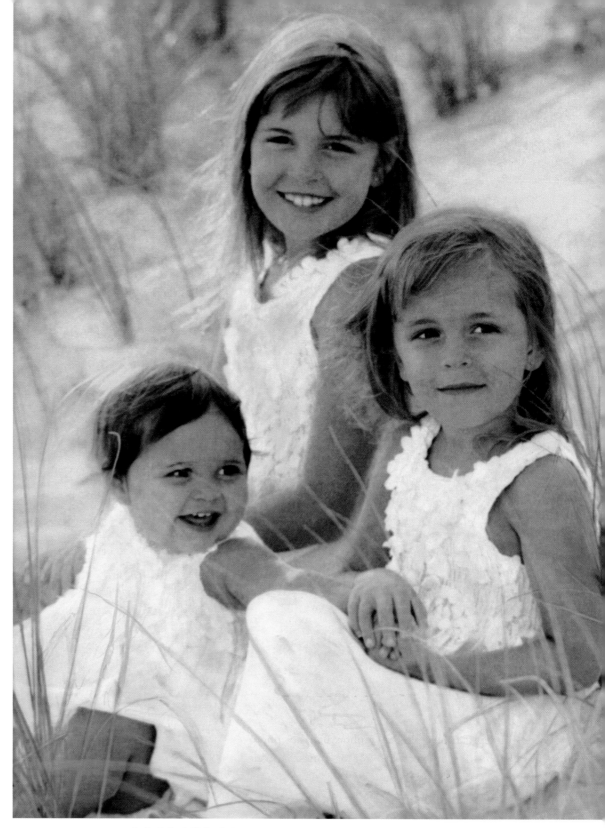

CASSANDRA, MACKENZIE, AND SAMANTHA

Coping with the unexpected is part of being a children's photographer. I scheduled this shoot for the "sweet hour" of 5:00 PM. The weather was perfect, but then the winds picked up. Rescheduling was not an option as the family was from a different state. Having scoped out the scene earlier, I knew a ridge of dunes nearby. The children nestled undisturbed by the gusting winds.

Introduction

Children make fascinating portraits. Discovering so many things for the first time, their faces clearly express honest, no-thought reactions. A hug, a kiss, a tear, a smile—all are universal symbols that translate messages of hope, joy, pain, and love. Few subjects have as much appeal.

Pictures preserve life and are essential for recording a child's development. The market for children's photography is vast, and it is a highly rewarding field, if you like children. Whether you are interested in pursuing this field professionally or just want to take better pictures of your children or grandchildren, *The Art of Photographing Children* will provide the tools and techniques you need to be successful.

The photograph on the right is a visual guide to principles of composition and photographic intent, topics that are addressed throughout this book. I captured this image nearly twenty-five years ago, ten years before I began to call myself a professional photographer. Through the years I have edited down hundreds of photographs, but I always come back to embrace this one, and use it to begin my visual presentation for college classes from introductory to master's-level.

Photography is both a literal and an interpretative form of communication. The literal message in this photograph is of a child climbing a tree, a patch of nature, near a highway. The design was intuitive; I only later developed a vocabulary to explain the principles of composition I share with students and write about in this book. Strong lines dominate the composition and draw the attention of the viewer to the subject. The red shirt moves forward (which I would later learn is a quality of the color red). The use of the foreground creates an illusion of three dimensions and adds great depth to the image.

The interpretation—the metaphor of the photograph—is about childhood, the boy's or yours or mine. The image of tree climbing recalls the lazy days of summer, of having all the time in the world. The juxtaposition of the tree against the distant highway gently reminds us that the boy is living in his own world, as children rightfully and enviably do.

At this point in my college classes I ask my students to write an essay answering the question, what is a portrait? A portrait means different things to different people. Traditionally, a portrait is defined as a likeness of a

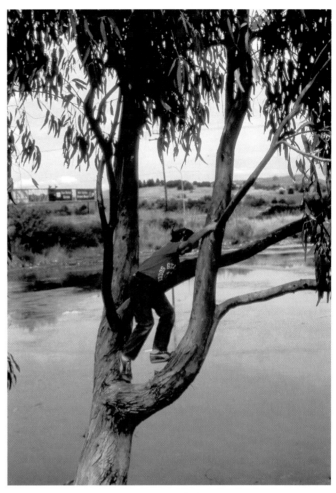

BOY CLIMBING TREE

After college graduation I considered becoming a photographer. The problem was that I did not have a mission. Hoping to find my muse, I moved to San Francisco, where I took this photograph. I find it interesting that I gravitated to a scene of a child at play, as if the picture-taking created distance—a psychological attempt to cross from my own childhood to adulthood.

person rendered by a painter or a photographer. This is an open-ended definition that leaves it up to you as a photographer to decide what it means to create a portrait.

To me, a portrait is a collaborative effort between the photographer and the subject. A portrait photographer communicates feelings, thoughts, and perspective with photography. A portrait photographer must be intuitive and communicative and open to spontaneity and chaos.

I did not envision becoming a children's photographer until my friends and I had children. This is a common thread among children's portrait photographers: Take enough pictures of your children, their friends, and your friends' children and you begin to develop a portfolio. Consider the words that Paul Strand so passionately wrote in "The Art Motive in Photography" (*The British Journal of Photography,* vol. 70, 1923): "Above all look at the things around you, the immediate world around you. If you are alive it will mean something to you, and if you care enough about photography, and if you know how to use it, you will want to photograph that meaning."

The Art of Photographing Children is a spirited journey into the world of children's photography, exploring the mediums of black-and-white and color film, digital photography, handpainting techniques, and other photo-manipulation processes. The photographs in this book are of my family, friends, and clients who seek my work while visiting the Hamptons in Long Island, New York. The first chapter, "History," presents an overview of the origins of and major movements in photography, showing examples of children's portraiture beginning with the invention of photography. "Equipment" investigates the current formats and features available in photographic equipment and arms you with all the information you need to select the right setup for your photographic pursuits. "Lighting" investigates available-light photography and the uses of supplemental lighting. "Composition" goes beyond the snapshot to examine the design elements that make a great photograph. "Important Moments" travels the timeline of childhood from infancy to the teen years, supplying photographic tips and techniques for portraying children at every age and in a variety of activities and settings. Moving beyond one's home environment, "The Photo Shoot" discusses location, wardrobe, props, working with assistants, and rapport; it invites the reader into the logistics of a few photo shoots and demystifies the topics of editing, printing, and presentation. "Painting Photographs" explains traditional handpainting techniques and other methods of adding color to black-and-white photographs. Finally, to provide the

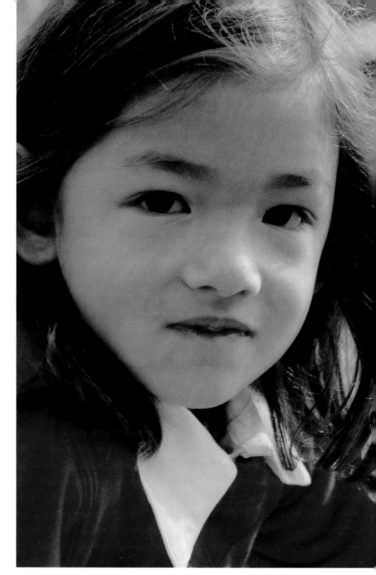

KEIRA

This picture provides a glimpse into Keira's private world. Using a fixed 105mm portrait lens created just the right amount of distance from the subject, encouraging introspection without self-consciousness.

reader with a broad scope of photographic styles, the book concludes with the works of six children's photographers chosen for their different styles and sensibilities.

My desire to teach photography, through my classes and my books, grew from my own learning experiences. Years ago I met with an astrologer who predicted I would live by the sea and be an educator dealing with film. At the time I was living in New York City and had no fantasies of living by the ocean. My aspirations of becoming a photographer or an actress were quiet at the time. I was a businesswoman with a marketing degree. What could I possibly teach? I thought.

A few years later, I found myself moving with my husband and our two-year-old daughter to Westhampton, New York, a quaint village by the sea. The idea of teaching arose as I learned how to handpaint photographs. The more I needed to know, the more I felt the need to teach, because I discovered that there was little information on the subject of handpainting. I photographed what I loved, first landscapes and then, inevitably, children.

I will conclude with the adage, "We photograph best what we love, we teach what we need to learn, and we write what we yearn to communicate." Adages are clichés, but they are clichés because they are true.

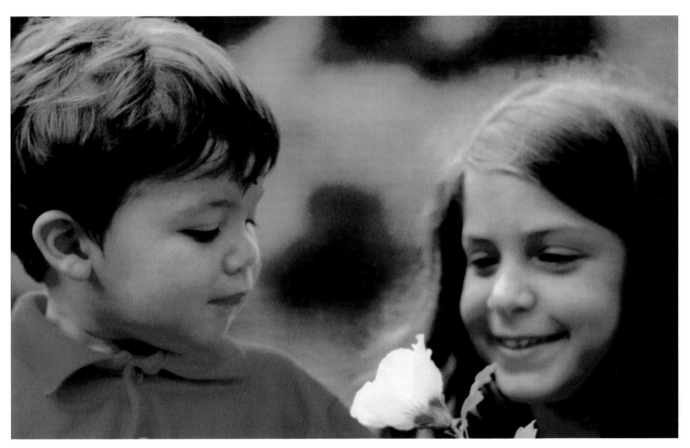

PAUL AND JOELLE

This picture was taken at the end of a photo shoot. I was waiting for a tender moment, and when Joelle showed Paul a flower I knew I had it. The fading sun added a rose-colored glow, which I accentuated when scanning the negative using an option in SilverFast Ai software. I printed the photo on Epson Premium Semigloss Photo paper.

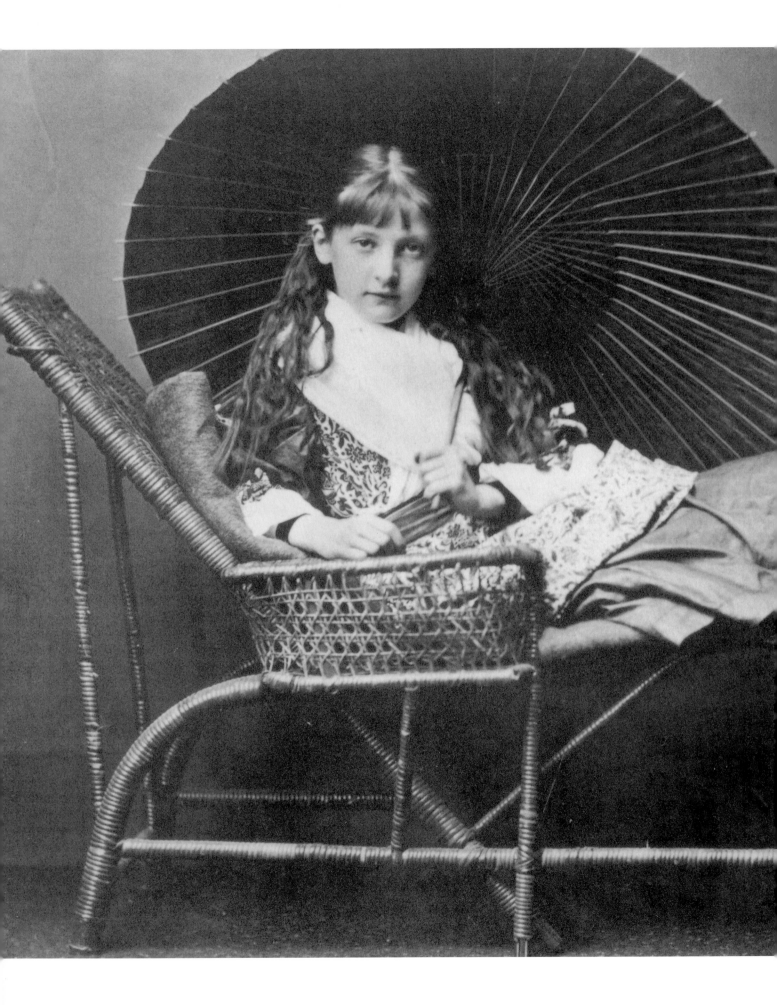

PHOTOGRAPHY IS A
MARVELOUS DISCOVERY,
A SCIENCE THAT HAS
ATTRACTED THE
GREATEST INTELLECTS;
AN ART THAT EXCITES
THE MOST ASTUTE
MINDS . . .

— Nadar (Gaspard-Félix Tournachon)

History

E VEN AS TECHNOLOGY surges forward, moving photography to new digital dimensions, and photographic manufacturers curb production on traditional darkroom products, the past continues to inspire. Many photographers today spend an incredible amount of time creating albumen prints and calotypes to mimic the photographs of the late 1800s. Looking back to early photographs of children sheds light on the social, technological, and economic developments that influence child photography today. Regardless of the photographic intent, the child is a metaphor that reflects society. This chapter surveys the history of photography with an emphasis on portraits of children and the art movements that continue to inspire commercial photographers, photo artists, and amateur photographers.

"Xie with Parasol" by Charles Dodgson (Courtesy of the Gernsheim Collection of the Harry Ransom Humanities Research Center at the University of Texas at Austin)

Early Origins of Photography

During the late 1820s in Europe, a race to develop a permanent photographic image was underway. In France the inventor Joseph-Nicéphore Niepce created the first permanent photographic image by a process he called heliography: exposing a copper-coated silver plate sensitized with iodine vapor to light. Frustrated by the lack of clarity and long exposure time—his first experiments resulted in an exposure of more than eight hours—Niepce partnered with Louis-Jacques-Mandé Daguerre, who was working to make the image seen in the camera obscura (see box at right) permanent.

Meanwhile, in England scientist and mathematician William Henry Fox Talbot was perfecting the "photographic drawing." Although his discoveries were first in realizing the negative-to-positive process—called a *calotype* (see next page)—this concept was too abstract and not supported by the academy of sciences. Without such support, Talbot's work remained relatively unknown, while Niepce and Daguerre were celebrated. Nevertheless, Talbot patented his process in 1841, knowing he was onto an ingenious idea.

Niepce died in 1833 and by the late 1830s Daguerre perfected the process they had begun together. Confident that his own work was different enough from Niepce's contribution, Daguerre named the process after himself.

Excited about the new discovery, Samuel Morse (inventor of Morse code) brought the first daguerreotype to America in 1840. It became an instant sensation, and

CAMERA OBSCURA

Camera obscura dates back to the time of Aristotle. Originally a darkened room in which observers viewed upside-down images illuminated by a pinpoint light, it later developed into a portable box with an opening (aperture), lens, mirror, and viewing screen. Today, students often learn about the mechanics of photography by constructing their own camera obscuras, and pinhole photography is popular among some contemporary photographers who strive to convey new messages through old technology.

by the 1850s approximately three million daguerreotypes per year were being produced in America. Most daguerreotypes were portraits.

The finest studios of the daguerreotype era in America were those of Mathew Brady (1823–1896) and Southworth and Hawes. Albert Sands Southworth (1811–1894) and Josiah Johnson Hawes (1808–1901) are considered the finest American portrait photographers of the nineteenth century. Southworth and Hawes successfully portrayed the sweetness and spontaneous charm of very young children, in contrast to the conventional stiff poses of the time.

With two studios, one in New York City and the other in Washington, D.C., Mathew Brady rivaled Southworth and Hawes for preeminence in the 1840s and 1850s. It is argued that Brady invented the celebrity portrait, as he photographed anyone of fame, wealth, or influence and promoted those images to propagate his own success. Obscuring the line between photography and art, his recipe for portraits was one part photograph (daguerreotypes and albumen prints [see page 14]) and two parts applied process, such as ink and oil paints. Furthering the mix, Brady created a factory-like work environment in which "operators" or assembly workers (both men and

This daguerreotype of the children of Lt. Montgomery C. Meigs was taken by an unidentified photographer in Detroit, Michigan, between 1850 and 1851. *(Library of Congress, Prints & Photographs Division, Daguerreotype Collection, LC-USZC4-3599)*

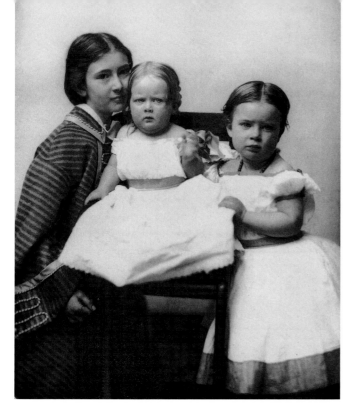

This daguerreotype of three sisters dates to around 1860 and is attributed to Southworth and Hawes. Posing has not changed all that much in 140 years. Notice how the tops of the heads create a line that leads the eye and that the two children dressed in white are balanced by the eldest sibling in darker clothing. *(Library of Congress, Prints & Photographs Division, Gilbert H. Grosvenor Collection of Photographs of the Alexander Graham Bell Family and Daguerreotype Collection, LC-USZ6-2015)*

This portrait by Mathew Brady of President James A. Garfield's children was created between 1865 and 1880 and is the product of a glass negative and wet collodion process. Brady sought celebrities and political icons as sitters to help market his studios. The strategy was to display the pictures in the gallery window and hence attract passersby to have their own portraits created. *(Library of Congress, Prints & Photographs Division, Brady-Handy Photograph Collection, LC-DIG-cwpbh-04667)*

CALOTYPES

Many early researchers into photography were scientists, and from the start photography's origins were steeped in curious experimentation with chemical reactions. Among his many discoveries, William Henry Fox Talbot found that treating paper with silver salt, drying it, and then treating it with another solution of potassium iodide would lead the way to creating a negative-to-positive image—the calotype. Shortly before exposure, he further sensitized the sheet of paper by coating it with a mixture of gallic acid, acetic acid, and silver nitrate. He then inserted the paper, while still damp, into a camera and exposed it to light through a lens. To fix the negative, Talbot used a solution of ordinary table salt. Later, table salt evolved to hypo sulfite and still later to sodium thio sulfite—which we darkroom technicians still call hypo. Talbot discovered that these negatives could then be contact printed, and thereby created the first successful negative-to-positive process. The calotype's most important contribution to photography is that it enabled multiple positive prints. The term *calotype* is taken from the Greek word meaning "beautiful picture." Calotypes are also known as talbotypes.

ALBUMEN PRINTS

Albumen paper was created in 1850 by Louis Désiré Blanquart-Evrard and remained the most popular basis for photographic prints throughout the rest of the nineteenth century. Creating an albumen print requires many steps. First, a sheet of paper is coated with a mixture of egg white (albumen) and table salt. Once dry, the albumenized sheet is then immersed in or brushed with a solution of silver nitrate. The image is then exposed by contact printing in sunlight. The resulting image is then rinsed, toned, fixed, and rinsed again. The albumen process was later replaced by the gelatin-silver process. Today a select group of fine art photographers are reviving albumen printmaking.

COLLODION PROCESS

Invented in 1848 by Frederick Scott Archer, the wet collodion process usually involved using a wet plate to produce glass negatives. Collodion was a sticky substance made by mixing guncotton with ether and alcohol. The collodion was poured over a glass plate, which was then made light-sensitive by immersing it in a solution of silver nitrate. This light sensitization and subsequent plate loading into the camera required complete darkness and immediate development. The key advantage of the collodion process was the significantly shorter exposure time. The dry collodion process, developed by the 1870s, eliminated many of the inadequacies of the wet collodion process, most significantly eliminating the need to process the negative immediately after exposure. The dry collodion process was eventually replaced by the gelatin-silver process.

women) completed the daguerreotypes and albumen prints. A photograph with the Brady logo was really a photograph from the Brady company, often not taken by Brady himself. During the Civil War years, when his eyesight was failing, Brady trained crews of photographers and assigned them territories.

Realizing that photography could be more than a commercial enterprise, Brady heeded his calling and ventured to the battlefields of the Civil War. Until the late 1870s photography involved a wet-plate technique, in which negatives had to be processed immediately upon exposure. Photographs were developed in on-site darkrooms that were constructed in tents adjacent to the battlegrounds. Brady began the tradition of war reportage, but it was not until long after his death that Brady's contributions to American history were fully realized.

Although widely popular, daguerreotypes had many disadvantages. They were fragile, difficult to duplicate, expensive, and time-consuming for both sitter and photographer. Technology intervened with the development of the dry collodion process and a lens specifically designed for portraits. With the invention of the dry glass-plate negative, prints could be created long after exposure.

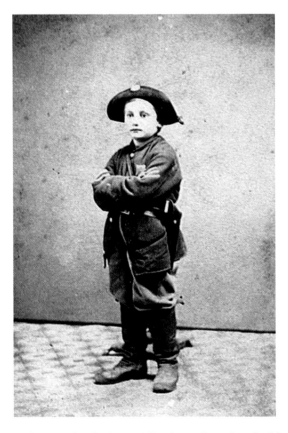

This portrait of a boy soldier is attributed to the Morris Gallery of the Cumberland, Nashville, Tennessee. It was created between 1860 and 1865 from a glass negative and wet collodion process. *(Library of Congress, Prints & Photographs Division, Selected Civil War Photographs and the Brady-Handy Photograph Collection, LC-B8184-10573)*

Raising Photography to an Art

Pictorialism was an art movement that arose grassroots-style in camera clubs and salons. Photographers, wanting to be expressive with their images without public retribution, lobbied to elevate photography to an art form, citing the use of composition, harmony, and emotion to illuminate and express. Pictorialism is a style of imaging that remains highly influential in today's commercial children's portrait studios. The then-revolutionary style of posing, use of lighting and props, and printing techniques can all be seen in contemporary portraiture.

In defiance of Victorian taboos, two photographers, German-born Wilhelm von Gloeden (1856–1931) and American Fred Holland Day (1864–1933), boldly photographed nude adolescent boys, using quasi-allegorical guises to make the images more palatable to the prudish public. Day, considered an improper Bostonian, was an admirer of Symbolist art and literature. He crafted light to create poetic compositions of nude boys. The youthful male body, symbolizing strength and vitality, continues as a visual motif throughout art history. Robert Mapplethorpe's work is a more contemporary example, and today the art world shows renewed interest in the nude male athlete.

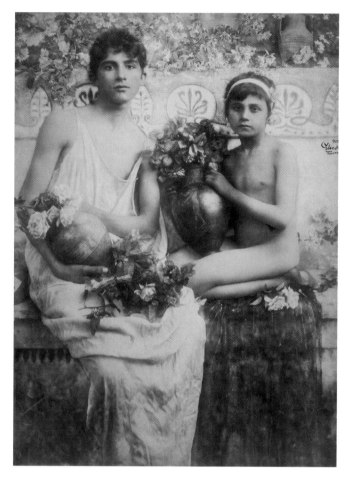

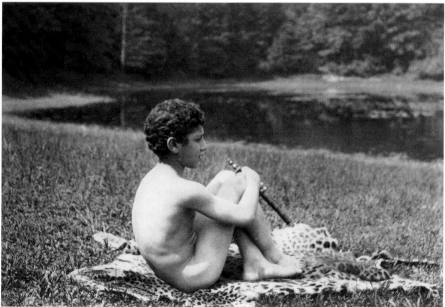

Thought to be less sensually provocative than the female nude, male nude photographs, such as "Nude Boy on Leopard Skin" by F. Holland Day, began to appear in camera journals after 1890. *(Library of Congress, Prints & Photographs Division, LC-USZ62-70391)*

"Two Boys with Vases of Roses" is an example of an albumen print from 1913. Baron Wilhelm von Gloeden worked primarily in Taormina, Sicily, and began photographing the male nude around 1890. No one was more successful at making these images acceptable. The Roman-like costumes, bronzed flesh, and overripe flowers are motifs von Gloeden used to explore eroticism. *(Courtesy of the George Eastman House, 67:0027:0001)*

Charles Lutwidge Dodgson (1832–1898), better known by his pseudonym, Lewis Carroll, is often credited with being the quintessential child portraitist. Dodgson, who was ordained a clergyman at Oxford University in Britain, authored *Alice's Adventures in Wonderland* and *Through the Looking Glass.* Beginning experimenting with the camera in 1865, Dodgson (the name he used when photographing) became an avid photographer for the next twenty-five years. Partially deaf and crippled, he was a loner who found his muse in children. His portraits are explorations in naturalism. He used props and costumes extensively and left posing to the natural flow and rhythms of play. For props Dodgson used stage props, books, croquet mallets, bicycles, mirrors, hats, dolls, flowers, baskets, and a trellis, among other items. He disliked elaborate backdrops, favoring instead a weathered wall, a natural landscape, or a simple blanket. He is credited with creating the storybook style of image making, a technique still widely popular in advertising and fashion, as well as in commercial and fine art studios. Like F. Holland Day and von Gloeden, Dodgson challenged Victorian social taboos. However, Dodgson changed the formula, instead photographing nude female children, always with permission of their parents. Dodgson's peculiar affinity to young girls is often viewed today with a raised brow. Nevertheless, there were no documented allegations of any impropriety. Only four of Dodgson's nude studies survive, all of which are handpainted.

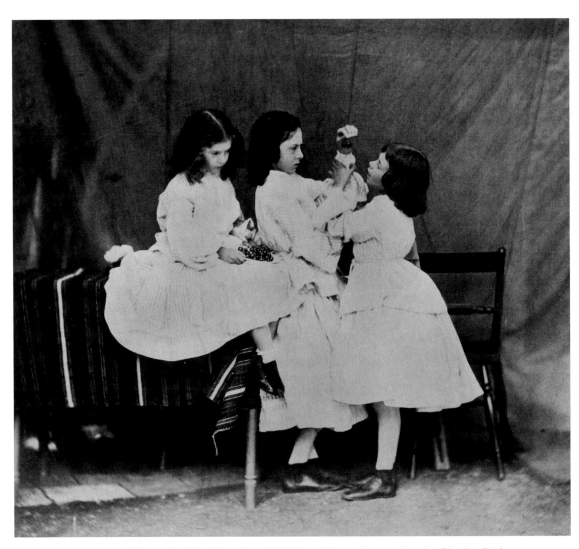

"Open Up Your Mouth and Bob for a Cherry" was taken by Charles Dodgson (Lewis Carroll) around 1861. The models are the Liddell sisters—Lorina, Edith, and Alice. Alice was the muse who inspired *Alice's Adventures in Wonderland,* considered by many to be the greatest work of children's literature.
(Courtesy of the Rosenbach Museum & Library, EMs 1284/18)

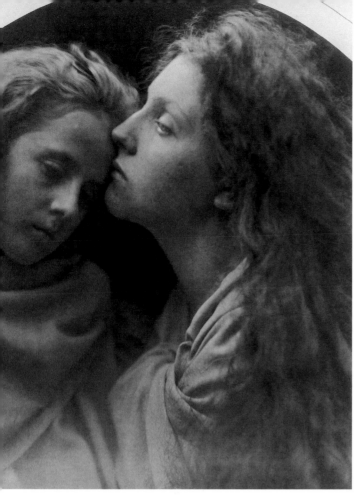

"The Kiss of Peace" is a perfect example of how Julia Margaret Cameron used allegory to create emotional and tender photographs. *(Courtesy of the Gernsheim Collection of the Harry Ransom Humanities Research Center at the University of Texas at Austin)*

Historically, the idealization of family life has been a popular visual motif. English photographer Julia Margaret Cameron (1815–1879) is perhaps the most well-known female Victorian photographic portraitist. Discovering photography in her late forties, she was influenced by such prominent friends as Tennyson, Darwin, and Longfellow, as well as by Pre-Raphaelite paintings and the Bible. Evocative illuminations, soft focus, and angel motifs highlight her portraits, and her impressionistic style invokes a mystical and romantic tone. She encouraged her family and friends to act out scenes from literature as she recorded with her camera. Today, many commercial photography studios use the angel theme.

The use of elaborate backdrops provided a means of visual narrative for photographer Henry Peach Robinson (1830–1902). Originally a painter and etcher, Robinson became a professional photographer in 1852; he is infamous as the photographer of "Fading Away," a photograph of a dying girl and her grieving family. Though even in the Victorian times in which he worked countless paintings detailed violence and death, the fact that Robinson's picture was a photograph raised public objection. Robinson's photographs were often composites of several different images. He first sketched a scene and then photographed it several times separately, each time incorporating different elements. The model in "Fading Away" was actually a healthy girl.

It is interesting to note that while painters of the time were taking their easels outside to work, Robinson created elaborate indoor stages using backdrops of clouds and real shrubbery and improvising under a skylight. Environmental portraiture is very popular today, and, to command complete control, commercial photographers are building elaborate sets—gardens, streams, bridges—just like those of Henry Peach Robinson.

Throughout the history of photography, portraits have reflected social, economic, and leisure pursuits of the times. As the industrial revolution began at the end of the nineteenth century, photography also changed, providing a voice for the new generation. Alfred Stieglitz is known as the father of modern art photography in America. He

EARLY CAMERAS

Early Kodak cameras did not have viewfinders, so the term "point-and-shoot" was literal. The composition was a matter of guesswork. The format was also circular and was not changed until 1896.

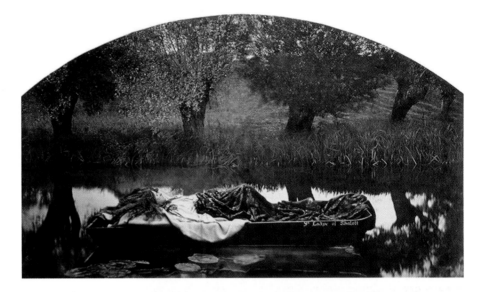

This portrait, titled "Lady of Shalott," is a good example of Henry Peach Robinson's elaborate indoor stage settings. *(Courtesy of the Gernsheim Collection of the Harry Ransom Humanities Research Center at the University of Texas at Austin)*

happened to be a student in Europe at the time when the Pictorialists' passion was at its peak. Returning to America, he quickly realized that an equal passion did not exist there and made it his life's mission to create and exhibit photography as art.

By the end of the first decade of the twentieth century, American women began making a noticeable mark as photographers as faster methods of completing domestic chores gave them more leisure time. They were able to create photographs around their household obligations, processing them later as time permitted. In contrast to photography's flexibility, painting was a discipline both rigidly demanding and time-consuming.

Hailed as "The Foremost Women Photographers in America" (*Ladies' Home Journal*, July 1901), the Allen sisters lived in a small community in Massachusetts and cultivated a down-to-earth portrait style. They portrayed provincial New Englanders in a Pictorialist fashion, using natural light in scenic rural settings or sunlit window light for most of the portrait settings.

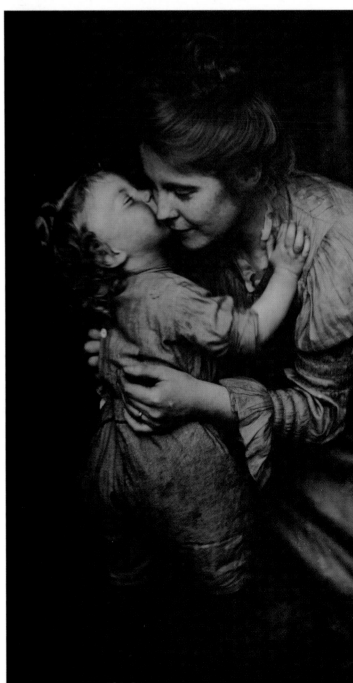

The universally poignant theme of love between parent and child is highlighted by the Allen sisters' beautiful lighting and use of the chiaroscuro style. This portrait of Eleanor B. Stebbins with her daughter, Marion Stebbins, is a modern print from a glass-plate negative. *(Courtesy of the Pocumtuck Valley Memorial Association, Memorial Hall Museum, Deerfield, Massachusetts)*

Documenting Society

While some use photography as an interpretative medium, others turn to it to document society. At the turn of the nineteenth century, change was everywhere, and photography became an important method of expression and documentation. In Georgia, W. E. B. DuBois collected photographs of African-American life for an exhibition at the Universal Exposition in Paris in 1900.

Arnold Genthe (1869–1942), originally of German descent, immigrated to California and took to the streets with a concealed handheld camera to record life in the Chinese quarters of San Francisco. His pictures were contradictions in aesthetics, both Pictorial and reportorial. The use of concealed cameras has continued throughout the history of photography. Garry Winogrand used a concealed camera to document unaware Americans in the 1960s and '70s.

In 1904 Lewis Hine (1874–1940), a teacher at the progressive Ethical Culture School in New York City, began to photograph immigrants as part of the school's teaching programs. Working as an investigative photographer for the National Child Labor Committee from 1908 to 1921, Hine created images championing the cause for children's rights. Many reforms came in response to his work. Today, over 6,000 prints and 3,800 negatives by Lewis Hine are in a collection at Ellis Island. All of his images in the Library of Congress—5,100 prints—are free to use, as stipulated by Lewis Hine in his attempt to posthumously advocate for children.

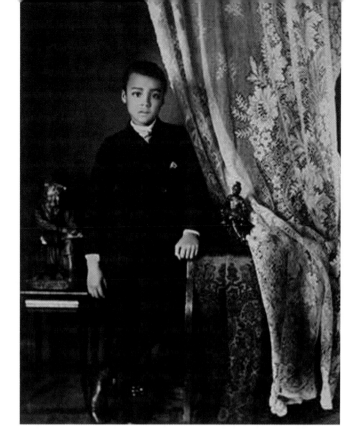

One of 363 photographs from the W. E. B. DuBois collection of the Library of Congress documenting life and culture of the African-American population living in rural and urban Georgia in 1899 and 1900, this photograph is of a purposely unidentified young boy. The dress of the young man and the lace curtain suggest culture and wealth. *(Library of Congress, Prints & Photographs Division, LC-USZC4-10672)*

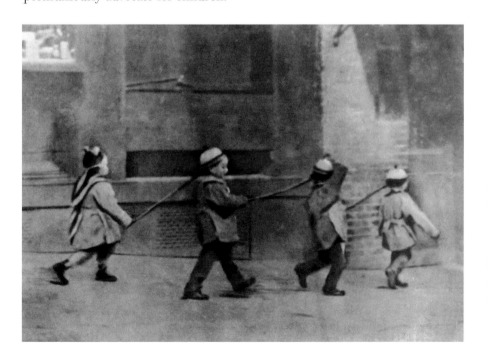

Arnold Genthe was an internationally recognized photographer who worked in the soft-focus Pictorialist style. "Pigtail Parade" is a candid photograph taken between 1896 and 1908 in San Francisco's Chinatown. It is a documentary-style photo that expresses Genthe's poetic voice. *(Library of Congress, Prints & Photographs Division, LC-USZ62-65750)*

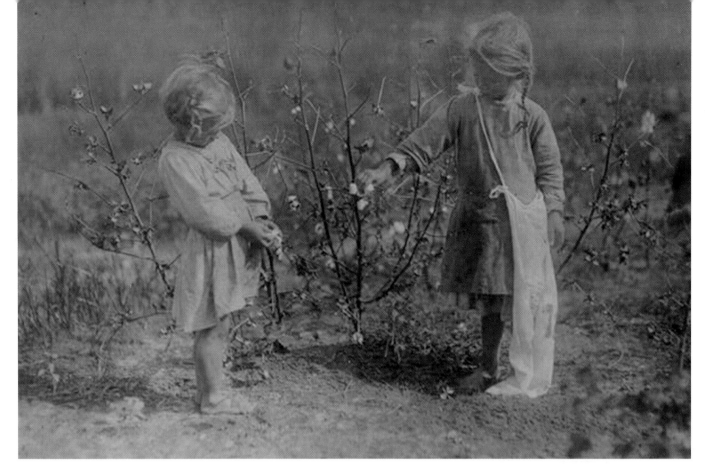

This photograph from a glass-plate negative was taken in October 1913 by Lewis Hine. An illustration of the harsh life of child laborers, it shows young children picking cotton on a farm near Houston, Texas. *(Library of Congress, Prints & Photographs Division, National Child Labor Committee Collection, LC-DIG-nclc-00206)*

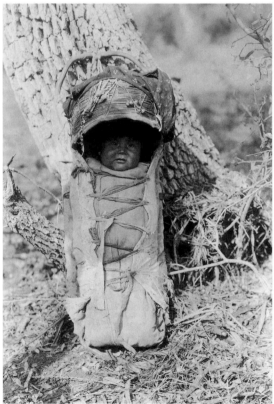

This photograph of an Apache baby is one of ninety-two images Edward S. Curtis captured of the Apache and Jicarilla Indians of Arizona and New Mexico between 1903 and 1907. *(Library of Congress, Prints & Photographs Division, Edward S. Curtis Collection, LC-USZ62-97090)*

Born in Wisconsin in 1868, Edward S. Curtis moved to Seattle, Oregon, and purchased part of a portrait studio where he became successful. But his life's calling snatched him into the vast lands of America during the beginning of the twentieth century, when he began a thirty-year mission to photograph as many of the American Indian tribes as possible. Called the North American Indian Project, the daunting work encompassed photographing tribes throughout the United States, including Alaska, as well as parts of Canada. He photographed 40,000 glass-plate negatives, attempting a scholarly and artistic document of daily life and beliefs among the different tribes.

Gordon Parks (born 1912) is an award-winning photographer, writer, and filmmaker, as well as a noted musician and composer. Parks's impoverished upbringing in a

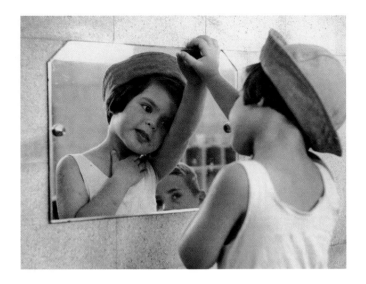

"Mirror Mirror," by Ruth Orkin, shows a young girl living in a children's home on a kibbutz in Israel. Although Orkin could not communicate with the little girl with words, she "had a wonderful time photographing her."
(Courtesy of Ruth Orkin/Getty Images)

segregated community influenced him to use photography to document conditions among the urban poor. He was the first African-American to work for the Office of War Information and the Farm Security Administration, which sent photographers on assignments into specific geographic regions. The photographs from the resulting collection represent an extensive pictorial record of American life between 1935 and 1944.

Ruth Orkin (1921–1985), the daughter of an actress and a mechanical wiz dad, began processing her own negatives at age twelve (as did I). At the age of seventeen, she rode her bicycle across country to attend the 1939 World's Fair in New York City. Orkin moved to New York in 1943 and began her career—like so many women photographers before and after her—taking baby pictures. Orkin is best known for her naturalistic urban portrayals of Europeans and New Yorkers in the 1940s, '50s, and '60s. In 1959 the Professional Photographers of America named Orkin one of the top ten women photographers along with Dorothea Lange and Margaret Bourke-White.

Each time I tried to complete this chapter, I checked my spelling and references in the many texts and online media sources, and sure enough I bumped into another photographer that I had to include. The truth is, the history of photography is fascinating, a bit scientific, a little investigative, and totally inspiring. Please use this abbreviated reference as a beginning. Follow my leads to explore in more depth the icons that interest you. By all means, explore the wealth of information, both visual and written, that the history of photography holds.

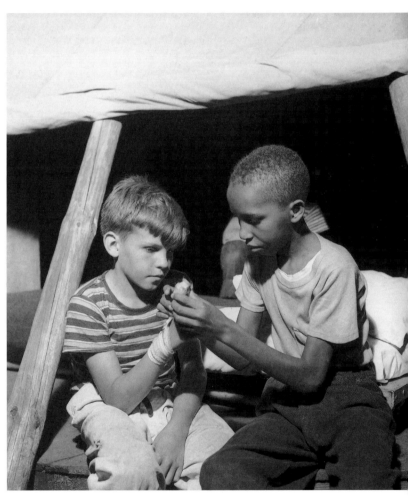

This photograph, taken by Gordon Parks around 1943, is one of millions of photographs that encompass the Farm Security Administration–Office of War Information Photographs Collection. It shows interracial activities at a Methodist camp in Southfields, New York. *(Library of Congress, Prints & Photographs Division, FSA/OWI Collection, LC-USW3-036777-C)*

THE CAMERA IS
AN INSTRUMENT
THAT TEACHES
PEOPLE HOW
TO SEE WITHOUT
A CAMERA.

—Dorothea Lange

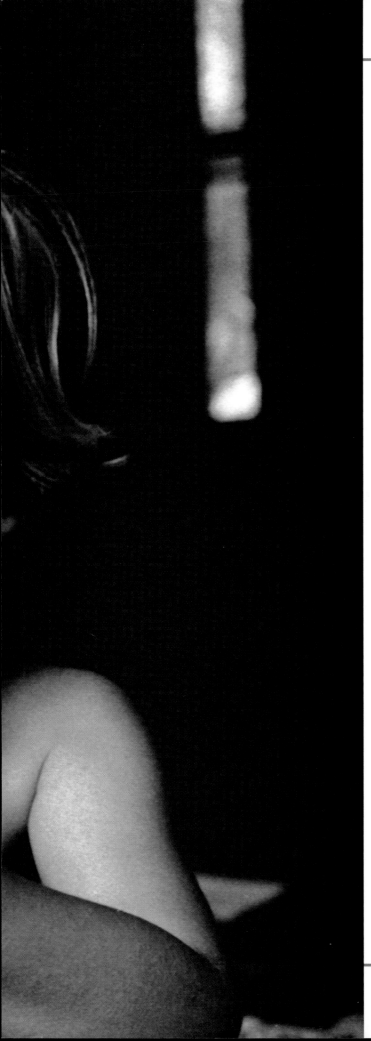

Equipment

P HOTOGRAPHING CHILDREN requires total attention to their state of mind—a state that changes constantly from smiles to tears to bafflement to wonder. These glimpses of magic slowly unveil but illusively disappear the moment the photographer tries to capture them. Like an audience engrossed in the subtle character shifts of an actor, the photographer watches the child, waiting for cues. Equipment is merely a facilitator for the photographer's vision. Nothing should come between the photographer and the child—only total awareness and total absorbency in the moment will allow the magic to be captured on film. Equipment must become an extension of the photographer's body, mind, and eye. Equipment should fit like a good pair of jeans, moving, adapting, and forming to the moment with comfort and ease.

Choosing the Right Setup

Like a child in a candy store—money in hand, anxious with indecision, tempted by so many rainbow-colored wrappings—you may become overwhelmed by the irresistible and mind-boggling choices available when shopping for photographic equipment. For the novice, deciding what to select can be overwhelming. More advanced photographers may feel uncertain about going in a new direction. Professionals must constantly reevaluate and possibly update their setups.

Many of us ponder questions such as, Should I go digital? How much should I spend? What if my purchase becomes obsolete in three months? To answer these questions, ask yourself, What will I do with the photographs? What size prints would I like to produce? How much am I willing to spend? The answers to these questions will help guide you through the kaleidoscope of possibilities.

The topic of selecting cameras and related equipment selection is steeped in ever-changing and often heated debate. Working portrait photographers—whether they specialize in studio, location, or fine art imaging—require a camera, a lens, a light meter, film and/or a memory card. From these basics, the choices are exponential. Budget, vision, and even ego determine purchases; technophiles proudly pack away the newest gadgets, while purists crave the simplicity of manual cameras.

This chapter reviews the current technology available in photographic equipment to help you make informed purchasing decisions.

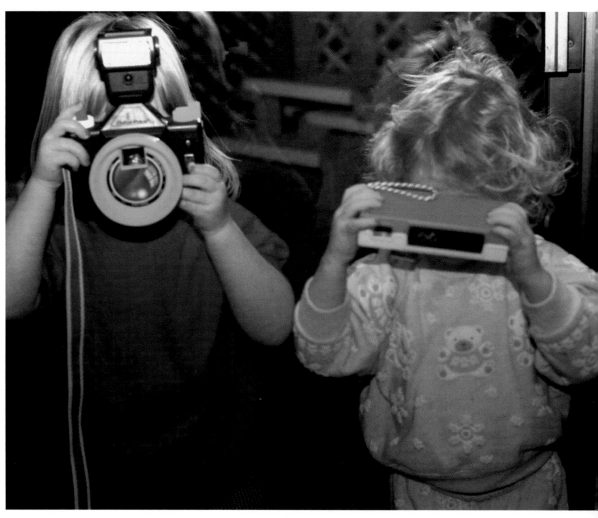

BUDDING PHOTOGRAPHERS
Children love pretending, and these girls giggled away as they photographed me photographing them. This photo was taken with a Nikon N90S camera with a 105mm lens on Kodak Gold 100 film. I scanned the photo with an Epson Perfection 2450 Photo scanner, edited it in Adobe Photoshop 7.0, and printed it on Epson Heavyweight Matte Photo Paper.

Formats

The first question to resolve when purchasing a camera is the format, or size. The decision to use one format over another is based on the desired quality of the final image, the type of photographs you're taking, and budget. While the medium-format camera is arguably the studio portrait industry standard, many professional portrait photographers, including me, use a 35mm camera and a digital SLR.

Most professional and serious amateur photographers use a single-lens-reflex (SLR) camera. The SLR camera was introduced in the late 1930s and made popular by the photojournalist Henri Cartier-Bresson. Continuously updated and incorporating the latest microchip technology, the SLR camera is a precision instrument, and I, like many photographers, rely on its technology.

The three camera formats most applicable for photographing children are the 35mm SLR, the medium-format SLR, and the digital SLR. Point-and-shoot cameras and disposables also have a place in the photographer's bag.

35MM SLR

The 35mm (describes the size of the film) single-lens-reflex camera is my choice for a professional-level camera. I like the ease, the malleability, and the ergonomics it offers. The camera fits in my hand and becomes an extension of my body. I am mobile, and my portrait sessions are fluid. I do a lot of work on location, and the portability of 35mm gear makes this easier.

Most new 35mm SLR cameras are electronic. They operate on batteries that power a built-in light meter and automatic exposure, film speed, shutter, and aperture controls. Many cameras are fully automatic, some allow for manual override, and others are hybrids, offering programs (sports, close-up, portrait), aperture priority, and shutter priority. In contrast, some manufacturers offer new manual models, such as the Nikon FM10, as part of their product line. Manual cameras function with or without batteries, and the user has full control of the aperture, shutter, and film speed settings. I often recommend this camera type to beginning photography students.

There are several advantages to using a 35mm SLR camera. It is typically smaller and easier to carry than larger-size formats, enabling the photographer to move and play with the child, unencumbered by heavy equipment. It utilizes a single lens for both composing and focusing: What you see in the viewfinder is pretty close to how the scene will be recorded on film. The wide selection of lenses opens up a world of possibilities for the creative photographer. The camera is relatively light: The lens and camera body typically weigh less than $2\frac{1}{2}$ pounds (professional models are noticeably heavier).

The main disadvantage, professionally speaking, is film size, which is only 1 x $1\frac{1}{2}$ inches (24 x 36mm), making focusing and careful handling of negatives ever more critical. Other disadvantages are the small viewfinder, which challenges fine focusing, especially if you have near vision; the fact that batteries control the workings of the camera (if the batteries die the newer electronic models are unable to operate); and the compromised picture quality of enlargements over 16 x 20 inches.

SLEEPY-EYED BRAD

I try to shoot a lot of film—three to four rolls per session if the child is up to it. Age dictates the amount of film I use. However, I do not just fire away. I try to make each trigger meaningful; otherwise I end up spending all my time editing. This photo was taken with a Nikon N90S 35mm camera.

MEDIUM-FORMAT SLR

The medium-format SLR camera uses a larger negative and is typically bigger and heavier than the 35mm SLR. There are several advantages to using a medium-format camera. The first is the choice of negative size: 6 x 4.5cm, 6 x 6cm, 6 x 7cm, 6 x 9cm. All medium-format cameras use 120 or 220 roll film; 220 film allows twice as many pictures as 120, but 120 film is still the most popular kind. The number of frames that fit within the roll depends upon the camera. For example, the 6 x 6cm format—known in the industry as the "two-and-a-quarter"—produces a square negative that is three-and-a-half times larger than the 35mm negative. When using a 6 x 6cm camera, the 120 roll film allows twelve exposures, and the 220 film allows twenty-four exposures per roll.

The larger negative produces sharper images with less grain, permitting cropping, which is more difficult with 35mm film. The unique square negative allows the photographer to decide later whether to keep the image square or crop it to a rectangular composition.

As with the 35mm SLR, the medium-format SLR utilizes a single lens to compose and focus with a pentaprism (the 35mm SLR comes with a pentaprism; with the medium-format it is a necessary add-on). The area of viewing is large, making focusing easier. Professional medium-format film renders sharper images with smoother gradations than those of 35mm professional film. Most medium-format cameras have removable backs, so the photographer can switch from black-and-white to color film in the middle of a photo session. Traditionally, the medium-format SLR camera has a higher flash sync (see page 56), although newer 35mm SLRs and digital professional SLR cameras match flash sync of medium-format.

There are several disadvantages to using a medium-format SLR camera. It is big and hard to handhold—fully loaded it weighs more than 7 pounds, which is very heavy for handholding and following children around—and, therefore, useful for studio shots with the camera on a tripod, but not for documentary-style photography or informal environmental portraiture. The camera often does not have a motor drive and has a louder shutter. The loud shutter is particularly disturbing if you are covering an event—picture yourself at your child's dance recital while a noisy "click click, click click" repeats every few seconds. Some contend that the manual shutter inherently creates stronger compositions and more thoughtful shooting. The

idea is that the medium-format portrait photographer does not just hit the shutter release with rapid fire; rather, he contemplates and carefully composes each image. Countering this argument, a 35mm camera facilitates spontaneous imagery.

There is a limited selection of fast lenses (see "Lens Speed" on page 34) available for medium-format cameras. Mamiya offers the fastest lenses—200mm $f/2.8$ for a medium-format portrait lenses.

Initial investment for a medium-format setup is typically at least twice the cost of a 35mm outfit; however, prices are dropping precipitously as more and more professionals are "going digital"; so, if medium-format is on your wish list, now is a good time to shop.

DAVID AND LOIS

When organizing this photo session for my students at the Maine Photographic Workshops, I allowed the children time to relax. Patience is so important when photographing children. Wait long enough and the children will forget about the cameras pointed at them. This photo was captured with a Canon 10D digital camera with a 28–80mm ultrasonic lens.

DIGITAL SLR

The buzz in the photo industry is of who has "gone digital" and what they purchased. It is the talk at holiday parties. If you are teetering on the edge—Should I or shouldn't I?—the choices may seem overwhelming; in fact, there are too many, but then again, choices are the spice of life.

Whether or not you go digital professionally, it is important for you as a photographer to dive into the digital world and surf its sea of acronyms. There is a tremendous learning curve, so it is never too early to wet your feet. Digital is the future—I have no doubt about it. However, there are a few obstacles to getting started. The first big hurdle is expense. A professional system requires a significant investment of money and time. In addition to purchasing a digital camera, you will need a memory card (see page 40), rechargeable batteries, backup batteries (the memory cards eat a lot of energy), a computer, a monitor, a printer, digital imaging software, and a scanner. Then you need time to learn—a lot of time.

Determining which digital camera is right for you requires research and cognizance of your budget and needs. Think about how you will use your digital files—whether to put on the Internet, for personal use, or professionally. Next, decide what size prints you'd like to produce.

There are as many types of digital cameras as there are film cameras. There are the point-and-shoot types, prosumer models that offer professional sophistication at advanced amateur prices, and professional lines. The prices range from very cheap to very expensive. The features of a digital SLR camera often parallel those of newer electronic 35mm SLR cameras.

Some retailers suggest choosing a manufacturer and staying with that brand as you purchase other camera types, because the technologies repeat themselves from format to format and the lenses are often interchangeable. For instance, Nikon lenses are interchangeable throughout their product line (except point-and-shoot).

There are many advantages to digital cameras. The costs of film and processing are eliminated. Additionally, the ability to preview the captured image decreases guesswork. You can see immediately if you got the shot.

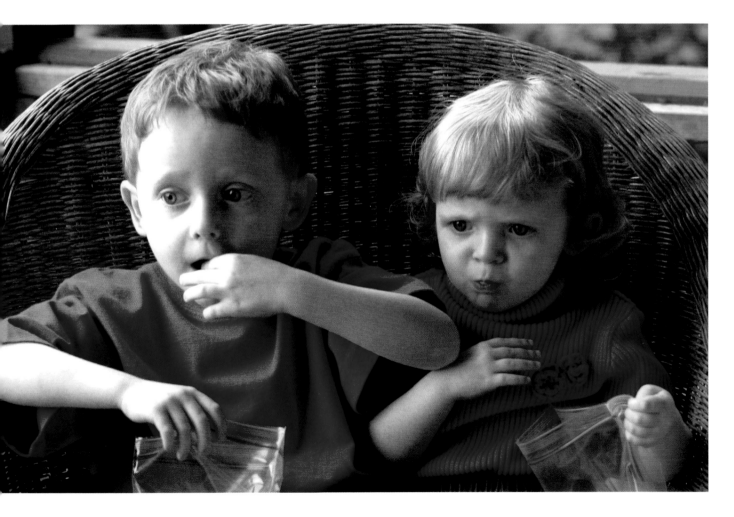

Photographing children digitally has many useful applications, from sending e-mail, to creating Web pages, to recording special moments with on-the-spot viewing.

Digital cameras are nonmechanical; they have no moving parts, and, therefore, less can go wrong. (Every semester the shutter on one of my students' SLRs breaks.) Traditional color films tend toward a color hue, such as blue, red, or yellow, but digital cameras are able to record unbiased color.

The traditional eye-level viewfinder and an accompanying LCD screen are available for composing. Some digital cameras have an LCD panel that pulls open to the left of the viewfinder. Some feel that using the LCD screen to compose makes focusing and composing easier, as the image is a close approximation of the final image before saving. I prefer to compose through the eye-level viewfinder, just as I would with a film camera.

The short life of batteries is a disadvantage of digital cameras. The LCD drains battery power tremendously, as do flash and large-size files. I use a power grip, which houses two rechargeable batteries and boosts the length of battery life. As a habit, when I come home from a shoot, I recharge my batteries so they will be ready for the next day's work. Many photographers have several rechargeable batteries, which they bring on location.

If you are accustomed to the swiftness of a 35mm motor drive, a digital camera may seem slow, so slow that you might worry you will miss a shot. The professional models' click-to-click rate is about 9 frames per second (fps), whereas the consumer models range from 2 to 5 fps. The newer digital professional and prosumer cameras have made tremendous advances in shutter reaction. I use a Canon 10D and never have a problem with my shutter not working fast enough.

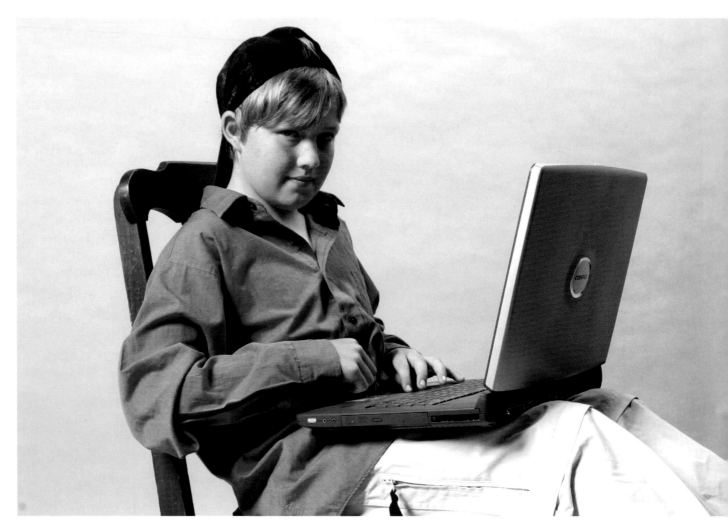

YOUNG EXECUTIVE

Creating excitement is a challenge when working in the studio. Dressing up was the answer in this situation. Dressed in hip-hop junior executive attire, feet propped up, and laptop in hand, this was one happy model. I took this photo with a Canon 10D digital camera with a 28–80mm ultrasonic lens.

While prices continue to drop, professional-level digital cameras remain expensive. Then, once you have a camera, you will need to learn how to use it and become familiar with the software that supports it, as well as other software that enables you to alter photos. If you are using the camera for business, calculate how long it will take to make back the investment and how long it will take to learn to use it. Also compare the cost of retouching the photos yourself versus sending the file to a lab, because while digital photography is fun and the wave of the future, everything done digitally takes a lot of time. You must decide if you want to spend your time learning and working on the computer—the "lightroom"—or if you would rather send the work out and spend your time working with new clients and creating new images. (See more about digital image capture on page 38.)

POINT-AND-SHOOT CAMERAS (FILM AND DIGITAL)

The point-and-shoot camera is perhaps the most popular camera on the market. This relatively new hybrid is manufactured with a wide spectrum of lenses and automated features, making the selection, at first glance, overwhelming. The point-and-shoot camera uses 35mm film or a digital chip and focuses through a viewfinder that is separate from the lens. The lens is fixed—it cannot be removed or changed. The battery-operated system, often including automatic controls for exposure, focusing, flash, and rewind, appeals to the amateur because of its "foolproof" design. As the name suggests, you point, the camera focuses, and then you shoot, recording the image somewhat spontaneously.

The leading camera manufacturers—Canon, Olympus, Samsung, Minox, Minolta, Nikon, Contax, Kodak, and Fuji—all make point-and-shoot cameras. Within each brand name there are many choices. The first area to investigate is the fully automatic versus the manual operating system. I recommend a system with manual override.

The second area to consider is the type of lens. There are four lens choices: fixed, short zoom (up to 85mm), medium zoom (up to 120mm), and long zoom (up to 300mm). As a portrait photographer you should choose a camera that offers a medium to long zoom lens.

The next consideration in purchasing a digital point-and-shoot is what you are going to do with the pictures. I have a 4-megapixel camera, which is plenty big for images up to 8 x 10 inches. My college-bound daughter

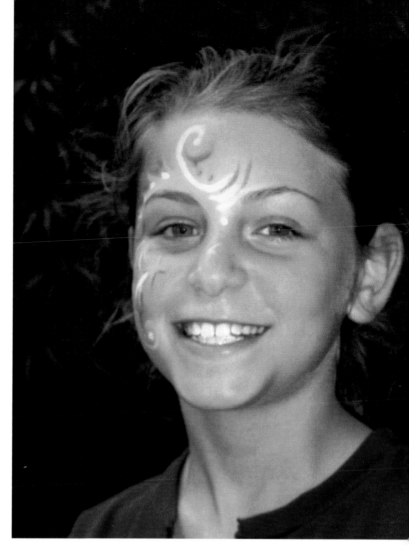

JOELLE WITH FACE PAINT

Atmospheric dark tones and contrasting illumination sets the child's face aglow. I shot this photo with a Samsung Maxima Zoom 145 camera on Fuji 800 film. The point-and-shoot camera automatically operates a flash in low-light situations. I could easily retouch the flash reflection using Adobe Photoshop CS to make it look more like catch lights (see page 50).

plans to make 4 x 6-inch prints, so a 2-megapixel camera is fine. There are digital point-and-shoots available with more megapixels, but you do not have to purchase more than what you need. Remember, the whole point to this camera is convenience. I chose the smallest point-and-shoot digital with the most megapixels, the fastest shutter speed, and the longest lens.

Disadvantages of the point-and-shoot are its lack of manual controls, the need to focus through a separate viewfinder, and the fact that the lenses are not interchangeable—even more reason to invest in a point-and-shoot camera with the best lens your money can buy.

DISPOSABLES

Available almost anywhere, from supermarkets to convenience stores, the disposable camera is a hassle-free, inexpensive item offered with or without flash and available in three different film speeds (ISO 200, 400, and 800) and various colors and designs. Arguably, one can take beautiful portraits with a disposable camera. Find the light, compose, and presto. I always had a spare disposable on hand before I went digital. Now, I always have my digital point-and-shoot in my purse. It is only a matter of time before digital cameras will make disposables obsolete.

I recommend using disposables for a child's first camera; you want to encourage picture-taking without the worry of lost or damaged equipment. I like the nontechnical nature of the camera—it is easy to use. However, creative control is limited with the fixed-focal-length 35mm lens, and facial features (especially the nose) distort if the photographer is too close to the subject.

PYRAMID

Tradition at my childrens' birthday parties is to make a human pyramid—always a laugh and great fun to set up. This picture was taken with a disposable Kodak camera. The wide-angle lens (35mm) was perfect for this composition; no one was cropped.

Features

When choosing a camera, consider the features that are most important to you. Learn the language to discover what the specifications mean and how they will impact your photography. More is not always better. Sift through the hype and find your place by educating yourself. Go to your local camera shop and hold the equipment. Touch it. Feel it. Do not just buy something over the Internet. Support your local retail provider and they will reward you with personal hands-on attention.

SHUTTER PRIORITY

Exposure refers to the amount of light that strikes the film when you take a picture. Proper exposure is the most important technical aspect of photography; good exposure leads to a good print, whether produced digitally or in the darkroom. For portraits, the exposure should be based upon how much light falls onto the face.

The shutter is a curtain inside the camera that opens and closes, controlling the amount of light that strikes the film. The longer the shutter remains open, the more light reaches the film, and vice versa. Shutter speed is measured in fractions of a second, such as 1/60, 1/125, 1/250, and 1/500 sec. Shutter speed settings have a direct proportional relationship: A shutter speed of 1/250 sec. lets in twice as much light as a shutter speed of 1/500 sec.

Shutter priority enables the photographer to select a shutter speed, and the camera then automatically sets an appropriate aperture value (see page 32) for proper exposure. Choose shutter priority when you are at sporting events or any other situation in which you want to stop action (shutter of 1/250 sec. or greater) or to blur action (shutter speed of 1/30 sec. or less).

Metering systems define how the camera interprets the lighting. Some cameras use a weighted system in which the darks and lights in a scene are averaged; some use a spot-metering system where only a minute segment is evaluated for the entire photograph. Electronic cameras also have a digitized computation that takes many segments into consideration and evaluates the data. The newer electronic systems are pretty precise. Many newer metering systems notify the user when the shutter is set too low to handhold; to avoid camera shake (unintentionally blurred or out-of-focus pictures), set your shutter speed to 1/focal length of the lens. I typically use a 105mm lens, so, in theory, I would set my shutter no lower than 1/125 sec. (closest and next highest shutter speed to 1/105 sec.) when handholding the camera.

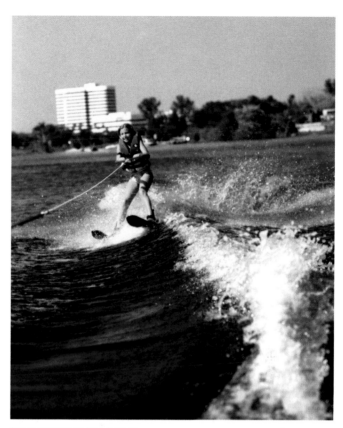

WATERSKIING

Photographing a moving subject when on a moving vehicle requires the fastest shutter speed the lighting can handle to avoid blurred images caused by vibrations. To take this action photo I used Kodak Gold 200 film and set the shutter to 1/2000 sec. with an aperture of *f*/8.

MINIMUM SHUTTER SPEEDS FOR HAND-HOLDING A CAMERA

LENS LENGTH	MINIMUM SHUTTER SPEED
2–28mm	1/30 sec.
35–50mm	1/60 sec.
85–105mm	1/125 sec.
300mm	1/500 sec.

A steadier hand can surely test these guidelines, but first learn the implications of this rule. How heavy is the lens? Is it practical for children's portraiture?

JUSTIN

By the use of a wide aperture (*f*/2.8)
Justin is softly illuminated against
a sparkling sea.

APERTURE PRIORITY

The aperture, or lens opening, controls the brightness of the light that reaches the film. The size of the aperture is indicated by an *f*-number, or *f*-stop, such as *f*/2.8, *f*/4, *f*/5.6, *f*/8, etc. Each change in the progression indicates a halving of the brightness of the light that reaches the film. The wider the aperture, the smaller the *f*-number; for example, *f*/2.8 indicates a big aperture and *f*/16 indicates a small aperture.

Aperture priority enables the photographer to select an aperture, and the camera automatically sets the corresponding shutter for correct exposure. Aperture and shutter speed are inversely related; when the aperture opens (letting in more light), the shutter (how long the curtain remains open) closes down in equal proportions to maintain exposure value. Imagine a scale with two trays. When in balance, the two trays are at equal level. If you remove weight from one tray you have to add to the other to maintain the balance. Opening the aperture and closing the shutter in equal proportions maintains balance.

Aperture priority is useful to most portrait applications, because aperture affects depth of field (how much of the scene is in acceptable focus), controlling how the subject is offset against the background. The rule is to use a wide aperture, such as *f*/3.5, *f*/2.8, *f*/2, for portraiture. However, use caution: A shallow depth of field reduces the range of focus, making accurate focusing critical.

PORTRAIT MODE

Many electronic cameras offer a dedicated portrait mode that automatically sets the aperture to the widest available opening (based on lighting conditions and film speed) and simultaneously sets a corresponding shutter speed. This mode is, perhaps, the easiest way to take portraits when lighting conditions are constant.

MANUAL OVERRIDE

Manual override enables the photographer to set all operating functions independently.

DIOPTER CONTROL

Designed for those who wear glasses, diopter control allows manual adjustments in the optical viewfinder to suit your personal vision. If you cannot see correctly through the camera, you will probably not be able to take pictures with pleasing results. Generally a small dial near the viewfinder can set it to suit your eyesight. Camera accessories are available on some older models to help correct vision problems.

DEPTH-OF-FIELD PREVIEW

Depth of field defines the area of critical focus. As discussed earlier, changing the aperture affects how much of a photo will be in focus, or its depth of field. A narrow aperture (big number, e.g., $f/16$) allows the entire scene you are photographing to be in focus; a wider aperture will make the subject sharp and the foreground and background fuzzy or out of focus. Some cameras have a depth-of-field preview that illustrates the range of acceptable focus. Depress the depth-of-field preview button and you will see how much light is actually coming into the camera through the aperture and how this aperture setting (f-stop) affects the focus. SLR cameras focus as if the aperture is wide open so that photographers can see what they are taking a picture of. However, if you are using an aperture of $f/16$, for example, the light is really much dimmer than the camera's viewfinder illustrates.

MOTOR DRIVE

A camera's motor drive advances the film automatically. Cameras usually include a menu of options. For example, Canon systems have three settings: S (for single, advances one frame when the shutter is released), Continuous (shots are taken as long as you hold down the shutter button fully), and Self-timer (timer starts when you press the shutter and the image is captured in 10 to 30 seconds.

For children's portraiture or sports photography, frames per second (fps) is an important feature—so read the fine print. The motor drive on a digital camera is typically slower than on comparable film cameras. Many digital cameras have a window to store two to five images before the delay and a "quick" or "burst" mode for rapid fire.

SCOTT

This picture was captured on Ilford HP5 Plus film with my Nikon N90S and a 105mm lens. The aperture was at $f/4$ with a shutter speed of $1/125$ sec. I carefully angled the lines of the boat to create a strong composition and focused on Scott's eyes (always focus on the eyes for a compelling portrait). An aperture of $f/4$ has a shallow depth of field, and the background blurs to create a soft, poetic image.

Lenses

While it is true, as Edward Steichen said, that "No photographer is as good as the simplest camera," a quality lens is essential. Invest in the best optics your budget will allow. The better the quality of the lens, the sharper the image. Lens size, indicated by *focal length*, measures the distance of magnification of subject to lens in millimeters. Technically speaking, focal length is the distance between the lens's rear nodal point and the focal plane when the lens focuses on infinity (a far distance from which light reaches the lens in more or less parallel rays).

Focal length controls angle of view (the amount of the scene shown on a given size of film). A normal-focal-length lens, also called a standard-focal-length lens, approximates what the human eye sees. Film size determines the size of a normal lens by measuring the diagonal of the film—the larger the film, the larger the focal length of a normal lens. For example, the diagonal of 35mm film measures 45mm; therefore, a normal lens is in the range of 45mm, which is usually a 50mm lens. For digital cameras, the diagonal size of the CCD or CMOS (see page 38), determines a normal lens. A CCD or CMOS is typically smaller (sizes vary significantly) than 35mm film and the lens equivalents in the table below, although the technology is striving to match the size. The table below identifies formats and only a few of the myriad corresponding lens selections.

Portrait photographers typically work with a lens twice the diagonal of the negative. The longer lens prevents distortion problems (particularly of noses) and creates some necessary distance between the photographer and subjects. For a 6 x 6cm negative the diagonal measurement calls for a 190mm lens, a 35mm negative calls for

a 105mm lens, and a 6 x 7cm negative a 210mm lens. My first Nikkor 105mm lens has an optical quality that newer lenses cannot duplicate. It is soft focus and beautiful. However, on the job, I now prefer to use a newer Nikkor 105mm $f/2$ D lens with autofocus and defocus controls, or my Canon 70-200 $f/4.5$ L series (L denotes Canon's professional line of lenses) lens for digital work. Both magnifications are strong enough to create some distance and at the same time short enough for an intimate rapport.

The choices of lenses is personal. Aside from a portrait lens, a photographer may opt for a zoom—a lens that encompasses several focal lengths—such as an 85–200mm. In contrast, a shorter focal length, such as a 50mm lens—considered normal in 35mm format—can distort if you move too close to the subject. For photojournalism-style portraiture a 35–50mm lens may do the job—it is wide enough to give the viewer perspective of the location.

LENS SPEED

Although speed (time) is usually a function of the shutter, speed also describes how quickly light pours through the lens. A lens with an aperture of $f/2$ is faster than a lens having the widest aperture of $f/4.5$. With a small aperture, such as $f/22$ (small hole, big number), light trickles into the lens, but with an aperture at $f/2$ (small number, big hole) the light pours through the lens full throttle. A fast lens allows the photographer to work in lower light situations without the use of a tripod. For a photographer like me who often works at dusk, it is important to have a fast lens.

LENS MAGNIFICATION AND FORMAT EQUIVALENTS

TYPE OF LENS	35MM FORMAT	6 X 6CM FORMAT	6 X 7CM FORMAT
Wide-angle lens	28mm	54mm	60mm
Normal lens	50mm	95mm	105mm
Small telephoto lens	85mm	150mm	180mm
Portrait lens	105mm	190mm	210mm

The lenses listed in this table correspond to 35mm and medium-format cameras. The lenses used on digital cameras vary tremendously in actual magnification since the number is dependent on the size of the CCD or CMOS. Consult your camera and lens literature to achieve the best approximation for lens equivalents.

SOFT FOCUS

My Nikkor 105mm $f/2$ D lens helps transform the background into beautiful-colored bubbles. To accomplish this effect, make sure there is adequate space between the subject and the background; set the camera to portrait mode or aperture priority, and select a wide aperture, such as $f/2$. Just remember that focusing is critical. I recommend using a tripod when photographing a child who will sit for you. Nicole would have sat for hours, as she, like many young girls, loves to have her picture taken.

CHRISTAL, JESSICA, AND TARON

This picture was captured at relatively close range with a Canon 10D digital camera with a 28–80mm ultrasonic $f/3.5$ lens—a 35mm equivalent that approximates a 60mm lens.

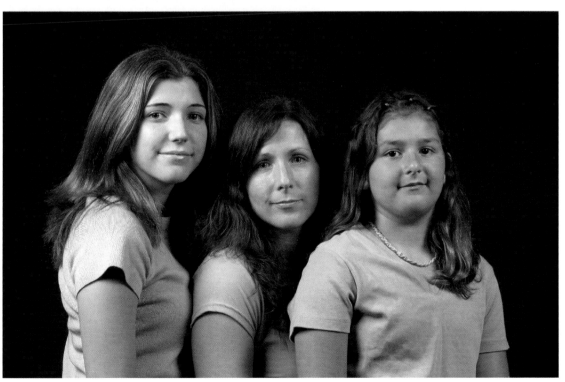

Film

There are a number of terrific films on the market that render sharp, beautiful skin tones, vibrant colors, and fine grain (see box at right). Leading film manufacturers for color portrait films include Kodak and Fuji. Kodak makes a line of portrait film called Portra, which comes in three types: vivid color (VC), neutral color (NC), and ultra color (UC). The film is available in all negative formats and has ISO ratings of 160, 400, or 800. Fuji Professional NPS film (ISO 160) renders a beautiful range of colors and is available in most negative formats. For transparency film, look again to Fuji or Kodak, specifically Fuji Provia and Kodak's E100S series. For black-and-white film, I recommend Ilford's Delta ISO 100 or Delta ISO 400 and Kodak's T-Max 400 CN film. These films produce exceptionally fine-grain images. For fun, experiment with Ilford's SFX film, which is a pseudo-infrared film: With a strong red filter (25A), you can achieve an ethereal look.

The general rule of thumb for choosing film is to select the slowest film the light conditions will handle. Slower films record sharper details and smoother gradation and have less grain and contrast—typically desirable qualities for portrait work. There are a few other factors that differentiate films: saturation, contrast, tonal rendition, and color bias.

If you want to produce very large color portraits from color negative film, use a medium-format camera and film. According to the Kodak Professional Portra Tech Publications, a 35mm negative enlarged to a 16 x 20-inch print (17.8x magnification) produces a 92 on the print grain index (a number of 25 or below is considered to have no visible grain). A 120mm negative enlarged to a 16 x 20-inch print produces a 62 on the print grain index.

I use a 35mm camera and often shoot black-and-white, ISO 400 film. I usually enlarge these images to 20 x 24 inches and handpaint them. I rarely have a problem with grain. Ilford's Delta films and Kodak's CN lines are extremely fine-grain black-and-white films.

BEN, CHARLIE, AND MAX

For this photograph I used Ilford HP5 Plus film, a fast all-purpose black-and-white film. I generally use ISO 400 film rather than a slower ISO 100 or 125 because I shoot in low-light situations and because I often photograph more than one child at a time and like to use as small an aperture as possible. Remember, all rules are made to be broken. While the rule for portraits is to use a wide aperture, I purposely use a narrower aperture to ensure the children are in focus.

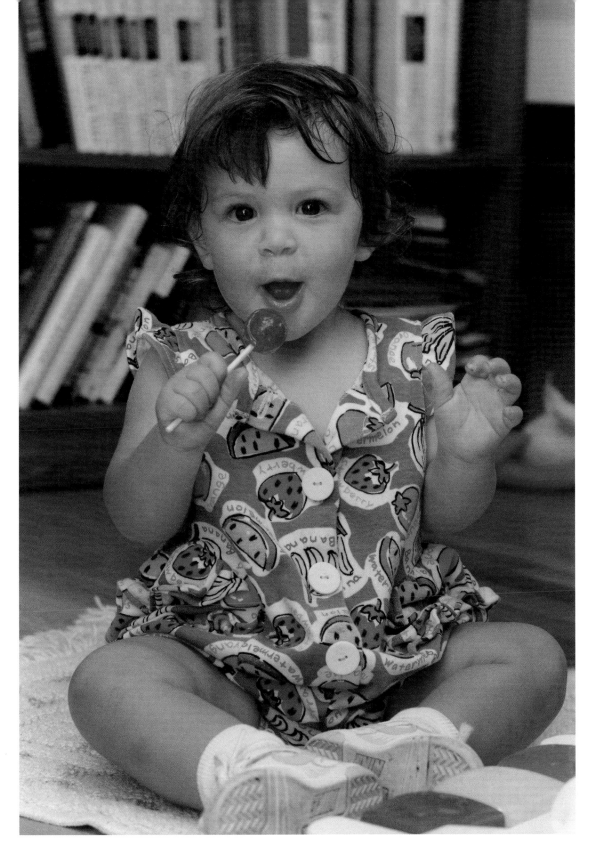

LOLLIPOP

Here I used Kodak Gold ISO 100 film, which reproduces brilliant colors and beautiful warm skin tones. Now available as a Kodak consumer film, its professional counterpart is the Kodak Portra line. Attempting to pose a two-year-old is not easy: The lollipop helped. Notice how the bright-colored books complement her colorful dress.

Digital Image Capture

Photography is an exciting field. The new discoveries that abound today are probably similar in scope to those made during photography's early years. Technology keeps redefining itself, and something that was not possible a year ago may be the industry standard today. I have embraced digital photography wholeheartedly. I find it fun and exciting and it has helped me come up with new ways of creating. I will attempt to summarize a few of the most important aspects in the ever-changing world of digital photography that will be helpful to you.

PIXELS

As with the 35mm or medium-format SLR camera, light enters the digital camera through the lens. However, the digital camera interprets the image in binary, rather than analog, form with an internal light-sensitive patch called a CCD (charged-coupled device) or CMOS (complementary metal-oxide semiconductor). The CCD or CMOS, which resembles a honeycomb under a microscope or a grid on a piece of graph paper, converts the scene into data describing the light by intensity, position, and color. Each cell on the CCD or CMOS corresponds to a solid-toned pixel (short for "picture element") of information—one you can easily see on your computer screen. The larger the CCD or CMOS, the higher, potentially, the quality of the captured image.

A pixel is the smallest part of a digital image, similar to a grain of film. The number of pixels that appear on a monitor or in a print are expressed as pixels per inch (ppi). The more pixels per inch, the sharper the image. Images can be enlarged (called interpolation) using software: New pixels are invented (interpolated) using neighboring colors to approximate and are then wedged between original pixels to make the picture bigger.

A *bit* (short for *bi*nary digi*t*) is the smallest unit of information describing a pixel. The size of an image file is described in *bytes*, in which one byte equals eight bits. One kilobyte (K or KB) equals one thousand bytes, one megabyte (MB) equals one million bytes, and one gigabyte (GB) equals one billion bytes.

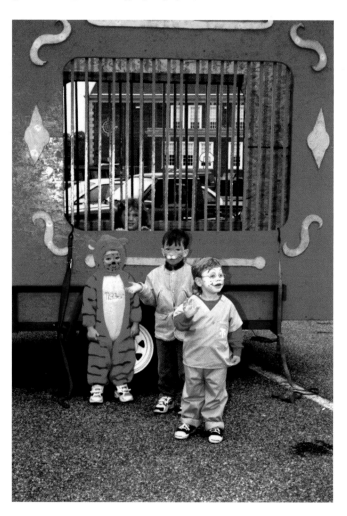

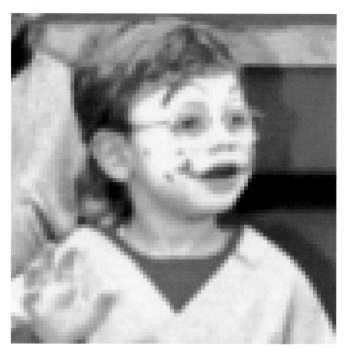

CHILDREN IN COSTUME

In the photo on the left, the pixels are not visible. When the picture is enlarged (above), the pixels become visible. Like grains in a photograph, pixels define the quality of the image. The more pixels per inch and the more information the pixels can hold (bit depth), the sharper the image. Consequently, like a film image, the more the picture is enlarged, the less sharp it will be.

RESOLUTION

Resolution is a term that describes a few different concepts relating to digital image capture. It is one of the most important concepts to understand and perhaps the most confusing. *Input resolution* defines the number of pixels a sensor (CCD or CMOS) can record or distinguish and is measured in megapixels (one megapixel equals one million pixels). The higher the input resolution, the greater the number of megapixels. Typically, the greater the number of megapixels, the larger and sharper the output, the better the image, and, usually, the more expensive the camera. *Optical resolution*, or physical resolution, defines image file and monitor resolution and can be measured in either pixels per inch (ppi) or pixel dimension, such as 600 x 1200. *Printer resolution*, the number of pixels per inch recorded by a scanner or a printer, is expressed as dots per inch (dpi).

Resolution equals information, so the more resolution a camera has, the higher the quality of the image. To yield an 8 x 10-inch print at 300 dpi (select 300 dpi for greater photograph quality) requires an image made up of at least 2400 x 3000 pixels.

Most consumer digital cameras do not have a high enough resolution to produce high-quality 8 x 10-inch prints. Some models—including the Nikon CoolPix series (5 megapixels), Nikon D70 cameras (6.1 megapixels), Minolta Dimage 7HI (5.1 megapixels), Olympus E-20N SLR (5.2 megapixels), and Canon EOS Digital Rebel (6.3 megapixels)—come close. To have a larger megapixel capture sensor you'll have to move up to the pros, such as Canon D10, Canon 1 D-Mark series, Nikon's D2H (11.1 megapixels), Kodak's DCS Pro 14N, or Olympus E-1 series (14 megapixels). However, at this time the prices of these cameras are well into the thousands of dollars (for just the camera bodies, with everything else an added cost).

Some medium-format photographers use a digital back, a device that attaches to a medium-format camera body in place of the film back and allows the photographer to use the medium-format camera body for digital imaging. These camera setups easily capture images with very high resolution.

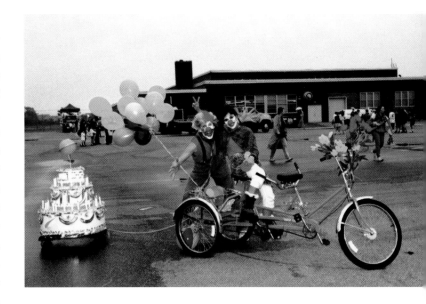

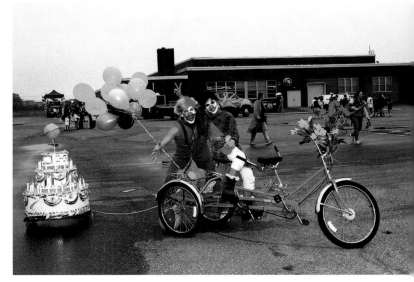

ON THE SIDELINES AT THE PARADE

Parades are a photographer's paradise. The colors are so intense, adding to the excitement of the event and the possibility of creating great pictures. The top photo has a resolution of 200 dpi. The bottom photo has a resolution of 300 ppi. As you can see, the bottom image is considerably crisper and shows much more detail.

MEMORY CARDS

Digital cameras record images not on film but on memory cards, which are like portable hard drives that stores digital information. When choosing a memory card, its speed and the amount of space it has for storage are important considerations

There are five standard types of memory cards: Compact Flash Cards are the most popular and among the least expensive. They store anywhere from 32MB to 4GB of information (even larger capacity will surely follow). Smart Media Cards are the second most popular type because they are ultra-thin and compact. The newer Secure Digital Card is a smaller card that will surely inspire other smaller cards as camera manufacturers continue looking to make room in the camera body to fit other features. Memory Sticks are small rectangular cards developed by Sony for use in their digital cameras, camcorders, and MP3 players. Microdrives are larger-capacity cards that record data using magnetic hard-drive technology rather than flash memory.

The amount of information a memory card can store ranges from 8MB to 8GB. The more storage space a card has, the more expensive it is, the more pictures it can store, and the better the quality of the images.

Speed is also an important factor, and memory cards are available in a variety of speeds, such as 4x, 12x, 16x, and 40x. Typically, the higher speed ratings help store pictures faster and reduce pause time between photos. Choose a card with enough memory so you will not miss a shot. A word of caution: Not all cameras can use the ultra-large memory cards or read them at super-fast speeds, such as 40x. Consult your camera specification before purchasing an expensive memory card.

I recommend purchasing the largest and fastest memory card you can afford, keeping in mind that you will need to purchase at least two (a professional will have four to eight on hand). I recommend buying a few 512MB cards instead of one 1GB card. This way, if you damage the card or lose it you still have another. I also use a card reader that downloads the images to my computer very quickly. While writing this book, I have witnessed prices for digital memory cards come down dramatically. Undoubtedly, as the technology becomes more commonplace, price reductions will continue. Memory cards are reusable; download the images you want to save onto your computer, and then erase the card and continue photographing with it.

FILE TYPES

There are a number of formats in which to save digital files. The three most common are TIFF files, JPEG files, and RAW files. TIFF (Tagged Image File Format) files are good for photo editing and archiving because no compression is applied to the pixels; but because they are so large, they are not recommended as a way to capture digital files. JPEG (Joint Photographic Expert Group) files are convenient and easy to use, and just about every software supports them. They are small files and are good for posting images to the Internet. I recommend setting your camera to "large file, highest quality" (lowest compression) for the best possible image capturing. RAW (not actually an acronym—the capital letters are used to follow the TIFF and JPEG labeling style) files are questionably the highest quality formats, because they have not been altered or interpreted in the camera. The advantages of using the RAW format are the ability to capture high-bit data, the lack of in-camera processing, and options and flexibility during the conversion process. The disadvantages are large file size, time needed to convert the files, and the inconvenience of working with high-bit files.

The size of the captured digital file determines the amount of memory needed; one file can take up a whole memory card. RAW data uses the most memory, then TIFF, and lastly, JPEG. Within each file type category are quality differentiators: high, medium, or low and compressed or uncompressed. The better the quality of the image saved, the more memory it takes.

Digital Imaging Accessories

I recommend learning digital to everyone. Learning is the mind's calisthenics. Keep learning and you will age more gracefully. Besides reading my book, consult the list in the bibliography for other sources. Purchase a scanner and some digital imaging software and jump right in. Learning digital is a lifetime endeavor. The technology changes just as fast as you learn a new concept. As you learn, find ways to incorporate the new technology into your work. Do not jump ship. If you buy a digital camera, say by Nikon, and then three months an even newer model comes out, do not feel that you have wasted your money. Learn it, use it, and stand behind your decisions. Do not look back, but look forward.

COMPUTER

There are as many choices of computers as there are cameras. The first consideration when choosing a computer is its operating system: Macintosh or PC. Many of my photographer and designer friends use Macs, but I have always used a PC. There are many new programs now available for PC only, such as digital workflow editing software. The Mac does seem more user-friendly, but I will stick with a PC and would recommend one to anyone who has learned computer technology in that mode. Then there is the debate over a desktop computer or a laptop. I use a desktop computer, but a laptop is on my wish list for location shoots and slide presentations.

One of the most important things to look at when choosing a computer for working with photographs is random access memory (RAM). RAM is where the data and files are stored temporarily while the computer is on. Working with photographs requires at least 256MB of RAM, but I wouldn't settle for less than 512MB.

MONITOR

The monitor is arguably the most important unit of your desktop system. Opinions vary regarding flat-screen versus traditional (CRT) monitors. The flat screen uses less desk space but is much more expensive. Size is the most important factor, and when it comes to monitors, bigger *is* better. You will need a 17-inch or larger screen in order to work with photographs. I use a Trinitron 19-inch CRT that enables me to adjust the monitor colors. My next monitor will be a 21-inch CRT monitor. CRT monitors last for approximately three to five years, after which time color renditions degrade. (See "Test Prints" on page 129 for information about calibrating your monitor.)

PRINTER

The choices of available printers could fill a book. Once again, first determine the size of the final images you will be producing. As a portrait photographer, focus on photo-imaging printers. Epson is the leader in this market, having dedicated their research into equipping the photographic industry, although Canon and Kodak are working diligently to gain market share. At the time of this writing, the Epson 2200 is the cutting-edge consumer printer, featuring 2880 x 1400 dpi resolution, 13 x 44-inch maximum printable area, seven pigment inks, and the option of matte black ink for matte paper. The inks produce archival results—a must for selling computer-generated images—when used in conjunction with Epson Premium papers and stored properly away from light.

Epson prides itself on its Print Image Matching (PIM), and the Epson Print Academy travels throughout the United States offering workshops to help photographers achieve prints of the highest quality.

SCANNER

A scanner is a good introduction to digital photography, allowing you to digitize your film library while learning the language and techniques of digital imaging. The two scanners relevant to this text are flatbed and negative scanners. Flatbed scanners scan reflective art; negative scanners scan negatives. Flatbed scanners are relatively inexpensive, while negative scanners are noticeably more expensive. Some flatbed scanners have transparency and negative scanning capabilities. I use the Epson Perfection 2450 Photo scanner, with transparency scanning capability of up to 6 x 7cm. Choosing a scanner that comes with bundled software is a smart way to stretch your dollars. Presently, Epson scanners are bundled with Adobe Photoshop Elements 2.0 and SilverFast Ai. Their strategy is that once you become hooked on their product you will want to upgrade to Adobe Photoshop CS or SilverFast 6.0 Ai, professional software for scanning that allows incredibly detailed control over the quality of the scan. (Remember, the better the scan, the better the pictures.)

MOM AND JOELLE

This picture was originally photographed in black and white with Ilford HP5 Plus film and scanned at 1200 dpi. I scan my negatives at a very fine resolution—sometimes even 1800 or 2200 dpi—to ensure the best possible file, with as many pixels as my computer can handle. Using Adobe Photoshop 7.0 I cropped and toned the image and added a purple background. I added the border using Auto FX Photo/Graphic Edges.

DIGITAL IMAGING SOFTWARE

Once the image is scanned, you may want to manipulate it in some form. Adobe Photoshop CS is the professional industry standard. (Adode Photoshop 7.0 is the earlier version, which I used until CS became available.) Adobe offers a consolidated version, Adobe Photoshop Elements 2.0, for a third of the price, which provides a gentle entrée into photo editing. Many of the tools and commands are the same as in Adobe Photoshop CS, but there are fewer of them. You can learn on this and then step up to the full works. Jasc Paint Shop Pro 8 is another popular digital imaging software that is arguably more user-friendly than Photoshop. Jasc Paint Shop Photo Album 5 is a great software program that enables the user to create slide shows with synchronized music, timed transitions, and many transition styles. Learn this software and then move onto Jasc Paint Shop Pro 8. Photoshop also offers eight different versions of scrapbook-making programs, which I cannot wait to explore.

Visual Imaging Solutions offers Auto FX software, a medley of photo-manipulation programs, including Photo/Graphic Edges, Dream Suite, AutoEye, Mystical Lighting, and Mystical Tint Tone and Color. The effects that are possible through these programs are amazing.

INK-JET PRINTER PAPER

Finding the paper that accomplishes your vision is a time-consuming and expensive task. Trial and error are your best bet. Printers recommend papers and settings, but I have found that these are just starting points. I have spent days testing paper on two different printers. I have also researched what other photographers recommend and I still feel strongly that you must experiment for yourself. Some papers to try are Ilford's entire line of ink-jet photographic papers, Epson's Premium papers, Kodak Heavyweight Glossy paper, Canon Photo Pro paper, Lumijet papers, and Somerset Photo Enhanced papers.

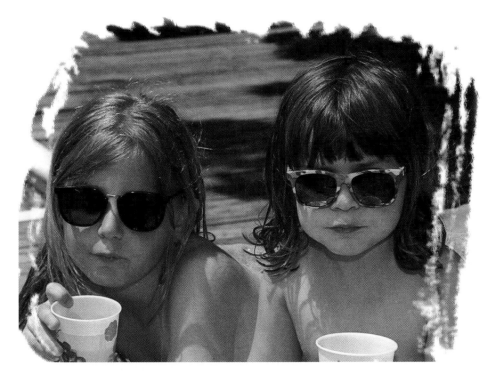

DRINKS BY THE POOL

Auto FX Photo/Graphic Edges has
hundreds of edges to transform your
images. This picture was originally
captured on color negative film.
I cleaned up the spots and fine-tuned
the print in Adobe Photoshop CS,
and then used Photo/Graphic Edges
as a filter to create the jagged effect.

PICNIC

Originally a black-and-white photograph, I added a warm tone using Auto FX Mystical Tint Tone and
Color. A sepia effect can be achieved in many ways, including using printer software and digital imaging
software, and creates a timeless moment. When not overused, the effect is wonderful.

THE LIGHT IS THERE, AND COLORS SURROUND US. HOWEVER, IF THERE WERE NO LIGHT NOR COLORS IN OUR OWN EYE, WE WOULDN'T PERCEIVE SUCH THINGS OUTSIDE OF US.

—Johann Wolfgang von Goethe

Lighting

Lighting is the photographer's medium for exploration and interpretation. It is the language that defines, tones, and animates the portrait. The portrait photographer narrates with light's exhilarating language. Lighting is the nuance describing the child.

Photography is the science of drawing with light. Light is electromagnetic energy that bends, bounces, reflects, and penetrates. The successful photographer is able to harness this energy, transmitting it into an image of humor, depth, or mystery. An understanding of light—the directions in which it strikes a subject, the colors it produces, and how to manipulate and supplement it—will enable you to create natural portraits that are honest and flattering.

The Sun: Available Light

The sun uplifts, heals, and nurtures. The sun illuminates and transforms. Learning to "see" the sun's light—to appreciate, embellish, reduce, or redirect it—is the key to successful children's photography.

Most images throughout this text utilize the sun as the primary light source, a technique known as *available-light photography*. Ambient light, natural light, or existing light are other terms used interchangeably to define the sun as the photographer's primary light source. Sunlight glows from the sky, hides behind clouds, enters a doorway, or appears through a window. It is the light source that many photographers seek.

Working with available light requires patience, ingenuity, and inventiveness. The sun, unlike studio lights, is in constant metamorphosis. The sun's light provides magic—an essential ingredient for producing truthful and evocative images. The transitional moments—sunrise, sunset, dawn, dusk, before or after a storm, fog—reinforce the ephemeral essence of children. The prepared photographer embraces these fleeting moments and captures magical memories.

Outdoor portraits embody a look that is hard to duplicate in a studio. Ambient light encourages a genuine rapport with children; without the constraints of a studio, the photographer is free to enter the child's world. The outdoor environment seduces the child into forgetting you are watching, allowing you to capture honest and memorable images. There is no setting like the outdoors for photographing children at their most natural and engaging.

The main disadvantage of working with available light is lack of control. The photo shoot is dependent upon a specific time. Even then, sunlight is mercurial. Photographing in sunlight requires adaptability and spontaneity. Like a child's temperament, sunlight is unpredictable and sometimes volatile. An overcast 4:00 PM photo shoot could easily become an afternoon hailstorm.

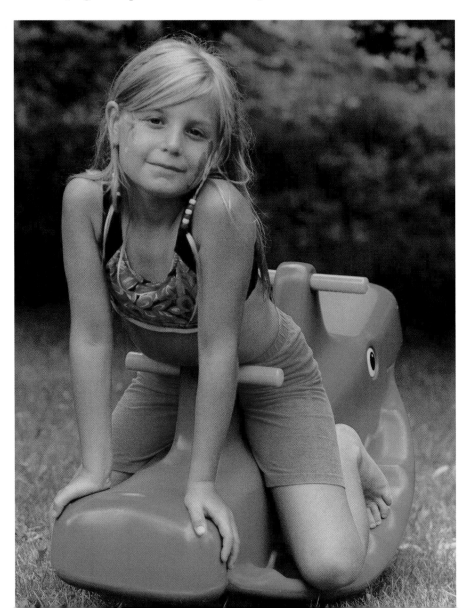

**NICOLE WITH
FACE PAINT**

Photographing in a natural environment, I utilized the soft, afternoon light to focus on a special moment.

TIME OF DAY

Flattering outdoor portraiture depends on the sun's angle to Earth: Timing is everything. The best times to photograph natural light portraits are early morning or toward dusk (approximately three hours or less before sunset) when the sun's angle to Earth is below 45 degrees. As the sun rises, approaching 90 degrees overhead, unwanted shadows appear below the eyes and chin. When photographing at midday or under extremely sunny skies, it is best to use reflectors or fill flash (see pages 55–57).

Generally, I schedule my photo shoots during the early morning or late afternoon, $1^1/_2$ hours before sunset or after sunrise, when the effects of the sun are most pleasing. These intervals are often referred to as the "magic" or "sweet" hours, because the warmer, softer light produces a radiant glow.

Working with young children necessitates compromise. The "magic" hours may overlap with the "witching hour"—the time, around 5:00 PM, when youngsters often become inconsolable. Scheduling a photo shoot for that time, therefore, may be less than optimal for children less than three years old. Children over the age of three are generally more engaging and cooperative. Photo shoots with older children can follow the recommended times.

TOWARD DUSK
The light gently skims across her face, creating a golden glow.

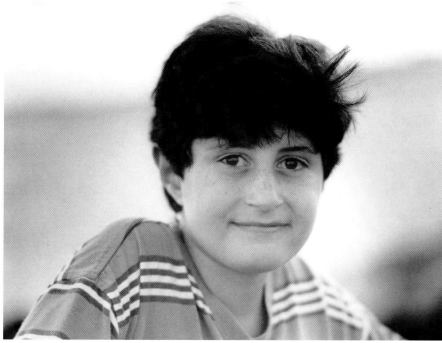

DAVID
My assignment was to create a head shot to illustrate David's personality. Soft, diffused early-morning light helped create a gentle reprieve from an active young man's life.

Direction of Light

"Seeing" light and understanding its directional characteristics will enhance your palette as a photographer. There are five lighting options when photographing outdoors: direct or frontal lighting, backlighting, sidelighting, shade, and diffused light. Each lighting option uniquely illuminates the child's spirit.

FRONTAL LIGHTING

Daylight shining directly on the face, known as frontal or direct lighting, typically induces squinting and unflattering shadows, especially under the eyes and below the chin. A bright directional midday light assaults, renders ugly shadows, and flaunts miserable expressions. Direct sunlight is best for portraying harsh or graphic images and is generally discouraged for children's portraiture.

During the magic hours, however, frontal lighting creates a dramatic effect. Consider the photograph on the right. The mother and child are purposely posed facing the sun. Photographed near sunset, the light beams directly on the child and reveals the mother in partial shadow. The child is richly illuminated but not blinded by an intolerable light source. This heightened moment creates emotional and symbolic interpretation.

BACKLIGHTING

Backlighting, in which the subject has her back to the sun, offsets strong directional light. A halo or rim of light highlights the hair and reinforces angelic sentiments associated with children.

There are several techniques you can employ to avoid a silhouette or underexposure. Program your camera for backlighting (many current cameras have this feature). Adjust the exposure compensation to +1 EV. Set the metering system to "spot meter," walk up to the child, and take an exposure reading directly off the face; set this exposure, and then step back, recompose, and shoot. You can also use a reflector or fill flash (see pages 55–57).

SCOTT AT THE QUOGUE WILDLIFE PRESERVE

On this bright day, backlighting was the best option since the light was too bright otherwise. I opened up one stop on my aperture to maintain soft and open facial qualities.

GINNY AND DRU

I photographed this family for more than an hour and then the light shifted, spotlighting the doorway. I quickly moved the subjects into the light, using the doorway to enhance the composition. Softened in the late afternoon, the frontal light accentuated the feisty spirit of the child.

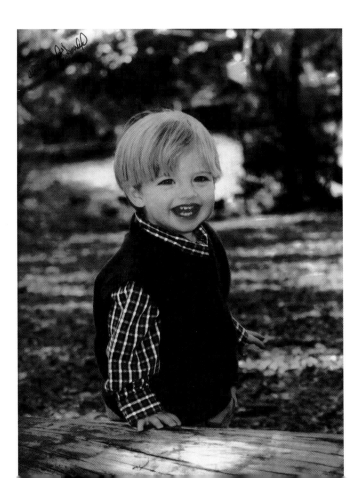

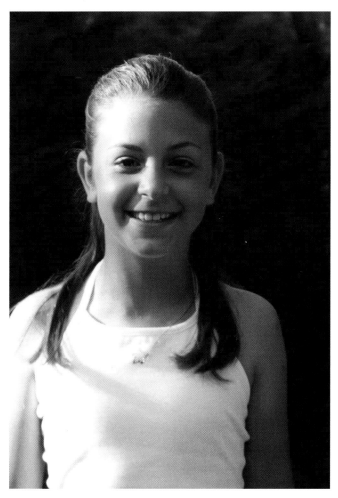

JOELLE—SPLIT LIGHTING

Notice how the light splits the face in half, yet the shadow side still shows details.

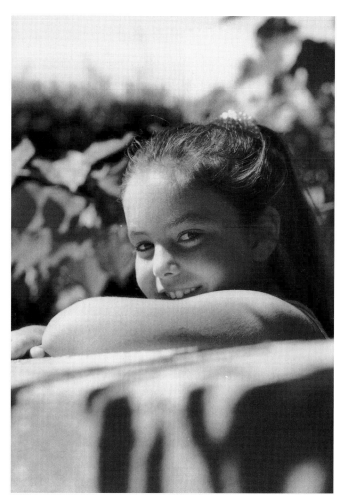

MIA

Black-and-white film adds to the mood of this sidelit photograph. The shadows, abstractions of nature, create mystery for the viewer.

SIDELIGHTING

The interaction of light and shadows defines the sidelit photograph. One side of the face is illuminated while the other falls into shadow. Sidelight illustrates depth and character, creating dramatic and mysterious images.

Sidelight introduces a third dimension in an otherwise flat picture plane. It accents the face, emphasizing form and texture, such as a child's velvety skin and silky fine hair. The best direction for sidelighting is usually oblique (slanting, diagonal, inclined) to the subject.

One problem you may encounter when using sidelighting or backlighting is lens flare, which occurs when sun strikes the lens. Lens flare causes foggy or bleached-out images or circular, prism-like patterns across your picture. Use a lens shade to prevent this from happening.

Sidelighting offers a few exposure choices. You may opt to create a powerful and intriguing portrait by overexposing the highlights and creating strong contrast (meter for the shadow side). One side of the face would be brightly illuminated while the other side falls into dark shadow, retaining visible details. To create a feeling of mystery, you can overexpose the shadows, thereby rendering a dark cast to the entire child. Averaging both the highlights and the shadows will result in a portrait that is sculpted by light. Reflectors and fill flash (see pages 55–57) subtly reduce the contrast of the sidelit portrait.

Classic lighting effects such as split lighting, broad lighting, or short lighting are possible using sidelighting. *Split lighting*, as the name implies, illuminates one half of the face while the other half fades to shadow. It can be used to create moody or mysterious portraits. *Broad lighting*, in which the main light illuminates the side of the face closest to the camera, is used to widen features. *Short lighting* (also called narrow lighting) shines on the side of the face away from the camera, narrowing the face. Short lighting is the most common type of studio lighting.

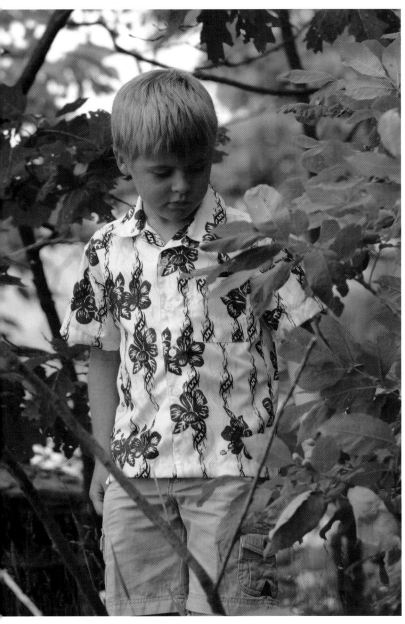

TRISTAN

Tristan was photographed on an overcast day, and yet the sun was still so bright, we looked for shade. A nature boy by nature, Tristan took to the woods. Notice how the sidelighting sculpts one side of his face. Tristan, protected from the sun, easily relaxes into his own world of exploration.

CATCH LIGHTS

Catch lights are the white glimmers in the iris of each eye. Their presence lights up the face and gives life to the picture. Historically, however, catch lights were viewed as imperfections and omitted from portraits by master painters such as Rembrandt.

Studio photographers use catch lights to guide in lighting setups, and the position of the catch lights is often the telltale sign of a particular photographer's style. Imagine the eye as a clock face. Catch lights will be at either one o'clock or eleven o'clock if the light is set up correctly. For instance, with short lighting (the most common lighting), which illuminates the side of the face away from the camera, the catch light is at eleven o'clock. With broad lighting, where the main light illuminates the side of the face closest to the camera, the catch light is at one o'clock (as in the photo below). Adjust the main light to acquire the desired position.

Fill light often adds a second catch light in the eye, which is objectionable to some photographers. Feeling that the second catch light creates a directionless stare, some photographers retouch it out of the picture.

Catch lights reflect like a mirror and sometimes reflect back the image of the reflector in the eye. Look closely at the eyes and adjust the light or the position of the subject accordingly to reduce this effect.

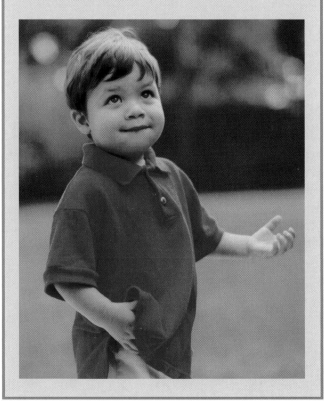

SHADE

The undesireable effects of direct sunlight, such as squinting, washed-out skin tones, and dark shadows, especially during midday, can be avoided by seeking shade. Shade exists under trees, boulders, tall grass, buildings, and overhangs. Explore the location and be imaginative!

Shade is scarce at the beach or in open fields. Just as time affects the sun's intensity, so do the seasons. I am reminded of a 10:00 AM beach photo shoot. It was a gorgeous fall day—cloudless cerulean skies, sun joyously shimmering off the Atlantic. The light was blinding. I quickly improvised (each moment the sun grew stronger and harsher) by directing the children to lie in the beach grass partially sheltered by their own bodies. My assistant held a large reflector overhead to further block the sun. Be aware that open shade typically casts a bluish hue, as most shadows have blue in them, and this often detracts from a nicely colored skin tone. Using a UV filter helps reduce the ultraviolet rays. I recommend using the filter always because it also protects the lens from damage.

A word of caution regarding shade: Make certain that it is devoid of light speckling. For instance, in a clearing in a tree grove, if you are not carefully looking, you may find that the light sprinkling through the leaves creates unwanted speckling on the child.

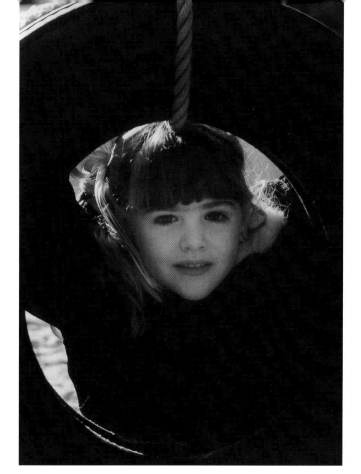

AMANDA IN TIRE SWING

For this shot, I used a tire swing as a prop to relax the child and shade her from the bright sun.

DIFFUSED LIGHT

An overcast day provides many possibilities for portraits. Without the sun's glare, you are free to move in a 360-degree radius and decide later which background looks best. This flexibility is critical when location is important.

Overcast conditions create soft flattering light. Contrast is reduced and shadows fill in naturally. Clouds, diffusing the sun like a giant umbrella, evenly distribute light. Light reflects off bright surfaces, such as white walls, sand, water, and asphalt, creating reflectors that reduce contrast and soften shadows. Squinting is usually not a problem unless photographing takes place midday.

Overcast lighting sets the tone for atmospheric and romantic photographs. When scheduling a photo shoot, my clients are often surprised to hear that I prefer cloudy days. Shooting under transitional weather conditions—a mist or a fog—bewitches both the photographer and the child.

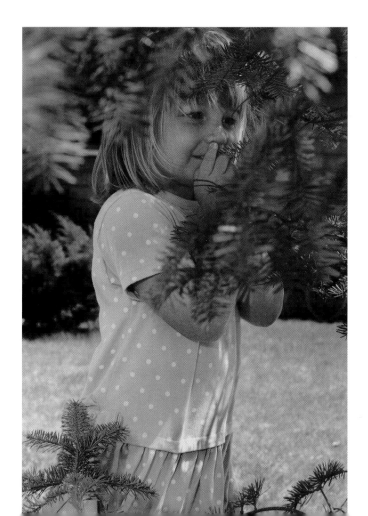

FINDING SHADE

To shelter Nicole from the sun, I moved her under the leaves and used the foliage to frame the image, creating a quiet, private moment.

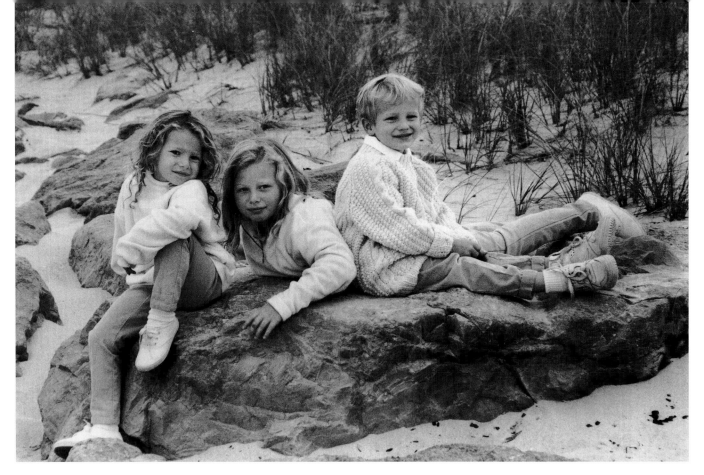

BRITTANY, CHELSEA, AND JULIAN

Taking advantage of an overcast morning, I freely explored different areas of the beach. For this shot I opted to photograph with the dunes in the background.

COLOR OF LIGHT

Light changes colors throughout the day, significantly altering the mood and tone of a portrait. Geographic location, the weather, the season, and time of day all impact the color of light. Before sunrise, light is typically muted, producing achromatic, cool, and flat tones. As the sun ascends and during the late afternoon, light takes on a red or orange hue. At midday the sun colors the scene with a "white" light, which produces the most true-to-life color on film.

Becoming aware of light's color shifts and of film's interpretation of those shifts takes practice. While a golden sunset is an obvious sight, the pink hint on your subject's face may be more subtle. Detecting blue facial shadows, typical in overcast conditions, is difficult. While inconspicuous to the untrained human eye, film records these changes.

Daylight color film is balanced for the near-white light characteristic of sunny midday. At this time of day, the light, theoretically, has equal amounts of red, green, and blue light. Nevertheless, there is no real white light. Every moment of each day, light shifts in color and intensity. There are two filters that alter colors, bringing them closer to pure white: the 82 series, which is bluish and counteracts excessive yellow light, and the 81 series, which is yellowish and counteracts blue light.

Complexions can become too blue when photographed in open shade. To minimize the effects of color shifts, use an 81A filter (a warm filter—the letters refer to intensities) to offset the blue light of shadows or overcast conditions. Photographs that consistently render skin tones too red or orange may profit from an 82A filter. I recommend using a 1A (UV) filter on a consistent basis. This filter blocks the ultraviolet rays that eyes do not see but that film records as blue.

Photographing Indoors

Windows and doorways typically diffuse daylight, creating ideal conditions for portraits. Natural indoor lighting is soft and flattering and can be easily controlled by positioning the child. This type of light offers many lighting opportunities, including silhouetting, backlighting, creating halos, and sidelighting.

The direction of the light is as critical when photographing indoors as it is outdoors. Again, the rule is to avoid direct sunshine. Move the child so that the light falls to his or her side or consider backlighting. Look for powerful reflective surfaces, such as a white wall or a highly polished floor. Use these structures as reflectors to naturally brighten the child's face and fill in the shadows. Or use a handheld reflector or fill flash. When photographing indoors, separate the child from the wall to prevent unwanted background shadows.

The background can be an added element in the composition, but complex designs will steal attention from the child. Look for plain walls or very subtle patterns. Backgrounds can also be obscured, made to fade to black, or muted by using selective focus and a wide aperture and by adjusting the intensity of the light source and subject-to-background distance. With studio lights, one can easily adjust light's intensity. Working with daylight presents more of a challenge. To render a more neutral background, move the child away from the background—10 feet if possible—and use a wide aperture to blur the background into swirls of color.

Light is the photographer's paintbrush. Learning to manipulate this tool begins with studying the sun's natural light. After all, electronic equipment is manufactured to merely mimic the effects of the sun. Notice how the world looks now that you are more aware of the technical details associated with light. As you continue to photograph, you should be able to take fuller advantage of light's divine intricacies.

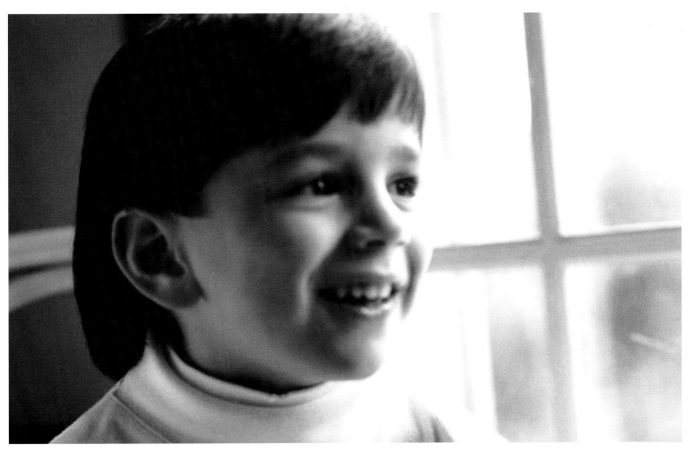

LEE

The bright afternoon light coming through the window gently illuminates Lee's face and adds to the sense of wonder invoked by his gaze. Sidelighting sculpts his face without overpowering it. The use of black-and-white film simplifies the composition and puts the focus on the child's face.

Supplemental Lighting

The sun provides, arguably, the most flattering light for creating portraiture. What distinguishes the candid shooter from the portrait artist, however, is the portrait photographer's sensitivity to the complexities of natural light.

CONTRAST

Contrast refers to the ratio of highlights to shadows. Supplemental lighting, or fill light, provides additional illumination to reduce contrast. To measure contrast, find the difference between the light and dark portions of a scene. Meter both areas—moving close to the subject to make sure the meter reads only the intended portion—and compare the aperture readings. You can also use an *incident meter*—a handheld device that interprets the intensity of light falling on the subject. For an overall exposure reading, place the meter in front of the face (just below the chin is usually best), point it back to the camera, and press the button for an exposure reading. Count the number of *f*-stop differences.

Lighting ratios define lighting in general and signify personal style. While some photographers create dark, mysterious portraits, many want flat lighting. Some photographers shoot only at a 2:1 ratio; others, including myself, work with a ratio that looks right for each session.

Every skin tone renders a different ratio; light complexions reflect more light than dark skin. Film exaggerates these differences. With time and practice, you can learn to visualize subtle shifts between light and dark. A low-key portrait creates mystery and intrigue. A high-key portrait evokes a sense of heavenliness.

If contrast is too great, there are three basic methods of ways of supplementing the main light source.

APERTURE VALUES

APERTURE IN FULL STOPS	APERTURE IN $^1/_2$ STOPS	APERTURE IN $^1/_3$ STOPS
$f/1.4$	$f/1.4, f/1.7$	$f/1.4, f/1.6, f/1.8$
$f/2$	$f/2, f/2.3$	$f/2, f/2.2, f/2.5$
$f/2.8$	$f/2.8, f/3.4$	$f/2.8, f/3.2, f/3.5$
$f/4$	$f/4, f/4.7$	$f/4, f/4.5, f/5$
$f/5.6$	$f/5.6, f/6.7$	$f/5.6, f/6.3, f/7.1$
$f/8$	$f/8, f/9.5$	$f/8, f/9, f/10$
$f/11$	$f/11, f/13.5$	$f/11, f/13, f/14$
$f/16$	$f/16, f/19$	$f/16, f/18, f/20$
$f/22$	$f/22, f/27$	$f/22, f/25.3, f/28$

It is important to understand aperture values. Photographers often refer to an aperture value as an f-number, and the photo jargon is f-stop. Newer electronic cameras now divide and include $^1/_2$ and $^1/_3$ f-stops. To understand lighting ratios and interpret the information on the LCD, a photographer must know what constitutes a full f-stop.

LIGHTING RATIOS

RATIO BETWEEN LIGHT AND SHADOW	F-STOP DIFFERENCES	EFFECT OF LIGHTING RATIOS	FILM TO USE FOR PLEASING PORTRAITS
1:1	0 difference	Flat lighting with no shadows	black-and-white, color, digital
2:1	1 stop	Visible soft shadows	black-and-white, color, digital
3:1	$1^2/_3$ stops	More noticeable shadows	black-and-white, color, digital
4:1	2 stops	Low-key dramatic effect	black-and-white, color
8:1	3 stops	Very low-key effect	black-and-white

A 1:1 ratio, called flat lighting, means there are no shadows. At a 2:1 ratio the light side is twice as bright as the shadow side, producing visible soft shadows. With a 3:1 ratio detail is still obvious in the shadows. A 4:1 ratio produces noticeable shadows with detail and texture maintained (if you are a good printer). At an 8:1 ratio the shadows are rendered "harsh" or black. Black-and-white film generally has greater latitude and can produce good results in lighting situations this dramatic; blacks will have no detail, and complexions will exhibit strong contrast.

REFLECTORS

A reflector is a board or disk made of reflective paper or fabric that is used to supplement light. Reflectors fill in facial shadows, softening the blackened areas under the eyes, nose, and lips. They add a catch light, or sparkle, to the subject's eye and lighten shadows. For best results, place the reflector opposite the sun and slightly raise the end of the reflector that is farthest from the subject.

Popular brands of reflectors include Fotoflex and Flexfill. These cloth reflectors fold down to a Frisbee-sized disk, are convenient for location shoots, and are easy to store. White foamcore covered with aluminum foil (for additional versatility) on one side, or reflective fabric sewn into heavy-duty frames make adequate reflectors.

Reflectors are available commercially in three colors—white, silver, and gold—that increase in potency, respectively. The white reflector is the most natural supplemental lighting tool and is perfect for subtly filling in shadows and adding a glimmer of light (catch lights) in the eyes. The silver reflector is utilized for a more dramatic effect or for when lighting conditions warrant additional push, such as an overcast midday photo shoot; the lighting is stronger and cooler-toned. The gold reflector, the strongest of the reflectors, adds a powerfully warm golden glow. Both the silver and gold reflectors are bright additive lights and may cause squinting. I recommend working with a white reflector first to learn its nuances before experimenting with the silver and the gold.

Reflectors are available in sizes ranging from 12 to 77 inches. Size is proportional to the reflector's effectiveness: The larger the reflector, the more powerful the supplemental light source.

Holding the reflector at waist level adds light, at least one f-stop, under the chin, nose, and eyes. Test the strength of the fill light by metering and adjust it by changing the distance of the reflector in relation to the child's face. Place the reflector to the side of the face that is in shadow to lessen the shadows and decrease contrast.

PEYTON

This photograph was taken in what I call the "white room." Using a window as the main light source I used a 4 x 10-foot white board to create a white wall, which bounced back light from the window on the opposite side of the studio. A white cloth was rolled across the floor to bounce more light upward. A white reflector wedged near the window's top ledge added even more white light for an uplifting and magical effect.

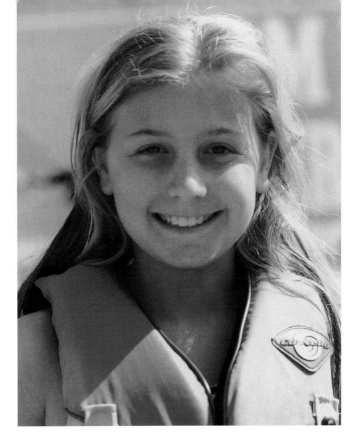

NICOLE WITH LIFE VEST
A reflector was held below Nicole's chest and angled slightly up. The result is a shadow that sculpts the face, adding dimension; yet, the shadows are certainly light enough to see all the details.

To subtract light from a scene, use a black reflector, a black panel, or a gobo—a panel usually mounted on a stand and positioned to shade part of the subject and help prevent lens flare (a common effect of shooting outdoors with backlighting). A black reflector can be used to redirect, reduce, subtract, or block light and to create shadows. To create a shadow, place the black reflector to one side of the face. To block light without creating dark shadows, place the black reflector as far away as possible.

You can employ an assistant to hold the reflector and manipulate its position, or reflectors can be held in position with a light stand and clamps. Additionally, you can place reflectors directly in front of the subject by laying them on the ground, or the subject can even hold the reflector for head shots. (Make sure you check your composition to ensure that the reflector is outside of the picture frame.)

Often the environment provides reflectors to capture the mood of the moment. Examples are sand, swimming pools, metallic surfaces, white walls, concrete, or asphalt. To add additional light, I often wear a white shirt and have a large white towel to place near the subject.

FILL FLASH

Fill flash is an alternative method for balancing the ratio between highlights and shadows. Most modern electronic cameras have a through-the-lens (TTL) metering system; this determines how much flash output is required by taking a reading through the lens and enables simple command of fill flash.

FLASH SYNC

To work properly, a flash must be synchronized with the camera's shutter: A sync cord or hot shoe (mounting "foot" slips onto the hot shoe bracket usually located on the top center of a 35mm camera) connects the two. When the shutter is released the flash triggers. Synchronization occurs when the flash triggers the proper shutter speed. The sync speed is the jargon used to depict the fastest setting. If the shutter triggers too fast, only part of the image will be illuminated, too slow and the image will be blurred (unless you use a tripod).

RED EYE

Red eye is one of the more annoying results of flash photography. Camera and software manufacturers continuously strive to correct this photographic flaw. Adobe Photoshop Elements 2.0 and Nikon View 6 have specific red-eye correction tools. Working with Photoshop CS is another option. I find the easiest way to remove red eye from film-generated pictures is with a red-eye pen—one dot and it's gone. I prefer this remedy to using red eye mode on my camera, which is too harsh and annoying. For digital photographs, it is easiest to correct red eye with one of the software programs mentioned above.

THANKSGIVING

I try to work with natural light whenever possible, but in low-light situations such as this candid classroom shot, a flash is often a necessity. I shot this photograph on Kodak Gold 100 film with my Nikon N90S. I used an SB-26 flash mounted on a power grip flash attachment.

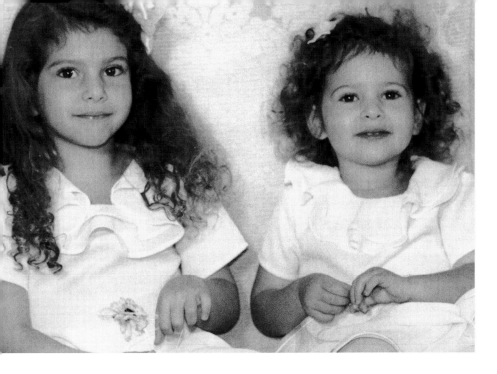

BARI AND RICKI

Redirecting the light source is called bouncing light. To create a soft lighting environment for this photograph, I bounced the floodlight off the white ceiling. Two 500-watt spotlights were used as fill lights along with a white reflector to soften the shadows under the eyes and add catch lights.

To use fill flash, set your shutter speed to the fastest sync speed on your camera and set your flash to "fill flash." Some flash units allow you to adjust the fill flash light output by $^1/_3$ increments. Practice with your camera and flash, making note of the output: no change, $^{-1}/_3$, $^{-2}/_3$, -1, etc. Process a roll and compare the prints. Use the output you like best for future portraits.

Positioning the flash directly at the subject is recommended only for candid "catch-the-moment" photographs. Typically, a flash aimed directly at the subject will intensify the shadows under the eyes and chin, create hot spots on the hair and face, and produce unwanted shadows in the background. The lighting is harsh and artificial.

To create a softer, more flattering light, cover the flash with a diffusing screen. Diffusing screens are available at photographic supply stores. I like the LumniQuest and Sunpack models. Diffusing the supplemental light helps create a more natural and multidirectional effect (like the open sky). Another method of diffusing fill flash is to bounce the light off a white surface such as a wall or a ceiling. This ensures that the light will not hit the subject directly and diffuses the light for a softer, more flattering effect. Placing the flash off to the side of the camera with a flash bracket creates a more realistic light that sculpts the face for a three-dimensional effect.

Using a flash enables the photographer to catch action and capture a moment and produces natural color renditions. Disadvantages of fill flash are that it produces red eye, the sudden bright light is distracting and uncomfortable for the sitter, and the flash creates unwanted shadows. Reflectors are a more natural method of supplementing light. Reflectors reduce contrast, add details to shadows and separate the subject from the background in a natural manner. However, there are many situations in which fill flash is necessary, such as when there is no assistant or when photographing action. The portrait photographer should be adept at using both fill flash and reflectors.

FLOODLIGHTS

Floodlights offer a continuous source of light, empowering the photographer with precise control. They are also an inexpensive way to learn about lighting. In my intermediate photography course at college, students learn to see light by working one continuous "hot light"—as it is known in the industry. Halogen lights are the type of hot light we use. Once the student learns to work with one light, we add a second as a fill. Position the floodlights at a 45-degree angle above the subject and at least 3 feet away to avoid creating circles under the eye sockets. Leave the floodlights on throughout the shoot so that the supplemental light does not jar the subject.

The disadvantages of floodlights are that they get very hot and that they require an outlet. Additionally, the cords could pose a hazard when working with children. To avoid accidents, secure the cords with electrical tape. The advantages of floodlights are that they provide a softer fill light than that of an electronic flash, and the photographer is able to see exactly how the supplemental light will illuminate the subject. Furthermore, the child can relax; there are no shocks of light and throbbing eyes. Think about how uncomfortable a flash makes you feel—it is worse for a child.

WE DO NOT TAKE PICTURES
WITH OUR CAMERAS, BUT WITH
OUT HEARTS AND MINDS.

—Arnold Newman

Composition

WITH EQUIPMENT IN HAND, and an understanding of light, we now turn to the foundation of the photograph—its composition. Composition is the visual structure of the portrait. While a painter composes on a canvas—a physical space where the preliminary drawing is outlined, erased, reworked, and molded by the artist's hands—the photographer composes in the camera's viewfinder. Arranging and uniting elements, visualizing in one's mind the final image, and knowing when to trigger the shutter, all the while being "in the moment," is the Zen of photography. While the act of composing is serendipitous, the photographer intuitively relies on a plan, which calls upon basic design elements—line, shape, pattern, color, perspective, and form. Learning the fundamentals of design will enable you to convey meaning, add depth to your photographs, and begin to develop a personal style.

Seeing Like a Camera

The camera is not a mirror image of reality; what the artist sees is not necessarily what the camera interprets, and vice versa. While an artist sees the world in three dimensions—foreground, middle ground, and background—the camera condenses a scene into two dimensions. The goal of the portrait photographer is to fuse both realities—to give the illusion of depth to a two-dimensional surface.

Photography's origins are theater and magic—a tenuous thread weaving illusion and reality. The camera's lens and the area of focus define the image. The photographer is a conjurer whose tools are the elements of design. Understanding how the camera interprets a scene and how to pull the necessary design tricks out of your hat will allow you to portray the illusive nature of your subject while completing a look-alike resemblance.

BARI

The diagonal of the tree was carefully placed along the picture plane to create a strong composition. Sidelighting illuminated the texture of the tree, invoking a sense of immediacy.

KISSING

Picture a photograph as being segmented into thirds—foreground, middle ground, and background—and use these picture planes to create a three-dimensional effect. In this picture, Zach and Jake are in the middle ground, surrounded by sand in the foreground and the horizon in the background, creating an illusion of depth. The photograph was captured with Ilford Delta 100 film, printed on Ilford Multigrade IV FB Fiber paper (matte), and handpainted.

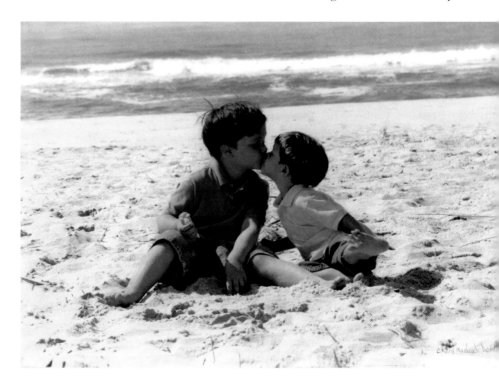

Environmental Portraiture

Selecting a setting that relates symbolically to the subject —called "environmental portraiture"—is an exciting and creative first stage of visualization. I often photograph in this manner, and most of the images that appear throughout this text are based on the principles of environmental portraiture. This aspect of portraiture is exciting; it is what fuels my photographic passion.

Young children are often photographed at or near home for comfort, but the exact location can be left to the creative eye of the photographer. Other popular settings are playgrounds, parks, and zoos, and each of these environments provide endless possibilities for environmental portraiture. As the child grows and becomes less fearful, encourage location sessions at a park, the beach, a riding stable, an apple farm, or an arboretum.

Include details of the environment when narrating a specific idea. Or use the environment simply as atmosphere when your message is less direct. A literal portrait is one in which the child looks directly at the camera; an interpretative portrait tells a story. All design elements in an interpretative portrait become integral factors. The background, lighting, props, shapes, and lines—a few of the many factors we discuss in this and other chapters— work together to tell a story about the child.

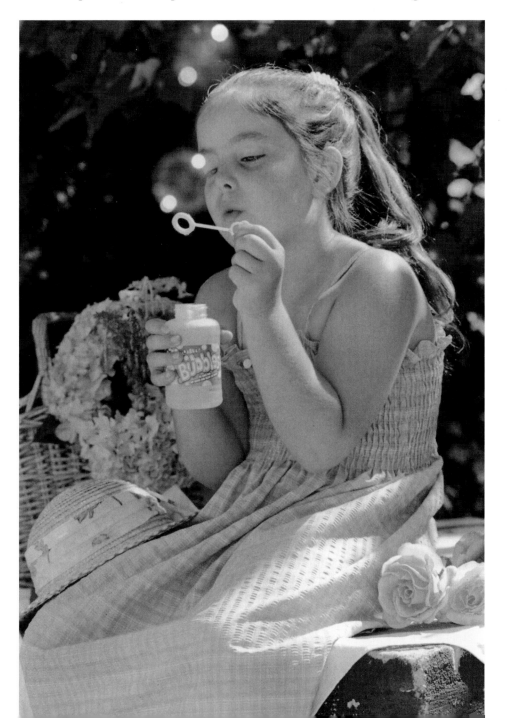

MIA
Blowing bubbles is a favorite childhood pastime. A relatively wide aperture ($f/8$) helps blur the background while maintaining sharp details in the illusive bubbles. The environment provides charming details—the hat casually strewn over her lap, roses sleeping to her left—and helps create a storybook-like illustration. "Once upon a time, Mia . . ."

Filling the Frame

The first rule of thumb when composing a photograph—filling the frame—encourages the photographer to look around the subject, checking all four corners of the viewfinder and making adjustments if necessary before triggering the shutter. Cropping the negative later is an option, but the more you crop, the grainier the image. Purists never crop, and I try my best not to. If shooting medium-format, composing to fill in the frame is less critical because the negative is larger and doesn't have to be blown up as much, but to improve your composition skills, you should train your eye to compose full frame.

Develop your ability to compose in the viewfinder by following this simple exercise. Cut a rectangle out of a piece of black cardboard and observe your surroundings through it; you will begin to see the world differently.

Certain things will be in the box and others will be left out. If you change your position, elements inside the rectangle will change. Small movements cause small changes; large movements cause abrupt changes.

Now, look through the camera's viewfinder and notice that the rectangular view is the same as it was during the above exercise. Pay attention to the edges of the composition. Everything in the viewfinder must be relevant. Chances are, initially, you are not filling the frame with vital information. Recompose, move in closer, change your angle, change the format—do something. As Robert Capa said, "If your pictures aren't good enough, you aren't close enough." Do not be afraid to get close to your subject. Encourage the child to relax, letting him forget you are present, and then move in close.

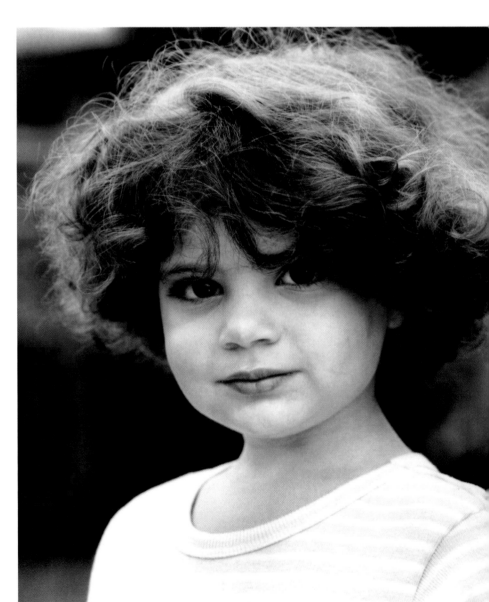

SOPHIA

I have been photographing Sophia since her birth, and when she turned five her mom felt it was time for a head shot, a character study. I moved in as close as I could with my 105mm Nikkor lens in order to fill as much of the picture frame as possible. As long as I kept talking to Sophia, she did not seem to mind me taking her picture.

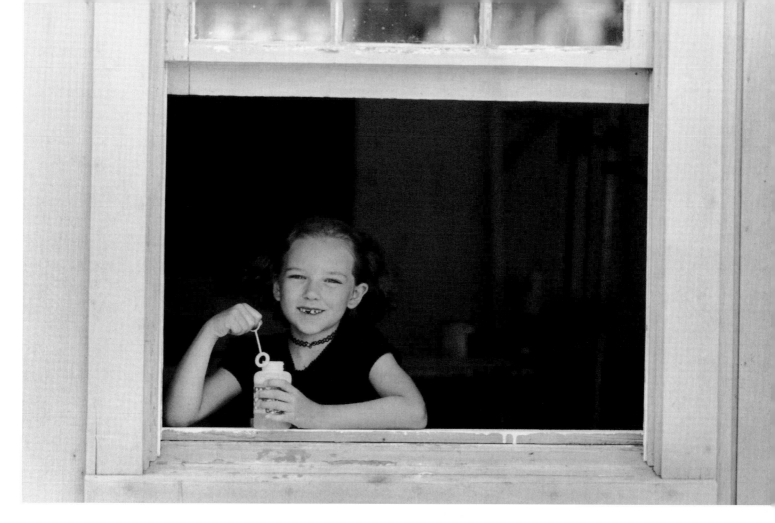

FRAMING THE IMAGE

Line the perimeter of your image with environmental elements that lead the viewer inward. Remember, the dominant force in the portrait should be the child; organize other elements to enhance the child. Trees, windows, doorways, porches, and arbors provide structural framing. Foreground elements create immediacy. Framing the subject also adds depth, which creates an illusion of three dimensions.

BALANCE

Harmonious composition requires balance. After framing the image, see if the overall design plan works. In time you will learn to know intuitively if it does. In the meantime, go through the following mental checklist: 1) Is there adequate space in the direction of the subject's gaze? 2) Did you leave enough space around the subject? 3) Is the picture bottom- or top-heavy? (Remember that negative space—the area not occupied by the subject—weighs at least as much as positive space.) 3) What do you see in the viewfinder? Does the picture feel right? 4) Do the design elements lead the viewer to the subject? 5) Is the picture too symmetrical (too balanced)?

KAYLA

Kayla was one of the child models at a summer master's workshop class on portraiture. The window frame literally frames the image, bringing the viewer inside. Notice how the reflection in the top section of the window is blurred, creating a nice pattern. Negative space weighs as much as positive space. The "empty" space next to Kayla serves to balance the composition.

CROPPING

There are two schools of photographers when it comes to cropping: the purists who compose in the viewfinder and those who crop the negative. I learned the former method, and it certainly has helped train my eye. Regardless of your persuasion, you can use cropping as a tool for creative imaging. The edges of the photograph create visual interest, and skillful cropping can add visual impact.

Pay particular attention to how the body parts fit into the composing space. As a rule, portrait photographers should not crop at the wrist and should avoid cropping at the elbows and knees. Make the cut above or below the joint. Before triggering, quickly scan the circumference of the composition, making certain you have not amputated an arm or leg.

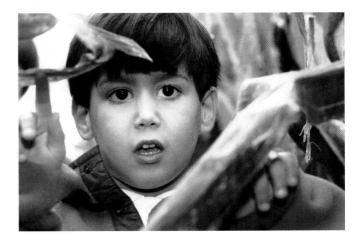

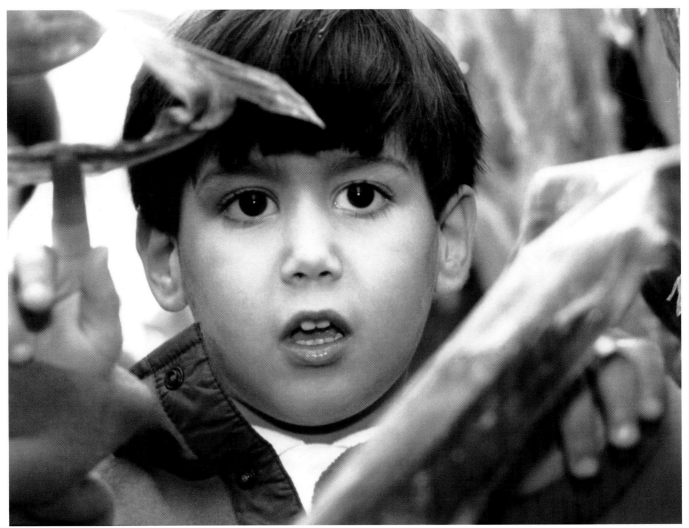

BILLIE

Shooting with black-and-white film is a sure way to learn to abstract the environment and create compelling compositions; in this case, the cornfield becomes a rich pattern of leading lines. Notice how in the uncropped version on top, the stalk line on the right literally leads the viewer right off the page. Cropping the photo (above) to form an upside-down triangle makes a stronger composition.

The Rule of Thirds

Ansel Adams said, "There are no rules for good photographs, there are only good photographs." While this is true, design systems are important for creating harmonious compositions.

The rule of thirds, a design strategy developed by painters in the early nineteenth century, segments the picture area into thirds. The four points of intersection—considered "hot spots," or focal points—are, theoretically, the areas of most visual importance. They are sections within the picture plane where the viewer looks for information; therefore, the photographer should place the most important elements at these junctures.

When we speak of children's portraits, the area of most visual importance is usually the eyes, and possibly also the hands. Therefore, placing of the eyes or hands at the "hot spots" makes good design sense. Contrary to popular notions, subjects placed smack in the middle of the page are, typically, less interesting—more static—than those placed off-center. If you study paintings or other photographs in galleries and museums, you will see the rule of thirds used repeatedly. Again, you can crop the negative to achieve the rule of thirds, but you may end up with a grainy photograph. Fine-tuning the composition in the viewfinder before taking the picture will strengthen one's eye and the resulting photograph.

Dividing the picture plane into thirds vertically and horizontally results in four intersecting points. Consider choosing one of these areas to place the focal area, or "hot spot," of your composition.

Successful artists and photographers learn the elements of design and then use, or don't use, the rules to shape their style. Richard Avedon blatantly defies the rule of thirds, positioning his subject smack in the middle of the picture frame. He uses a white backdrop (really just a sheet of paper tacked behind the subject), and the resulting high-contrast, in-your-face portrait is a telling example of how to break the rules for structural, emotional, or narrative advantage.

PETER

Peter waited patiently through a long session of picture-taking until he was free to ride on the tractor. Notice how even though Peter is placed in the center of the image, his eyes—the focal point of the photo—are in the upper right "hot spot."

Vertical Versus Horizontal

Early in each semester, I tell my students, "Remember, the world is also vertical." Turn the camera to see a long, rather than a wide, plane. While it is true that maneuvering the equipment vertically is more cumbersome, professional and consumer SLR cameras now provide ergonomic features for triggering the shutter and operating autofocus in the vertical position.

A vertical format isolates the child, improving composition by rescaling the background and adding negative space above the head ("heaven" space). Try following these basic guidelines for choosing format: 1) vertical for one person, 2) either vertical or horizontal—your choice—for two people, and 3) horizontal for three or more subjects. Of course, these are only suggestions.

When framing the image, be conscious of the space between the head of the child and the top of the frame. Blank space above the child's head calls attention to his young age (small child versus big sky). On the other hand, using the foreground, filling the frame with the child's face, creates immediacy and a sense of "being there."

GABRIEL

The vertical format gives a portrait a look of importance—even when photographing an infant. Strong diagonal lines in the foreground lead the viewer into the picture. Circles suggest harmony and the circular shape of the hat is subtly repeated in the wheel placed bottom right.

PROM BOYS

Horizontal photographs are perfect for two or more subjects. Horizontal lines are softer psychologically than vertical lines, thus giving horizontal photographs an inherently informal character. Selecting the horizontal format enabled me to move in close and frame the image with the heads on the left and right boundaries.

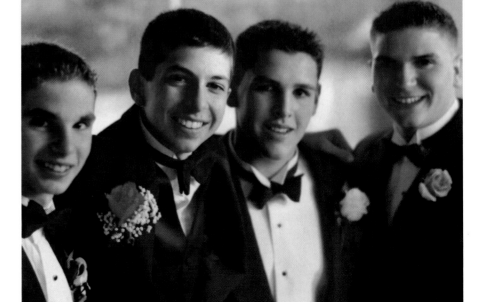

Perspective

Perspective narrates mood. Face-to-face, the photographer relates to the child naturally. Keep in mind that relating to the subject at eye level often requires getting down low on your knees, or even lying on the ground. A portrait in which the child is looking down conveys a sense of strength and importance—a future Mr. President. Shooting from above, pointing the camera down toward the child, conveys a sense of solitude, wonder, or smallness.

The idea you are trying to convey with a photograph will help determine whether it should be a head shot or a full-length portrait. For example, a storytelling picture usually calls for a full-length portrait, which creates a physical distance and gives a sense of looking in.

The type of lens you use affects perspective. A telephoto lens narrows the view, making objects far away look closer and rendering focusing more powerful. A 105mm telephoto lens for 35mm cameras and a 180–190mm lens for medium-format are appropriate for portraits.

KATHLEEN ON SWING

Standing on my stepladder, looking downward at Kathleen, I patiently watched her play. I set my shutter fast enough (1/500 sec.) to prevent blur from the motion of the swing. Then I composed in the viewfinder until I found the angles that made the picture visually graphic and waited for the perfect expression. The perspective emphasizes the child's youth and vulnerability.

PAUL AND LUKE

Children love climbing onto the lifeguard chair, and I usually save this as a treat (with parents' permission) for the end of the shoot. Paul and Luke look larger than life smiling down from their throne—an unusual perspective, as children usually look up to adults.

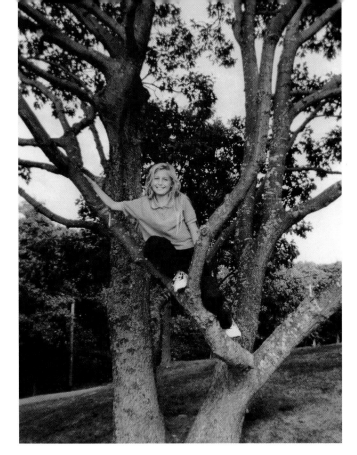

TREE CLIMBING

To best capture Nicole in this environment, I used a 3-foot stepladder. Placing the lines of the tree trunks to frame my picture, I slowly composed, making certain that an important visual element was touching all around the perimeter of the viewfinder. The trees frame the image and provide a window to look into the child's world. The nice thing about photographing a child in a tree (with the parents' permission, of course) is that you can take your time composing the picture because you know the child isn't going anywhere.

ALI

I often let children explore the environment as I follow them around with my camera at eye level. I constantly recompose to be always ready to snap the picture. This photograph is an example of a storytelling picture that illuminates a private moment in the life of the child. Even though we do not see her face, we have a sense of Ali.

Background

The background of your photograph can either make or break a portrait; thus the industry motto: "Watch your background, watch your background, watch your background!" A cluttered background can ruin a composition. So will a tree growing out of the child's head. Moving to change perspective helps avoid potential problems. I bring a small stepladder with me to all photo shoots; the ladder provides an immediate change of perspective and helps remove unwanted background clutter. Sometimes, all it takes is one step up to make a big difference.

The growing demand for a natural background is evident in the number of photographers who shoot in natural light or create sets that mimic bucolic settings.

Straight portrait photographers use backgrounds to complement the subject or to portray the child in a stylistic manner. The commercial studio photographer usually works with painted muslin canvases, which are available in any design imaginable, to complement the child. Sometimes photographers choose a background that screams with color (lime-green, lipstick red) to emphasize the energy of the child. Increasingly, studio photographers are building elaborate sets that give the effect of sitting in a garden, standing on a balcony, or reflecting by the side of a pond.

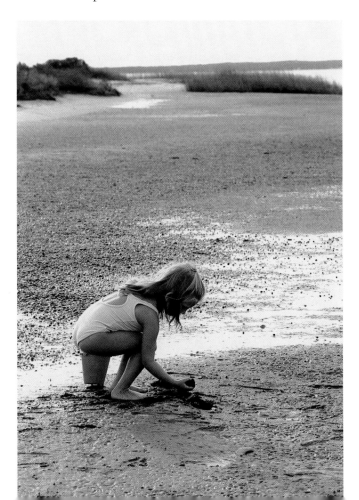

Contrast

Without contrast, a composition could become boring and static. Too much visual similarity leads to monotony. If all of the elements in a photograph are the same color, or the same size, or the same shape, for example, there is no information to lead the viewer's eye. Contrast creates variety, tension, and excitement. Juxtaposing structural elements in a composition—small against large, old versus new, light against dark, warm colors versus cool colors, horizontal next to vertical—adds life and movement and engages the viewer.

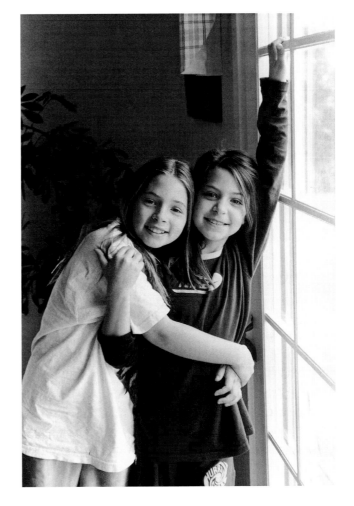

JOELLE AND KATIE

One snowy afternoon we had a spontaneous photo session after having photographed everyone's hands for a class of mine. We used southern exposure, which produced a beautiful glow. The girls were dressed in contrasting black and white, and they lined up in the picture as if in rotation: white, black, white (window). I did not actually plan this, but perhaps I saw the pattern subconsciously.

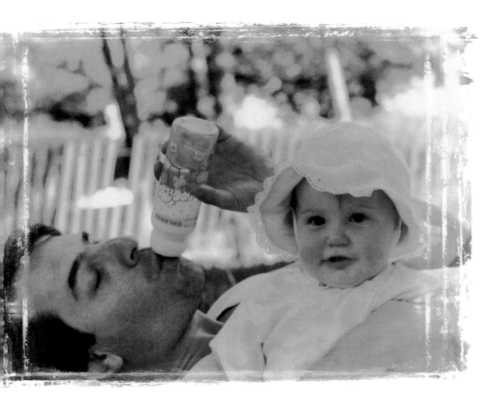

FATHER AND DAUGHTER

So often, we see pictures of mom and baby. This photo captures a moment between father and child. Notice how elements such as the baby's soft pink skin next to the father's stubble and the baby's upright position with the father lying down, add contrast to the image. Having dad pretend to drink from the bottle adds an element of humor while balancing the composition. The picture was altered using Auto FX Photo/ Graphic Edges software.

Color

You could spend a lifetime studying color. There is so much information on the subject, ranging from the technical, scientific, physiological, and psychological to the sublime. Color can create a sense of time, place, or emotion. It can be the subject itself, or it can be used to create abstract images. Colors, whether loud or quiet, tell a story. Patterns, repetitions, or similarities of colors and shapes help to create movement within the picture.

The whole notion of whether you should shoot in color or black-and-white film is steeped in opinionated debate. While it is said that black-and-white photographs are more artful—or timeless—the power of a strong color image jostles the senses; color has the power to WOW the viewer. Black-and-white pictures tend to be more subtle. Most successful color photographs, while seemingly happenstance, are carefully orchestrated, using color theory and color's psychological properties. The incorrect use of color creates a clichéd photo, one you have seen countless times. Used correctly, color creates a lasting impression.

When shooting in color, think about how the photograph will be used, whether for a magazine, a scrapbook, or wall art. If it is going on a wall, consider the surrounding colors. If the picture is for stock or an editorial piece, look at the source and see what effects the editors like. Highly saturated colors are typically popular. Furthermore, consider all the colors in the photograph; do they work together or detract from each other?

THE COLOR WHEEL

Knowing a little color theory helps in planning wardrobe, location, and background. The color wheel is a universal visual artist's tool that is useful for depicting and explaining the logic, organization, and properties of color. The color wheel organizes the colors in a way that makes it easy to observe the relationships between them. Colors near each other on the wheel are called analogous. Colors that fall directly opposite each other on the color wheel are called complements.

COLOR WHEEL

The color wheel comprises twelve colors, and its foundation is the three primary colors—red, yellow, and blue—so-termed because they cannot be produced from any other colors. The secondary colors are created by combining any two primaries: Red and blue make violet, red and yellow make orange, and blue and yellow make green.

Notice the placement of the secondary colors on the wheel: Each secondary lies between the two primaries that yield it. Tertiary colors are formed by mixing a primary with a secondary color. There are six tertiary colors: red-orange, red-violet, blue-violet, blue-green, yellow-green, and yellow-orange. Notice that, like secondary colors, the tertiaries fall between the two colors that create them.

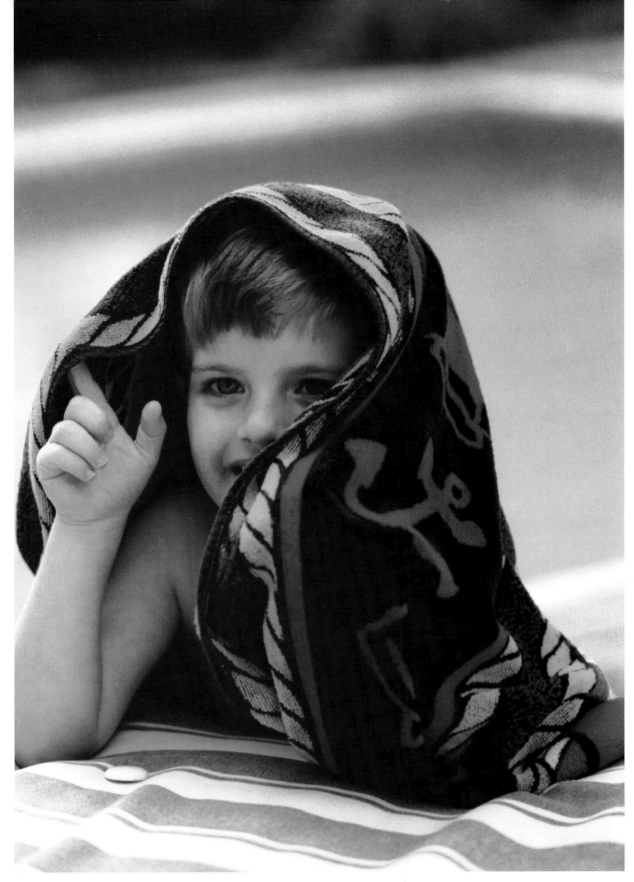

GLORIOUS COLOR

I waited a long time to take this picture. I realized that the colors of the towel would contrast against the analogous background color scheme of aquamarine water and green grass. The red accents dotting the towel create depth, since warm colors (reds, yellows, and oranges) move forward and cool colors (blues, greens, and violets) recede.

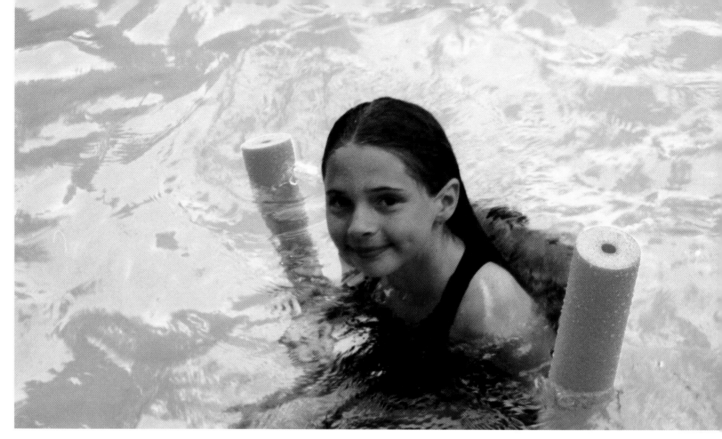

KATIE

Orange and blue are complementary colors, and it is no wonder that manufacturers make floaties for children in this flaming color. Complementary colors, eye-catchers, typically create satisfying results.

COMPLEMENTARY COLORS

Complementary colors are located opposite each other on the color wheel. Red and green, blue and orange, violet and yellow, and yellow-green and red-violet are all complementary pairs.

Familiarizing yourself with complementary colors is useful for creating dramatic effects in your photographs. Complements placed next to each other in a composition intensify each other. For example, a child's red shirt will pop against a green background of grass or trees.

COLOR AND MEANING

Colors also have psychological implications. Red is often seen as the most emotional color; it is associated with excitement, courage, ardent love, fire, and, in its most ominous sense, with sin, cruelty, and violence. Yellow, the lightest of colors, is often associated with happiness and divine love, and is considered a cheerful color. In its negative sense, though, yellow signifies cowardice and deceit. Blue is said to be meditative, and the ocean or a swimming pool are great backdrops for children's photographs. Blue also denotes wisdom and serenity and is associated with constancy, loyalty, and peacefulness. Often blue is seen as symbolizing virtue or purity. For some, blue also represents a certain elegance and maturity—especially, say, a navy blue. Among the secondary colors, green is associated with fertility and in its negative sense symbolizes jealousy. Violet and purple symbolize royal sovereignty and dignity and are often associated with magic. Orange is similar to yellow in its associations. Knowing these aspects of the different colors will enable you to use their effects to further emphasize the statements of your photographs.

Selective Focus

Choice of lens and selective focus dramatically alter the background, resulting in a portrait that is soft and flattering. To achieve this effect, portrait photographers use a telephoto lens (85–200mm for a 35mm lens) or a portrait lens (105mm) and a wide aperture ($f/2$). A long lens immediately reduces the depth of field (the area of acceptable focus), and, as desired, isolates the subject. A wide aperture further enhances the blurred background. Portrait photographers often focus on the subject and blur the background. This technique immediately highlights the subject in a flattering and pretty manner. It is also useful for eliminating a displeasing background. By using a wide aperture, you can alter these details into blurred colors or tones.

Setting your camera's program mode to "portrait" automatically opens the aperture to its widest. When working with aperture priority—an operating mode I usually use—you can set the aperture and the camera will automatically set the shutter speed for a proper exposure. Manual operation is most useful when working in an environment in which the lighting remains constant, giving the photographer full control over the aperture and shutter speed settings. Regardless of the exposure mode, the rule of thumb is to shoot with a wide aperture for portraits. However, please note that a wide aperture requires critical focusing, since the depth of field is narrow and only a small segment of the picture will be in focus. It is best to focus on the eyes. You may have to make adjustments depending upon the nature of the photo shoot. A mobile toddler might require greater depth of field to insure acceptable focus. Therefore you could work with a smaller aperture, such as $f/8$.

Try positioning your subject as far away from the background as the scene allows. The farther away the background, the less pronounced it becomes.

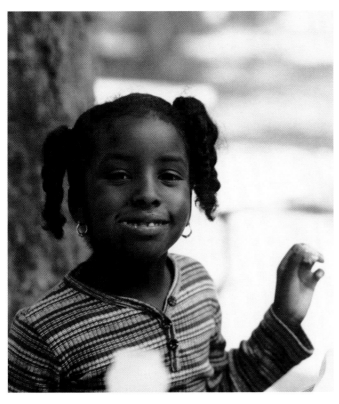

OLIVIA

The technique of selective focus is one of the first lessons in my introductory photography class. It is a continuous thrill to see the light in the students' eyes when they conquer the concept. Suddenly, the camera becomes a tool for expression. Focusing on a subject and blurring the background often creates a new way of looking at the same old thing.

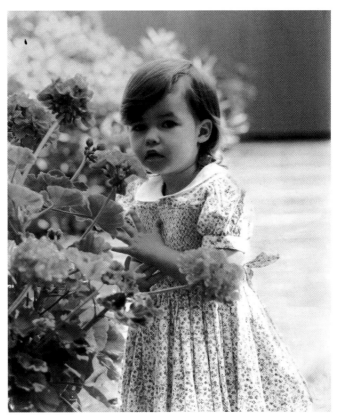

ISABEL

By focusing on Isabel and using a wide aperture of $f/2.8$, I created a feeling of great depth. The distant background is softly blurred while Isabel and the flowers in the foreground look as if you could reach out and touch them! Handpainting further enhanced the effect.

Lines

Lines are everywhere, defining everything. Lines create shapes, define contrast, and configure the environment. Like color, lines have psychological implications and invoke various emotional responses. Horizontal lines imply tranquility; vertical lines project pride and dignity. Diagonal lines create visual movement. Leading lines help move the viewer across the picture area and create a dynamic, rather than a static, image. Positioning subjects in a triangular formation hints of permanence..

The environment exists because of lines. Use these lines to lead the viewer to the subject. Utilize lines for posing and body language. The angle of an arm, the position of hands, the tilt of the chin, the creases in a dress, all create lines that add to (or detract from) the composition. Define the lines, use them, break them, or soften them. Find the lines for powerful composing.

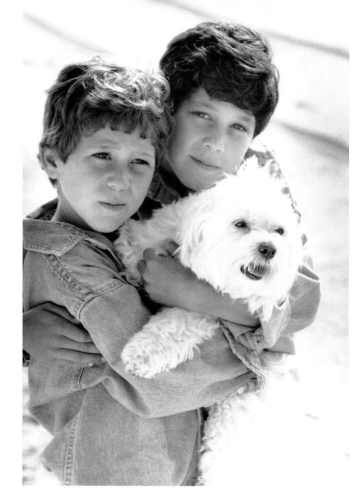

JARED AND JUSTIN

This high-key photograph is defined by lines in the background, in the boy's shirt, and even in the angle in which I framed the image.

KEIRA

Notice how many lines intersect the composition: the diagonal line of the dock, the diagonal line of the stick going in the opposite direction, the horizontal line where the grasses meet the water, and the vertical line created by Keira herself. All of these seemingly random lines draw the viewer's eye to the subject.

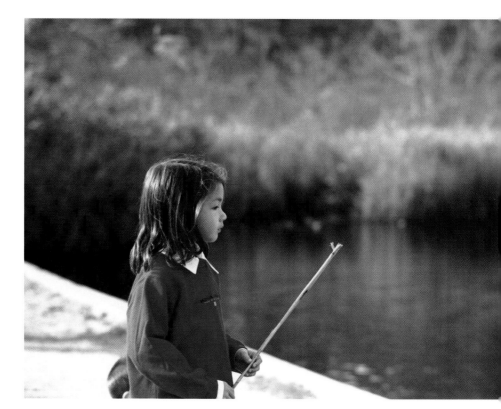

Patterns

Patterns exist when one or more design elements repeat. Patterns are visually pleasing, often decorative, design elements that harmoniously unify the composition. Interesting patterns occur naturally: the formation of geese in flight, rows of evergreen trees shaped like triangles, the repeating colors of a rainbow. Patterns are waiting to be discovered; it is up to you as the photographer to see them. I talk about this when I teach landscape photography, but the theory works for environmental portraits as well. The photo of Joelle and Bari at right is a powerful example of color patterns. It was a cold, foggy winter morning. I chose bright colors for Joelle and Bari to wear and drove to a predetermined spot. I had not been to the area for a month or so, and was awed to see the very same colors I had chosen in the environment. I strategically isolated the area where pink petals dusted the earth and red buds remained, composing a picture that complements the subjects and creates visual harmony. It looks as if I planned the whole scenario.

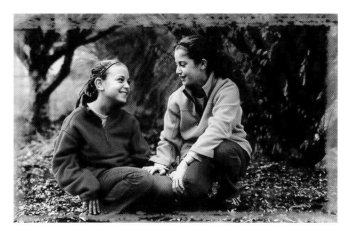

JOELLE AND BARI

I added a magenta border digitally to further the pattern of magenta to green (magenta border, green grass in background, magenta jacket, green jacket, magenta border). I also used the lines of the trees as leading lines.

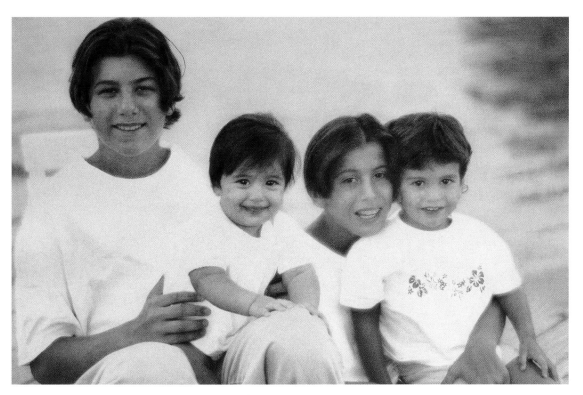

CLIFFORD, ZOE, REUBEN, AND LLOYD

When photographing a family, it makes sense to coordinate colors or even dress everyone in the same colors. Here the eye automatically recognizes the pattern of the clothes and moves onto the faces, which is what the portrait is all about.

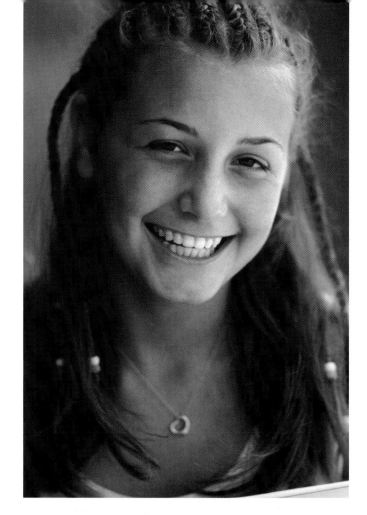

NICOLE

Sidelighting helps create texture.
Here, the subtle lighting gently illumi-
nates the smooth texture of Nicole's
skin. The entire photograph has a soft
dreamy feeling.

Texture

Texture creates immediacy. The soft, velvety cheeks of a
baby, the rough bark of a tree trunk, and the shiny surface
of a still lake all lend a tactile, "reach out and touch it"
feeling to a photograph. Sidelighting the subject helps
emphasize texture. Generally speaking, the greater the
intensity of the light and its angle, the more strongly the
texture unfolds. Late afternoon light provides a beautiful
opportunity to highlight texture

MICHAEL

Children's skin is soft like velvet—a cliché because it's true. Texture abounds in this composition:
the soft fabrics of Michael's shirt and the towel behind him, the coarser weave of the bassinet, and
the shiny reflective surface of the mirror. Using black-and-white film further emphasizes texture
by removing the distraction of color.

SOURCES OF INSPIRATION

The best way to improve your compositional skills is to look at photographs—lots of them—and paintings. The latest trend in photography is to combine painting and photography, so it is important to know art in its many forms. The following list identifies museums and art organizations that I encourage you to visit either personally or on the Internet.

ART INSTITUTE OF CHICAGO
111 South Michigan Avenue
Chicago, IL 60603
312-443-3600
www.artic.edu

CENTER FOR CREATIVE
PHOTOGRAPHY (CCP)
AT THE UNIVERSITY OF ARIZONA
1030 North Olive Road
PO Box 210103
Tucson, AZ 85721-0103
520-621-7968
www.library.arizona.edu/
branches/ccp/

GEORGE EASTMAN HOUSE
900 East Avenue
Rochester, NY 14607
585-271-3316
www.eastmanhouse.org

HIGH MUSEUM OF ART
1280 Peachtree Street, NE
Atlanta, GA 30309
404-733-4400
www.high.org

INTERNATIONAL CENTER
OF PHOTOGRAPHY
1133 Avenue of the Americas
New York, NY 10036
212-857-0000
www.icp.org

INTERNATIONAL PHOTOGRAPHY
HALL OF FAME
Oklahoma City, OK
405-424-4055
www.iphf.org

LIBRARY OF CONGRESS
101 Independence Avenue, SE
Washington, DC 20540
202-707-5000
www.loc.gov

LOS ANGELES COUNTY MUSEUM OF ART
5905 Wilshire Blvd.
Los Angeles, CA 90036
323-857-6000
www.lacma.org

METROPOLITAN MUSEUM OF ART
1000 Fifth Avenue
New York, NY 10028-0198
212-535-7710
www. metmuseum.org

MUSEUM OF FINE ARTS, BOSTON
Avenue of the Arts
465 Huntington Avenue
Boston, MA 02115-5597
617-267-9300

MUSEUM OF FINE ARTS, HOUSTON
PO Box 6826
Houston, TX 77265-6826
713-639-7300
www.mfah.org

MUSEUM OF MODERN ART
11 West 53 Street
New York, NY 10019
212-708-9400
www.moma.org

MUSEUM OF PHOTOGRAPHIC ARTS
1649 El Prado
San Diego, CA 92101
619-238-7559
www.mopa.org

SAN FRANCISCO MUSEUM
OF MODERN ART
151 Third Street
San Francisco, CA 94103-3159
415-357-4000
www.sfmoma.com

WALKER ART CENTER AND
MINNEAPOLIS SCULPTURE GARDEN
Minneapolis, MN
612-375-7622
www.walkerart.org

To improve your photography skills, learn alongside professionals at one of the following schools:

BROOKS INSTITUTE OF PHOTOGRAPHY
801 Alston Road
Santa Barbara, CA 93108
www.brooks.edu

CENTER FOR CREATIVE
PHOTOGRAPHY (see above)

CENTER FOR PHOTOGRAPHIC ART
PO Box 1100
Carmel, CA 93921
831-625-5181
www.photography.org

INTERNATIONAL CENTER OF
PHOTOGRAPHY (see above)

MAINE PHOTOGRAPHIC WORKSHOPS
PO Box 200
2 Central Street
Rockport, ME 04856
877-577-7700
www.theworkshops.com

PHOTOGRAPHERS' FORMULARY
& WORKSHOPS IN MONTANA
PO Box 950
7079 Highway 83 North
Condon, MT 59826-0950
800-922-5255
www.photoformulary.com

SAN FRANCISCO ART INSTITUTE
800 Chestnut Street
San Francisco, CA 94133
415-771-7020
www.sfai.edu

SANTA FE WORKSHOPS
PO Box 9916
Santa Fe, NM 87504-5916
505-983-1400
www.santafeworkshops.com

There is so much to learn about composition, and so many ways to improve your eye. In addition to studying fine art paintings and photographs, start to notice how pictures are organized in the daily papers and in the magazines you read.

Movies are a rich resource for ideas to improve your compositions. Look at how individual shots in movies are composed. What fun, to think you are going to the movies as if you were going to school!

OUR CHILDREN TREMBLE
IN THEIR TEEN-AGE CRIBS.
WHIRLING OFF ON A THUMB
OR A MOTORCYCLE.

—Anne Sexton "The Child Bearers"

Important Moments

EIGHTEEN YEARS seems like a long time, yet childhood disappears in a heartbeat. As a young parent, I received daily proverbs—"Enjoy them while you can, before you know it they will be going off to college"—but I had little patience for this advice. Immersed in the details of motherhood, the words had no basis in my reality. "Grow fast. Yeah, right!" I would mutter as I wrestled with the tenth diaper of the day by noon. Ironically, as I write this book, my daughter prepares for college. The past eighteen years weave through pages of family scrapbooks as I ponder time's elusiveness. A virtual passport, photography travels time. Beginning with newborns, this chapter travels the timeline of childhood, highlighting milestones in a child's life.

The Early Years

I have been a mom for more than seventeen years, but I still marvel at the sight and scent of a baby. Babies are so innocent, so delicate, so soft and affectionate, so honest and spontaneous, so cuddly and curious, so clean and pure. Photographing infants brings back cherished memories of my own little ones.

Like any new endeavor, photographing babies is at first challenging. There are tricks, such as soft lighting, gentle music, and cooing words. The photographer must see with child-like vision, relax during moments of duress, and wait for the spirit to emerge. Most important, the photographer must love children.

Infants cry loud, and if you are not a parent, this might frighten you. But an infant's crying is actually an opportunity to capture a mom or dad calming their child, so have the camera ready. Photographing infants is often stressful for the parents, who may be unwilling to let go of their angel for even a moment; the slightest cry sets off an anxiety attack. Consider, too, that although newborns are gorgeous in the eyes of their parents, they do have ruddy complexions and wrinkled, raisin-like skin.

FIRST MONTH

Days old and, oh, so delicate! You should approach photographing a newborn with caution. The best photographic positions are a side view, looking down, or with the infant held in the arms of a loved one. A propped position, when the baby is not ready to sit, looks just like that.

PHOTOGRAPHING WHITE

Photographing the newborn dressed in white heightens a sense of heavenly wonder. High-key photographs—where the tones or colors are light to white—evoke a sense of peace. Choosing white requires careful exposure to maintain details in the highlights. Furthermore, color negative film bias produces either a pinkish, bluish, yellowish, or greenish tinge to white depending on the film. Digital technology attempts to remedy this problem by allowing for manual adjustments of white balance, and digital imaging does not have a color bias.

Newborns see only nearby objects (10 inches away); they coo with excitement but will also cry when overstimulated. Knowing this, you must work quickly. Have your camera in hand, set the aperture and shutter speed, prefocus on the area of the eyes, and wait for the right moment.

Photographing infants with siblings helps relax them. Infants enjoy physical contact and the sounds of young voices. When including more than one child, make certain that the children's clothes coordinate in color and style but do not dominate. Photographers beware: Babies will cry when over- or understimulated. Parents are usually excellent assistants for photo shoots. They know how to encourage cooperation and are experts at the art of distraction.

DAYS OLD

Enamored with the miracle of their baby, parents want to capture every moment. Whether to photograph a newborn in color or black-and-white is a matter of personal preference, style, and desired effect. I chose black-and-white for this portrait to create a timeless effect.

DAVID, ISAAC, AND SOPHIA

I photographed the two-week-old twins, Isaac and Sophia, as a surprise for their father's birthday. Their older brother, David, was seven at the time and we hoped he would help us with the shoot. As you can see, the infants were hysterical and David cooperated with humor. I photographed the children on black-and-white film and handpainted the print for the final presentation.

SECOND MONTH

By the second month, the baby lifts her head, shakes a rattle, and enjoys the visual world. The baby coos, giggles, and squeals with excitement, and already knows the power of a cry. Place mom and dad directly behind the camera and ask them to call the child's name, which will surely invite a "Hi, I love you" smile. I find that parents are fabulous assistants. They jump, they make cooing sounds, and they will do almost anything to grab the child's attention, in the hope of catching an adorable expression. I am always in the ready position. I have to work swiftly, because within ten minutes, the child is exhausted, and the parents or grandparents are worn out.

I usually place the child on the floor with soft, clean blankets. Any elevated surface increases the risk of an accident. Select colors for their narrative intent and have all the colors in the photograph (foreground, middle ground, and background) relate harmoniously. Color (or lack of color) depends upon your personal style and your intent. Knowing your client's tastes helps. Dressing a boy in blue and a girl in pink is traditional, and pastels are common with babies; but that is not to say that bold colors or reversing color stereotypes are inappropriate. Keep patterned outfits to a minimum. Black-and-white photography enhances a sense of timelessness and artfulness, taking the early stages of a child's life into another realm.

REBECCA

Rather than using a flash with an infant, I recommend a faster film, such as ISO 800 or even 1600. Photographing in my living room, I used natural light streaming through the windows and skylight. Mom and grandma stood behind me and raised quite a racket in an attempt to make baby smile.

THREE TO SIX MONTHS

These next three months are marked by significant motor skill development, providing great photographic opportunities. Baby can now stretch, holding her head high as she proudly searches for familiar voices. Her personality is emerging and she laughs and giggles, knows parents from strangers, and makes eye contact. The baby is already growing teeth, which is another milestone for parents.

Strangers often frighten babies, so having mom or dad nearby is wise decision. Suggest, however, that the parents stay back and let the child be; if the child begins to look for a parent or become agitated, make the parent's presence known immediately to ease the child's fear. It's also a good idea to spend an hour or so before the shoot with the family to help create a trusting relationship with both parents and child.

A PRIVATE MOMENT

This quiet moment speaks a thousand words. Notice how the light skimming the mother's hair creates a halo effect. The picture was photographed with Ilford HP5 Plus film, printed on Ilford Multigrade IV FB Fiber paper, and toned for an antique effect.

HIGH CHAIR

The high chair provides a perfect location for photographing a baby. It is safe, and the child knows that food is on the way. Black-and-white photography helps create an image that goes beyond cliché. We have seen it all before in color, but an image transformed into black-and-white shows a new perspective. Three pictures in a series—a triptych—create a storyboard; this is a popular style of presentation.

SIX TO NINE MONTHS

The baby now sits unsupported, creating wonderful opportunities for the photographer. At home, place the child in a high chair and watch the personality emerge. Children are happy when eating, drinking from a cup, banging on a tray, throwing food, and laughing. I like using a high chair because the child is strapped in (comfortably), and I do not have to worry about safety. You can eliminate the high chair with a head shot or use the chair's lines shapes, patterns, and color as design elements. For the studio photographer, try sitting the child in a miniature wicker chair.

Since the child's features are becoming proportioned, a compelling head-and-shoulders portrait or head shot is appropriate. Beyond the differences that are obvious in the terminology, head-and-shoulder portraits differ in that they generally include information about the sitter. Clothing, props, and background suggest the lifestyle, culture, habitat, and wealth of the sitter. In a head-and-shoulders portrait, the background usually includes a mood element, such as texture, lighting, or color, whereas with a close-up head shot, the background is typically unobtrusive, plain, or softly focused.

Because you will be working quickly, it is a good idea to have the entire shoot already sketched in your mind, so that you are ready, all eyes on the child, not worrying about the rule of thirds or bungling with depth of field. Play music, have parents sing, make unusual sounds. Create a festive, upbeat atmosphere and the child will respond, fully charged with emotion. The smile says it all.

As another option, place colorful toys or other age-appropriate objects on a blanket or rug and permit the child to explore. Call the child's name, or better yet, have mom or dad stand behind you and call for the child. Photograph from above or at eye level, which may require lying on the floor. Use the colorful objects as design elements, carefully frame the picture, and wait for the right expression. Add props to encourage mobility, and an anchor for standing; babies this age are usually quite proud of this feat and their expressions will show it.

NINE TO TWELVE MONTHS

The facial expressions at this age are fabulous. Try being a fly on the wall, letting the child safely explore, and magic will unfold. Babies love to play peekaboo, which allows for wonderful image-making, because every time you say "Peekaboo," it is as if it is the first time the child hears the refrain.

Children often have something in their mouths—a binky, a bottle, or their fingers—and it is difficult to catch them empty-handed as they juggle a favorite teddy, blanket, or bottle. (My daughter sported three binkies, holding one in her mouth and one in each hand. I wish I had thought to capture this on film.) Try to distract the child with a favorite song, and maybe you will free the security item for a moment. If you cannot pry it loose, do not worry; the parents know the objects all too well, and their inclusion in the portrait is part of capturing the spirit of their child.

TODDLERS

Toddlers are adorable little people, walking, climbing, rocking, dancing, and singing; this is a wonderful age to photograph. Children at this age burst with energy, spontaneity, and excitement. Bring music to the sessions and photograph at the home for added comfort; the child will eventually relax.

MICHAEL

This child's happiness bounces off the paper. A monochromatic palette (colors of the same hue) reinforces the child's illumination. The triangle of light under his left cheek is a telltale sign of "Rembrandt lighting," a dramatic lighting pose named for the signature style of the Dutch master.

CHARLIE

When I photograph a family, I try to blend into the household, staying long enough so that the children go about their business of being children. Instead of creating a storyline (particularly difficult with an energetic toddler like Charlie), I let it occur and try to be there at the "decisive moment"— a phrase coined by the late Henri Cartier-Bresson—when lighting, composition, and subject create poetry.

Toddlers play ball, jump, skip, and generally love interaction. Make eye contact with the child. At this stage, children begin to develop a vocabulary; they can speak around fifty words, so they will understand you. Talk *to* them, not at them. Find a way to let the child know you care. Children at this age often have something they want to show you—a favorite doll, their room, a boo-boo. Win the child's heart by being interested and animated.

Attention span is short, so have a bag full of tricks ready. Bring bubbles and use them as a prop or for an entertaining intermission. Children love bubbles; they love to look at them, run after them, catch them, touch them, and blow them. Set your camera to a fast shutter speed (1/500 sec.) so that you can run with the child and catch the action.

Try photographing toddlers with their older siblings. Older brothers and sisters often have the magical power of convincing the toddler to stay still for a moment and strike a pose, before he is off and running on a new mission. True, the job becomes more difficult for the photographer because of the added number of subjects, but toddlers usually love their older siblings, and the opportunity to capture heartwarming moments is worth the effort. Patience is the photographer's best tool, especially with a toddler. Wait long enough, let the toddler run, run, run, and eventually he will tire. It is a waiting game.

ARIEL AND GABRIEL
Gabriel, like most toddlers, doesn't enjoy sitting still for long. Big sister Ariel was able to persuade him to pose for the camera long enough for me to capture a special moment between siblings.

PEEKABOO

When I complete an assignment, I often continue to photograph if the child has energy, like Mara did, and I have the time. Many photographs in this book are outtakes, pictures from a photo session that were not selected by the client. I see children's photographs with different eyes than a parent does, and I try to meet my artistic style while still creating a portrait that pleases my client.

Playtime

As children get a little older, they start to venture beyond the home and begin exploring new environments. The park is a wonderful playground, more special than the backyard and full of new areas of exploration no matter how many times a youngster visits. Keep in mind that a new environment may also present problems. I live one mile from the beach, and I know from experience not to schedule a photo shoot with children who have never been to the beach. Let them visit a few times with their parents first. Youngsters may be frightened of the coarseness and heat of the sand.

Make-believe provides a Pandora's box of opportunities. Children love to pretend, and many studio photographers have a box of clothes for the children to play with and be photographed in. As the seasons change, so do the color opportunities. Fall is the red of the apple-picking season, the orange of pumpkins; winter offers the white blanket of snow. Think about all the events that encompass a child's life and invent new ways of illustrating them. Stretch your imagination to go beyond clichés.

PLAYGROUNDS, PARKS, AND ZOOS

Parks, zoos, and playgrounds are ideal settings for children's portraits. The playground is full of shapes and colors that are perfect for dynamic compositions. More important, children have a lot of fun being in this environment, and you can capture honest, spontaneous pictures. Playground apparatus is built of basic shapes and often painted in primary colors; triangles, rectangles, and squares abound on the playground. Use these elements to create dynamic compositions.

Parks are also terrific environments for child photography. Children love playing in parks, and their enthusiasm for life spontaneously unveils. Parks are rich playfields in which to capture moments of childhood glory. Visit the location prior to the scheduled session and visualize the photographic opportunities. Decide where you want to lead the child, how you will frame the image, and which film, aperture, and shutter settings you will use. Bring a change of clothes in case the child gets dirty.

The zoo is an awesome environment in which to capture children being children. Like the playground, the zoo is full of brightly colored buildings and equipment, and the animals are sources of awe and wonder. Many zoos have created amazing environments to house the animals. You could sit for hours mesmerized by the animals in their habitats and the honest reactions of the children.

KIDS AT THE ZOO

See how the colorful clothes speak for the children, who are too engrossed in what's happening in the aquarium to notice me photographing them. Always looking for patterns, the eye quickly traces the dots between yellow trimming on socks and colorful hair ribbons. This photograph was captured on Fuji Sensia film at ISO 100.

SCOTT

Parks are perfect places to let children explore and put their natural exuberance on display. Just make sure that you, as well as a parent or assistant, keep a close eye on the child. A park, especially one with lakes and ponds, can be as dangerous as it is wonderful.

THE BEACH

The beach is full of wonders—the roar of the surf, the cackling of seagulls, sparkling sand, and colorful seashells—that the child gleefully inhales. Because they are also places of potential problems, get to know these areas before the photo session. However, the unfettered expressions you are liable to capture as the child explores the terrain are worth the trouble.

BRITTANY, CHELSEA, AND JULIAN

For this photo session, I explored different areas of the beach and ended up taking some shots with different backgrounds. The change in positioning helped maintain the children's spirited involvement.

LIFEGUARDS

I was photographing a wedding on the beach and saw a group of children watching from the lifeguard chair. I knew it would be a great picture and snapped away. Finding model releases (forms that grant the photographer the right to use the photographs) was the challenge. I recommend having releases in your bag, so you are ready for the unexpected.

BIRTHDAYS

Birthdays are obvious growth indicators and rich in photographic opportunities. Some families commission a portrait to mark each year or every other year, while others wait every three to five years. If you are thinking about becoming a children's photographer, photograph your children's milestones (or friend's children's milestones); your confidence will build, and a portfolio will develop. Many photographic careers begin at a birthday party.

Both storytelling pictures and candid shots work well at birthday parties. You can opt for either a "look at me" picture or a documentary approach in which you catch the children playing and interacting with one another. Age will indicate which is more appropriate, as will your personal style. Follow the subjects with your camera and you are bound to capture spontaneous expressions. This requires patience and trust that the moment will arise to click the shutter.

Children over the age of three are old enough to be encouraged or coaxed into sitting for a portrait, and more traditional three-quarter and full-length portraits can be composed. Here, wardrobe and body language become even more prominent than with the head-and-shoulders portraits discussed previously, and the background is often as telling as the subject.

Many birthday parties for young children take place at midday. Use fill flash (children over two can handle the flash without too much distraction) to reduce the contrast between highlight to shadow. Most cameras have a fill flash option (TTL), and newer cameras and flash units allow control of fill by +/- $^1/_3$ intervals. Test your flash unit beforehand to see which compensation is best. On bright, sunny days, a flash is essential. On a cloudy day, you still need some fill to reduce the dark circles under the eyes, although you can cut it back to about $-^2/_3$.

HAPPY BIRTHDAY

Birthdays are obvious markers on the timeline of a child's life. I positioned myself away from the group and composed in the viewfinder. Instead of saying, "Everyone look at me," I photographed in a documentary style, merely recording the event as it unfolded.

RAPPORT

Advice on how to relate to children can be found throughout this book, but rapport is such a major component of a portrait photographer's work that it is important to summarize the essentials. Relate to the child with an open heart and clear your mind from discursive thoughts by constantly refocusing your attention on the child. From infancy through the teen years, children speak their own language. Learn to understand their inflections, nuances, and syntax. Play with children and they will let you into their world, which is full of photographic wonders.

Parents tend to appreciate pictures of their children smiling and often need encouragement to move off the beaten track. The typical "say cheese" pictures, in which a child is asked to "perform" a smile, are not true portraits in that they actually take the sitter out of his inner consciousness. Instead of going up to the child and actually positioning the face, place the subject in position and then let the poses naturally unfold during conversation. Ask questions to invoke a mood or characteristic of the young person. Try questions like, What is your favorite sport? Who is your best friend? What are you going to do tonight? Ask questions that allow children to reconnect with themselves, and this will project out and into your camera.

BATH TIME

Children usually love a bath, and I recommend photographing a child playing in the bath (of course totally supervised and age-appropriate) to create a heartwarming picture. Children can be either naked or dressed in swimsuits. This type of photograph is not a typical commercial image; it is a picture that encourages the photographer to work outside the box. It is an opportunity to take risks.

Lighting in the bathroom can wonderful—for example, in new homes with bathrooms the size of standard bedrooms and lots of windows—or harsh and awful, as in a traditional box-shaped room with unflattering lighting. If you can, use natural light and have fun. In a small, poorly lit room, you will have to use a flash. Bounce it off the ceiling to create the most natural effect.

MAKE-BELIEVE

Children love to pretend. Given the opportunity, they will move into their imaginary world and forget about you completely. I always encourage the child to pretend and often ask questions like, Who do you like on television?, to help transition them to their special place. Alternatively, I ask the child to make me a pretend sandwich. Or I might ask the child to color me a picture. Chances are you will seize a memorable moment.

Dress-up suddenly transforms the ordinary into a magical mystery tour. An obligatory photo session becomes playtime. It is amazing how the child's whole personality changes when she puts on a hat, overalls, or a lace dressing gown. Use dress-up for a quick respite from a photo session, and then have the child go back refreshed into the old pose.

SELF-PORTRAIT WITH NICOLE

Having recently become a big sister, Nicole, my firstborn, was hungry for attention. One day, with Joelle down for a nap, I suggested to Nicole we play dress-up. She wanted to be a bride and I wondered if I could fit into my wedding gown (seven years later and a few weeks after giving birth). The lighting was exquisite so I suggested to Nicole that we take a picture. At first, she wasn't too eager, because for me that usually means work. But I set up the self-portrait and showed her how, with the timer, I would run into the picture before the shutter clicked. What fun we had!

BATH TIME

Children love bath time. The water is a source of both entertainment and relaxation. Instead of grinning and bearing it during the "witching hour," give the child a bath. At appropriate ages, play dates can continue right through bath time.

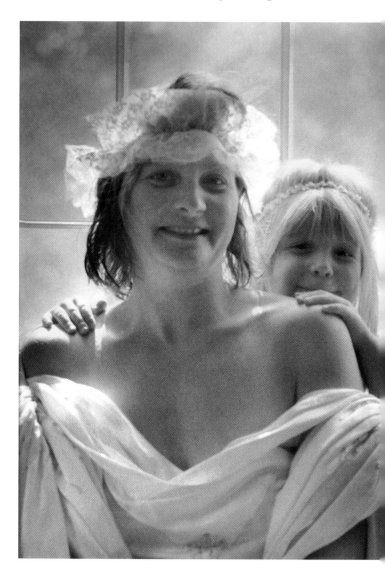

SEASONAL ACTIVITIES

Holidays, parades, and seasonal activities such as apple and pumpkin picking provide visual playlands full of photographic opportunities. The holidays are full of color, joy, and play and lend themselves to storytelling images as well as straight portraits. When photographing such an activity, I recommend allowing two hours of actual shooting time. You will not be photographing every second, but you may need this much time to capture the pictures you want.

PUMPKIN PICKING

Pumpkin picking has become a national pastime. Farms sponsor hayrides, harvest mazes, all-you-can-pick events, and activities. There are so many possibilities for black-and-white or color photos. If you can't decide, shoot color and decide later if you want to convert the images to black-and-white or sepia, especially easy if you are shooting digital.

HALLOWEEN

Halloween is a celebration day full of visual possibilities. This is a self-portrait with my daughter Nicole's friends. I shot a roll of film with the camera set on a tripod and used a timer to trigger the shutter. I ran back and forth to prepare the camera, but allowed enough time to look totally at ease. Later, I purchased a remote that activates the trigger from a distance. The children were great sports. I used a 24mm wide-angle lens to add a vastness to the picture. The autumn leaves coordinated perfectly with our various Halloween attire.

At School

The early school years (nursery school, kindergarten, and elementary school) provide lots of opportunities for photographing children in action. Because the children are absorbed in activities, you will be able to capture charming moments. I encourage photographers to go into schools and photograph children at work and at play. Go to the classroom, read a story, teach an art lesson, and visit the playground. Set up an activity, and you will quickly see that the children, busy in their own worlds, forget all about you.

More formal school activities, such as musical concerts, plays, and award ceremonies, are wonderful settings for candid photography. These events usually occur in an auditorium where you have little control over lighting. It is best to use a fast film and a good quality flash that has a strong power rating.

Cameras with built-in units are virtually useless when photographing people more than 18 feet away. I always chuckle to myself when I see parents photographing their child from 35 feet away with a disposable camera.

I recommend using fast films, such as Kodak Max ISO 800, which produce rich colors and smooth transitions between shifts in color. Shoot at a small aperture of $f/8$ or $f/11$ to increase the focusing area, and double-check that your flash will cover the intended range. If not, move in closer or change the aperture.

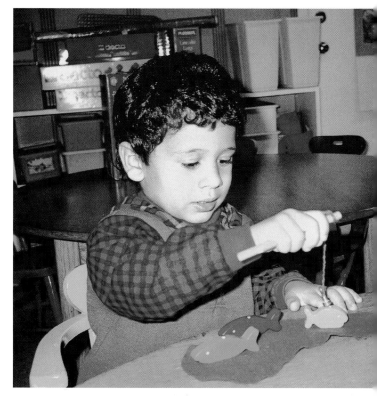

NURSERY SCHOOL ACTIVITY

Young children usually have short attention spans, but when they are involved in an activity, they become fully engaged. I try to capture ch in their own worlds, completely unselfconscious and occupied. I try t the viewer who the child really is.

LOOKING THROUGH THE CURTAIN

This photograph was commissioned for the Westhampton Beach Nursery School twenty-fifth anniversary. I took the photograph from a second-story classroom above and shot through a lace curtain to obscure the details. I used the window as a structural element and as a metaphor. To secure detail of the curtain and of the scene below, I used a small aperture ($f/16$) and put the camera on a tripod. The photograph was shot on Ilford HP5 Plus film, printed on Ilford Multigrade IV FB Fiber (matte) paper, and hand-painted to further enhance the sense of time standing still while the past and present whirl around us.

CHILDREN DRAWING IN PLAYGROUND

When my children were younger I was active in the PTA and was always involved in children's activities. As part of a committee to rebuild the playground, I photographed children drawing their ideal playground environment. I composed the picture using the shapes of their bodies to create an interesting composition.

SCHOOL PLAY

I photographed this middle school play from a balcony 40 feet from the stage. This was a job for a powerful flash— a built-in flash would not have been successful, because they typically cover distances of up to only 12 feet. The students' colorful costumes contrast against the darkened backdrop.

AUXILIARY FLASH

Most new cameras (except high-end professional level models) are equipped with a built-in flash that automatically activates when lighting conditions are low. However, these flash units are not suitable for many situations, and photographers should have an auxiliary flash. An auxiliary flash should allow for TTL (through-the-lens), auto, and manual selections. Auto flash is as simple as turning on the flash and setting the camera to the appropriate sync speeds (some cameras even do this task for you); the flash then determines an appropriate burst of light. With TTL metering, the flash sensor determines the appropriate power flash through the lens, instead of through the flash sensor itself as occurs with auto flash. In order for TTL to work, the flash has to be dedicated to the camera: The flash and the camera have to be able to communicate. Different manufacturers allow for different flash units. Some cameras, like the Nikon SB-27 and F100, simply mount onto a hot shoe, while others require a separate adapter to enable them. I use a Metz 54 MZ that has an adapter; I mount it onto the flash and then the flash slips onto my Canon 10D digital camera. With my 35mm system I use a Nikon SB-26.

Read the camera and flash manuals before purchasing to make certain your flash has enough power. Basically, the two ways to control the intensity of the flash are through aperture (the bigger the opening, the brighter the flash potential) and distance. The manuals will list flash coverage distances based on ISO, aperture, and lens selection. Most flash units also include an LCD panel that will state how many feet your flash will cover based on the ISO and lens you are working from. I would purchase the flash with the most power available for your camera and within your budget.

Sports

For many families, sports are an important part of the children's lives. Parents want pictures of their child pitching, shooting baskets, riding bikes, and waterskiing. A few easy techniques will enable you to take great action shots.

Capturing sporting events requires using a fast shutter speed (1/250 sec. or faster), fast film, a flash, or a combination of these three ingredients. Action shots are fun to look at, easy to master, and full of rich memories. Action photos distinguish the amateur photographer from the more advanced. However, you do not need a professional camera to accomplish these pictures. I bumped into a friend recently and she updated me on the new camera equipment she had just purchased, rationalizing a $2,000 camera because it "enabled her to take action shots." Please note: A simple camera can accomplish this task. It is simply a matter of using a fast shutter speed and knowing when to trigger the shutter.

Now is the time to use shutter priority mode (see page 31). Opt for the fastest shutter speed the lighting will allow (e.g. 1/2000 sec.) along with the aperture most suitable for your composition (shallow or great depth of field). Some newer electronic SLR cameras offer a sport-action mode, which automatically sets the camera to the fastest shutter speed the lighting and film speed indicate.

Successful action shots depend not so much on technique, but rather on anticipation, which is really the basis for all good photography. It is knowing what you are looking for and how to anticipate it, all the while being in the moment—"the decisive moment."

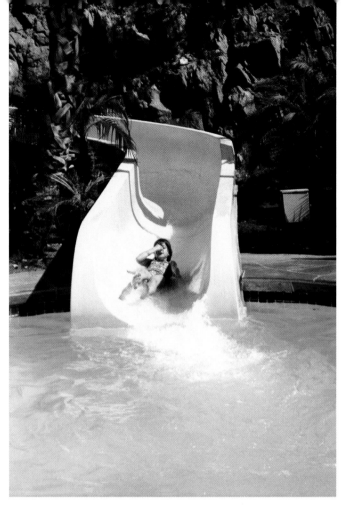

COMING DOWN THE SLIDE

With shutter set to 1/500 sec., camera at eye level, scene composed through the viewfinder, and finger on the shutter release, I waited. The slide forms an S-curve, which adds visual interest—a favorite composition lesson for my college students. After I show them S-curves, they all seek them in their photographs.

BIKE-A-THON

To photograph the children and stop the action, I set my shutter to a fast speed of 1/1000 sec. Since it was a bright day, I was able to close down my aperture and establish a great depth of field.

PANNING

Panning is another technique for recording action. However, rather than stopping action, panning captures the motion in a blurred manner. The subject is in focus, but the background is blurred. Correct panning takes skill, practice, and luck. It is the most challenging lesson in my introductory photography class (Photography 101), but once mastered, it always wows the viewer.

The goal is to create an image that conveys a sense of motion. To accomplish this technique do the following:

■ Plan the picture.

■ Choose a background that affords considerable contrast between highlights and shadows (light and dark areas).

■ Determine where the subject should be when you snap the picture.

■ Set the shutter to a speed of 1/30 sec. or slower (1/15 sec. or 1/8 sec.). The slower the shutter, the greater the panning effect.

■ Set the aperture based on your exposure reading.

■ Prefocus by asking someone to stand in the exact position at which you will be clicking the shutter and then focus.

■ Create distance between the subject and the background by using a long focal length (if you have a choice) or moving in close to the subject. The longer the distance between the subject and the background, the greater the blur.

■ Stand holding the camera firmly in hand and twist your upper body in the direction of where your subject will move.

■ Begin following the subject, starting from before the point at which you wish to take the picture.

■ Follow the motion with the camera, steadily moving in a parallel sweep with the subject's movement.

■ When the subject reaches the spot you have preselected for focus, release the shutter and continue following the subject in one smooth movement until you complete a 180-degree arc.

SKATEBOARDING

Panning is a sign of having mastered the technical aspects of photography, but I must admit I have never been commissioned to do a panning portrait. This picture is one I captured of a student so I could demonstrate to my class how to pan.

Teens

Teens, referred to in the industry as "seniors," are in a league of their own. Any rules you have acquired for photographing young children do not apply to adolescents. Teenage girls love modeling; they love to dress up and want to feel beautiful. Secretly, they all want to be discovered, and you can have a lot of fun photographing them once a trusting environment unfolds.

Teenage boys, on the other hand, usually shy away from the camera. They feel uncomfortable, and the photographer has to be prepared to break the ice. Talking to boys and trying to relate to them helps. However, don't try to be too cool; they will know it. Find an honest way to relate and you will be rewarded with expressive and interesting pictures.

Teenage boys sometimes resent having their picture taken, yet secretly appreciate that their parents care enough about them and think they are good-looking enough to want to have them photographed. Knowing this, I work on building a rapport with teenage boys I photograph, slowly chiseling away the veneer of awkwardness. Talk long enough and they will forget you are the adversary. I periodically photograph a family with three teenage boys who tolerate the picture-taking because their mom asks them to do it. They are mature enough to cooperate, but still, I have to work with their awkwardness. Since I teach at a college, I have developed a manner of talking to this age group. After the third year of photographing this family, I brought my beautiful teenage daughter along as an assistant and a decoy. The idea worked beautifully. The boys were very interested in Nicole, and I was able to direct the shoot, while Nicole knelt directly in front of me holding a reflector.

JOHN, WARD, AND ROBERT

These young men were cooperative out of love and respect for their mom, who wanted a family portrait before her husband's special birthday. I try to relate to all my subjects by finding a common thread. I ask a few leading questions and the conversation usually begins to flow. People like to share who they are if they feel they are really being heard.

GOING TO THE PROM

Teens love prom. Prom is, in fact, an industry. There are hair
and clothes magazines completely dedicated to prom, and
dress and shoe manufacturers, florists, manicurists, limousine
services, and more all compete for teens' business. All dressed
up, the teens dazzle, as do the photographs.

THERE IS AN OLD
ADAGE IN MUSIC: "IF
YOU PLAY WHEN YOU
PRACTICE, YOU PRACTICE
WHEN YOU PLAY." THIS
IS TRUE IN PHOTOGRAPHY
AS WELL . . .

— Ansel Adams

The Photo Shoot

THE PHOTO SHOOT IS a collaborative effort that joins many elements, transforming chaos with a click of the shutter. The photographer assumes multiple roles in the production, including director, supporting actor, set designer, lighting technician, and cameraperson. The child, of course, is the star. Sometimes the session goes smoothly; there is chemistry and—puff—magic; the sun peaks from behind the cloudy charcoal sky, highlighting the child's hair, as a rainbow appears. Other times the photo session can be a nightmare; the child has an earache, the lighting is ghastly, and everyone's patience is tested. This chapter demystifies the photo session, discussing everything from the initial consultation to choosing wardrobe and props to the postproduction stages of editing and presentation.

Initial Consultation

Children's photography may look easy, but it is not. Careful planning at every stage of a photo shoot is critical for producing successful photographs that will please you and your client. Planning is an ongoing process that continues throughout each phase of the photo session and is especially important behind the scenes and between client contacts. Visiting with the family prior to the scheduled session, selecting the location, choosing the wardrobe, and selecting backgrounds and props are all necessary stages in the process. However, your initial contact with the client may be the most important step.

First contact with a new client is usually made over the phone. During this conversation try to find the answers to the following questions.

- Who is your client? How did he hear of you? Where has he seen your work? Does he know another client?
- What other types of pictures does your client like? Has he ever commissioned a portrait before?
- Is this a special commission—for a birthday, a surprise, or an anniversary?
- What type of person is your client? Try to discover the lifestyle of your client without seeming nosey.
- Where and how will the picture be displayed? Knowing the final size of the image will help you gauge a price range and will immediately trigger ideas regarding format.
- Would your client prefer a head shot, three-quarter-length portrait, or full-body shot?
- Does your client want a formal or informal portrait?
- What would he like the child to wear? The client's answer to the previous question should help determine wardrobe.
- If you have a studio, determine what set designs, backgrounds, and lighting your client prefers and whether you have them available.
- Does your client have any ideas about location? The family will probably know if they want beach or woodlands. However, if not, help the client decide at your next meeting by showing your portfolio.

SETTING YOUR PRICE

Professional portrait photography comes in all prices. Some photographers charge a sitting fee and charge additionally for each print. Others offer a combination price based on the size of the final image and the volume of the pictures purchased.

There are many variables in determining your price: overhead, equipment, assistants, film and processing, etc. To arrive at a base price, add these costs (plus others particular to your style) and determine a markup for your expenses. Next, decide what your time is worth, then guestimate the number of hours necessary to complete the job and multiply that by your hourly rate. Finally, add these columns to arrive at a starting price. Bear in mind that digital photography is no less expensive than traditional film-based photography when you factor in capital expenditures and your time. While there is no film-cost factor, the transferring, editing, and printing is probably more time-consuming for digital than for traditional printmaking. Amortize your digital setup, charging a percentage of the total to each shoot.

What is your market? Research the competition and determine how you fit in the market. What are area photographers charging? How do you compare in terms of reputation? Consider your personal style and then price yourself. Wear it; see if the prices feel comfortable. Can you get behind them? Are you worth it?

Choosing the Location

"Location. Location. Location." The real estate adage holds true in portraiture. To heighten creative potential, always be on the lookout for new locations. Follow the laws of feng shui to find the right energy spot and open your heart and mind to nature's magic. Even if you are shooting in a studio or on a set, and have already photographed five children, find a way to see the situation (setting) with fresh vision. Otherwise, you are in an assembly-line business, clicking the shutter and creating a product, not a portrait.

With camera ready, scan for possible scenes. Location sets the tone and mood of the photograph. Visualize the scene by looking through the viewfinder; photography is seeing what is not there, seeing what can occur, and then making it happen. Location scouting is a means of connecting with this magic.

Match a locale, set, or backdrop with your clients' preferences. If they want the beach, do not push the forest. Bring a digital camera or a Polaroid to document your recommendations. Once the location is determined, revisit it at the same time of day that the photo session will occur and study the details. Find the angle, notice the lighting, and anticipate the problems. Know the answers to the "what ifs?": What if the sun is too bright? What if it is very windy? What if there are bees? The more you anticipate, the better prepared you will be for the inherent chaos of a photography session. No matter how well prepared you are, making pictures is a synthesis of many elements, including unpredictable qualities of people and nature; the unknown always presents itself.

Bring a notebook to record the data you collect, and make a sketch or do a dry shoot. Use a friend or your own child as a substitute model and experiment with light, angle, and camera functions. Determine the best film for the job and have an alternative plan ready in case the weather shifts. The dry shoot is imperative to proper planning and spontaneity.

SAND CASTLES

My assistant went to the beach ahead of time and began the sand castle kingdom, which the children enthusiastically continued to construct. Then, the wind kicked up. Patiently, camera ready in hand, I waited for the wind to die down, the hair to stop blowing, and the expressions to ring true.

Second Consultation

Ideally, the second consultation takes place face-to-face with the client. Meeting clients at their home is invaluable for seeing who they really are. Studio portrait photographers do not typically make house calls. Instead, they hold a consultation meeting at their studio, usually in a reception area that is warm, friendly, and conducive to conversation.

Now is a good time to meet the children. Introduce yourself and study their faces as unobtrusively as possible. What are the salient attributes? What should you accentuate—big blue eyes, golden blond hair, adorable smile? What do you want to subdue—heavy weight, birthmarks? Begin thinking about how you will handle any possible problems. For instance, how do you prepare for the child who wears glasses? Should the glasses be included in the portrait? How will you handle reflections and flare? Scope out the possible "what ifs?" and have a concrete game plan for action. With the eyeglasses example, you should discuss the options with the family, deciding whether to pop out the lenses or retouch the reflections and/or glare with photo-editing software.

By the end of the second meeting—or telephone conversation, although I am a strong believer in person-to-person communication—you should be able to answer the queries listed in the sample worksheet below (feel free to adapt it to suit your needs).

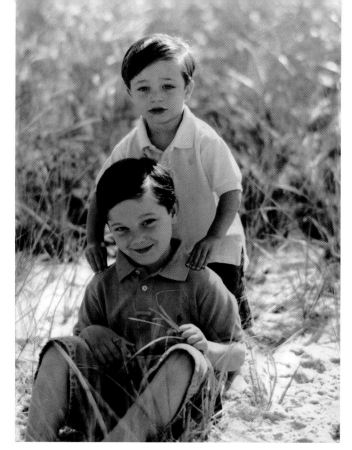

JUSTIN AND JAKE
Aperture and shutter selections depend upon the nature of the job. For example, for this photo the client specifically wanted to have soft focus so the blades of sea grass would sparkle. I therefore knew that I would have to shoot in the early morning with a wide aperture of $f/5.6$. The children may look posed, but they are not.

PHOTO SHOOT WORKSHEET

DATE: _____

CLIENT: _____

NAME(S) OF CHILD(REN): _____

LOCATION: _____ FINAL PRINT SIZE: _____

DESCRIPTION OF EVENT (OR TYPE OF PORTRAIT): ___ FORMAT (VERTICAL OR HORIZONTAL): ___

_____ FILM/ISO: _____

WARDROBE: _____ LIGHTING: _____

PROPS: _____ EXPOSURE COMPENSATION: _____

BACKGROUND: _____ APERTURE: _____

ASSISTANT(S): _____ SHUTTER SPEED: _____

Selecting Wardrobe

Take care when coordinating clothing for the photo shoot. There are basic guidelines used by many portrait photographers, but keep in mind that these are only guidelines and may not be the best choice for a particular shoot. First, determine if the portrait is to be formal or informal. Formal attire includes sports jackets or dresses and dress shoes. Informal attire includes denim and beachwear. Khakis with button-down shirts are semiformal, a casual but organized dress style. I encourage the children to go barefoot (which they love) for a natural, relaxed style.

Light to medium colors blend with a light background; dark colors work well with dark backgrounds. A photo shoot at the beach calls for soft pastels, whereas, a photo shoot at the edge of the woods suggests navy blues, dark greens, or browns.

Children of different ages should dress accordingly. Newborns typically wear white, baby blue, or girly pink. Some argue that dressing newborns in bright clothing offends the senses, but this is not always the case. As I have mentioned throughout this text, the rules are starting points—know them and then change them when it will work better otherwise. Toddlers can wear almost anything; choose their attire to complement the environment and their personality and lifestyle.

Casual everyday clothes usually work best when photographing children. Children are free spirits and do not want to be confined by clothing. They want their clothes to be part of their personalities, as do adults. Unfortunately, the pseudo-casual photo shoot, in which the jeans, sneakers, and shirts are brand new, the hair is professionally groomed, and the families spend a lot of time and energy looking casual, is more the norm.

SHINNECOCK INDIAN GIRL

Cholena and her mother were teaching a children's dance workshop at a friend's dance studio and were both dressed in traditional clothes to illustrate the customs and dance of the Shinnecock Indian nation, based near my hometown in Southampton, New York. Later, I visited the reservation, toured their museum, and listened to a lecture about their history. I was deeply moved. The natural setting perfectly complements Cholena's traditional garments.

ASSISTANTS

Location photographers often employ assistants. There are so many details that an extra pair of hands and eyes becomes invaluable. An assistant can transport equipment and act as personal assistant, babysitter, and driver. My assistant runs with the reflector, tells me if a strand of hair has fallen across a face, notices if the child squints, hands me film and helps create a playful environment. I often use my students as assistants.

How many assistants you need depends on the nature and location of the photo shoot. For young children, one assistant usually suffices. If the family has three children under the age of five, you will need two assistants. For a shy teenage boy, no assistant might be the wisest option; if he's shy, why bring in more people?

I often employ the parents to act as assistants. They know just the right words to make a child smile, laugh, and relax. They stand behind me and make funny faces, jump, and sing silly songs—whatever is necessary to help make the child cooperate. Rarely, but sometimes, if I feel that the parent is hindering the process, I will politely remark, "I think Charlie will be more relaxed if you leave him to me."

Posing

To pose or not to pose. . . . Whether or not to have children pose depends on the nature of the photograph, the setting, and the subjects. With a formal portrait, the typical rule of thumb is to make eye contact with the subject. In this way, the subject makes contact with the viewer. The posture, body language, and perspective convey character.

I often allow the child to strike a pose. They have fun doing it, and I then fine-tune by placing the hand just so, or asking the child to look over here or there.

The following is a list of some general guidelines to try for posing.

- When photographing more than one child, keep the heads close together and vary the heights of the children so that the viewer moves from one set of eyes to another.
- When photographing groups, a smaller aperture, such as $f/11$, is preferable to allow for greater depth of field and sharper focus.
- When photographing one child, leave more space above the head to emphasize youth. This is especially important when using a monochromatic background where visual space provides the only reference. In a natural environment use objects to reinforce the size and age of the child.
- For chubby faces, use a three-quarter view with strong sidelighting in which the side of the face away from the camera is illuminated (short, or narrow, lighting; see page 49).
- To emphasize beautiful eyes, angle the camera to look downward, so that the child is looking up with open eyes.
- Backlighting blonde-haired people adds an angelic glow as the light skims the top of the hair.

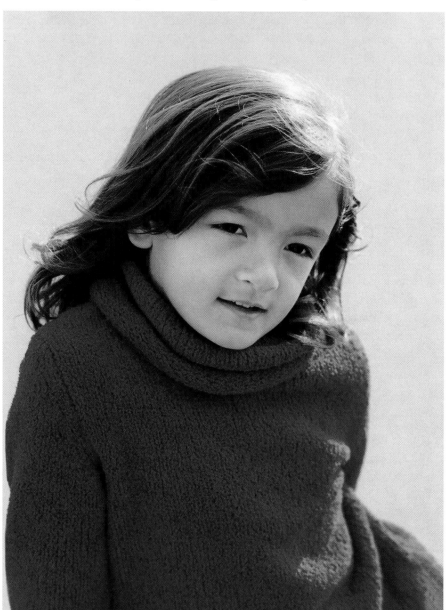

BRIDGET

Bridget enjoyed the self-affirming process of being photographed, so I moved in close. I conversed with her softly, using trigger questions to help her transition into her own private reverie so that I could fully celebrate the essence of Bridget.

THE GANG: PHOTOGRAPHING GROUPS

The biggest challenge when photographing groups is creating visual harmony. The individuals in a group photograph should be united by a pattern, be it their clothing, body language, or hair coloring. The human eye naturally looks for such connections. Placement of hands creates a visual connection. Varying head height, which thereby varies the height of each pair of eyes (the most important feature in the portrait) helps create a dynamic composition.

Group portraits are challenging because the odds of capturing a great expression on all the subjects simultaneously decreases as the group increases. Some photographers charge more for more than one child. When I shoot more than one child, I shoot more film. If the children are young, the shoot takes more time because I have to allow time for them to unwind and regroup.

Rapport with more than one child is challenging, and group interpersonal dynamics often challenge the photographer. With young children, one child is bound to say, "Shut up" or "You look stupid," making the other child pout. The photographer must be able to command control over the scene. I recommend having at least one assistant or parent to help control the possible chaos.

DAVID, SOPHIA, AND ISAAC

Sophia and Isaac, twin three-year-olds, were challenging to pose. Like most toddlers, they were constantly on the go. David, the elder sibling, was asked to be the group leader and rein in the twins. They finally rested long enough to capture a sweet moment.

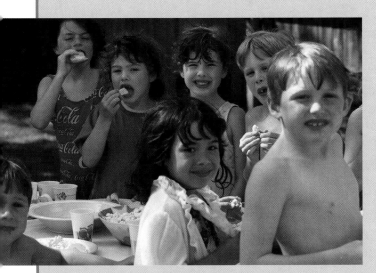

KINDERGARTEN PICNIC

My daughter Nicole invited her kindergarten class to an end-of-the-year picnic. I used the children to frame the image and captured them in all three picture planes—foreground, middle ground, and background.

BRIANNA, LANA, MICHAEL, AND TREVOR

This more posed group photo is a good example of backlighting and open shade. The photo shoot took place at midday—not an easy time to photograph since the sun is so bright and casts heavy shadows under the eyes. We found shade in a protected area and I positioned the children with the sun behind them.

Props

Props are additional items that add details of the subject's lifestyle and further illuminate personality. At times, a prop becomes a necessity—the child will not let go of her bottle, special teddy, or binky—so turn it into a positive and include it in the picture. Props are grounding tools that channel nervous energy. Actors use props for this very purpose. Props are also good distractions for children. Sometimes props, such as a charming hat, add a sweet element. Hats have tremendous narrative power.

A few words of caution when using props. Check the item for tears, straggly ends, limp flowers, and visible tags. Clean them of all imperfections as best as possible before shooting so you are not unpleasantly surprised when you process the film. If you are shooting for stock photography, remove brand identification such as the names of toy manufacturers and clothing manufacturers' logos. You will have a hard time selling images with any brand identification. Nowadays it is not so simple to find generic items, because everything manufactured is stamped with a name for marketing purposes. Stock up on items that work, so they are always on hand. Check lighting when introducing a hat, as hats create shadows that usually cover the eye area, the most important area of the portrait. You may have to compensate by having the child tilt her head up, turn toward the light, use a reflector, or open up $^2/_3$ of a stop.

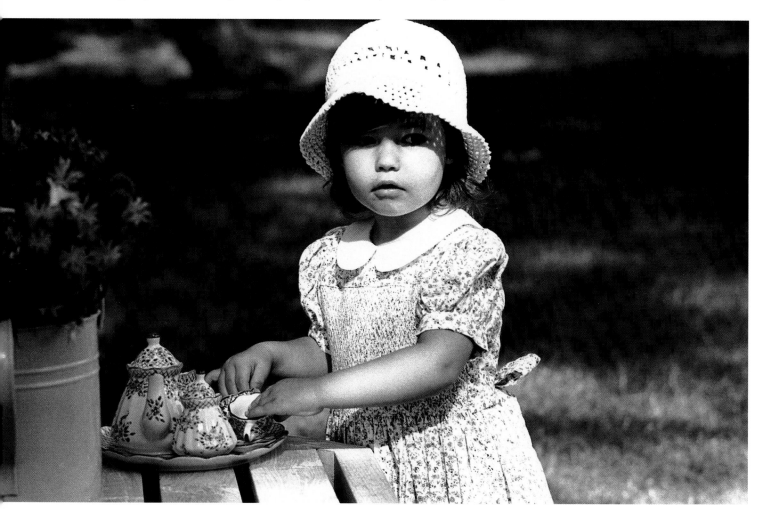

TEATIME

Isabel loves to pretend. We looked for bunnies and had a tea party. She only speaks a few words but understands plenty. Having studied acting, I know that props anchor your reality. I use this lesson in all of my sessions and I seek appropriate props, which are sometimes noticeable and sometimes used just to set the mood.

ARIEL

Riding stables offer many possibilities for environmental portraiture. The horses, saddles, and fences are all environmental elements and props that enhance the composition.

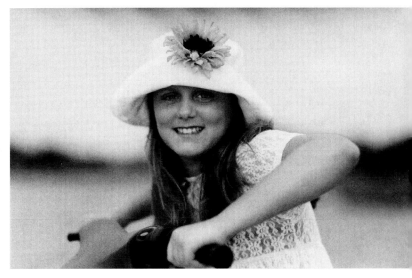

LINDSEY

Hats are great props that ignite imagination. Once the hat was placed on her head, Lindsey naturally moved into make-believe mode. Lindsey is sitting on a Jet Ski going nowhere, but her eyes suggest she's cruising.

PHOTO SHOOT CHECKLIST

The day or night before the photo shoot, make sure you have the following items ready:

- ❏ Camera
- ❏ Backup camera
- ❏ Batteries
- ❏ Spare batteries
- ❏ Film
- ❏ Extra film
- ❏ Alternative film
- ❏ Flash
- ❏ Flash diffuser
- ❏ Reflector
- ❏ Bug spray
- ❏ Stepladder
- ❏ Sync cord or hot-shoe adapter (if required)
- ❏ Permanent marker
- ❏ Hairbrush
- ❏ Hairspray
- ❏ Bench
- ❏ Filters
- ❏ Tripod

This list will help you prepare for your photo shoot. Most important is a backup camera, just in case your primary camera malfunctions. Have plenty of extra batteries and film. Overestimate your film by four rolls; you never want to be caught without enough. I always bring along a stepladder to provide me with extra height if I need to remove unwanted background. I use the bench for posing.

Right before the shoot, conduct a final check of the camera and settings:

- ❏ Exposure mode
- ❏ Focusing mode
- ❏ Film advancing mode
- ❏ Exposure compensation
- ❏ Shutter speed
- ❏ Aperture
- ❏ ISO setting (DX or manual)
- ❏ Batteries for camera and flash (source and spare)

Review each detail prior to every photo shoot, just as a pilot goes through each dial on his instrument panel prior to every take-off. No matter how prepared you are, unwelcome factors will present themselves. Uncontrollable variables include bad weather, a cranky child, a demanding client, a jammed camera, or an assistant who doesn't show up. This is the nature of the photography business.

Photo Shoot:
At the Playground with Nigel & Kiara

Nigel is an adorable and energetic three-year-old. Ever since I first saw Nigel, I wanted to photograph him (love at first sight). It took a year, but finally his parents and I discussed the session. It was winter, the coldest of the last fifty years, which hindered my excitement. I thought about an indoor session using available light, but quickly reconsidered. The idea just did not excite me, and Nigel is too young and frisky to sit still. Then the lightbulb went off—snow, I thought. What a great idea, but Nigel had the flu. Finally, there was a break in the weather. (I listen to the radio a lot during my shooting season.) The forecast was calling for 70-degree weather, and I scheduled the shoot to take place in two days time.

The shoot was scheduled for 4:00 PM, and the day was heavily overcast. I employed my older daughter, Nicole, as an assistant. She followed Nigel with the reflector and added to the playful atmosphere. I chose Fuji NPS 160 film because it has an ultrafine grain and reproduces gorgeous colors. Funny enough, photographs taken on cloudy, almost rainy days produce beautifully radiant colors.

We had selected Nigel's wardrobe days prior to the shoot. Nigel was dressed in play clothes and felt good about himself and his Pumas (he showed them to me many times). Nigel's sister, Kiara, was dressed in coordinating colors so that photographs of them together would be harmonious. We all played tag; I was it. Nigel laughed and laughed and laughed. "You can't catch me," he chanted teasingly. Nicole ran helplessly after us with the reflector. Kiara proved a superb second assistant.

I set my camera to portrait mode and continuous focus and tracked Nigel's constant motion. I shot two rolls of film, playing with Nigel the whole time and knowing that I needed just one great shot. Sometimes I can get the shot on the first take. I know intuitively when I have the shot without even seeing it. A feeling of "I got it" warms me. I have developed this sixth sense over the years. This feeling is one of the reasons I love photography.

With young children up to the age of five, I try to work with one roll of film (36 exposures). I always tell my students, "Film is cheap, so don't be afraid to shoot a lot"; but a young child's ability to engage fully is limited to maybe thirty minutes.

NIGEL ON THE SLIDE
An artist's delight, the playground is chock-full of lines, shapes, patterns, and colors. The overcast sky actually intensifies the colors.

Children ages five and up are easier to photograph, in that they follow directions and are able to have detailed conversations. As children grow older, they become more and more self-conscious, and it is my responsibility to relax them. I talk in grown-up language to them and encourage the children to talk about themselves. Usually they open up and eventually forget that I am photographing them. I sometimes invite a child to look through my camera, to touch accessory equipment and see for themselves that the machines being pointed at him are just recording a moment.

LAUGHING

Nigel's exuberance is obvious in this profile, which the sun so beautifully illuminates. This is an example of short lighting, the most commonly used studio portrait lighting setup, in which the side of the face away from the camera is lit.

KIARA AND NIGEL

Children often make wonderful assistants. Kiara, Nigel's sister, wore colors that coordinate with her brother for extra photo opportunities.

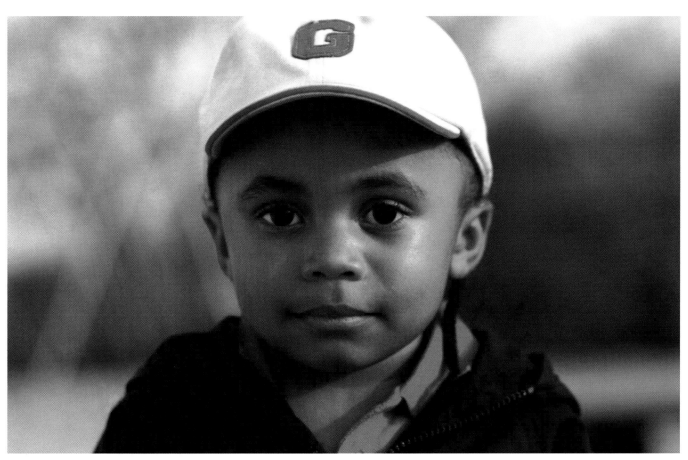

HEAD SHOT

Here I captured Nigel in a moment of reflection. I focused on his eyes, and the blurred background added to the softness of the moment.

Going Fishing with Kyle & Corey

The shoot was scheduled for a late August afternoon (5:30 PM) at a local marina, and the children were outfitted in fishing attire with contrasting tones. Working with Ilford HP5 Plus, I shot three rolls of film.

Kyle and Corey, ages nine and six, respectively, were old enough to cooperate and listen to directions, which definitely makes my work less stressful.

We fished from the dock for a few minutes and then decided to go out in the rowboat. To get the best perspective, I lay belly down on the dock, which, to my chagrin, was moving! As I have mentioned many times, the unknown always presents itself. This required a shutter speed faster than the motion of the dock to prevent a blurred image—tricky business when factoring in my desire for a small aperture (f/11 or f/16) to have great depth of field, as well as the rapidly receding light. Luckily, the dock was rocking gently, to a rhythm I could count. I used a shutter of 1/60 sec. with a 105mm lens (already subject to image blur). I held my breath and waited for the tide, moving with the water. I shot more than one-and-a-half rolls of films. The boys wandered out, and I directed them to come closer. I tried all compositions that I could think of, all the while keeping conscious of the background and framing the image by redirecting the boys. We didn't have life jackets on—not too photogenic—so Kyle and Corey's parents stayed close by. Finally, exhausted, I spotted a fabulous tree. I asked the boys if they would like to climb the tree for a few more pictures and they happily agreed, although you can see by their body language that they were tired. The golden fading light complements their lazy expressions.

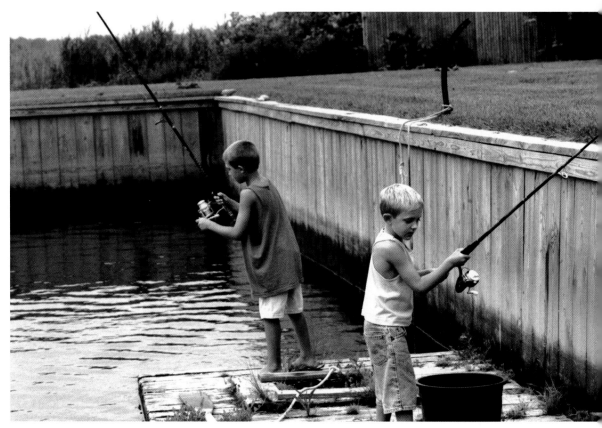

FISHING

This first picture I took is a storytelling image. I often use my first takes—"first thought, best thought." This image gives the viewer a peek into Kyle and Corey's world. However, knowing I was working for hire, I quickly changed direction, talking to the children to establish eye contact.

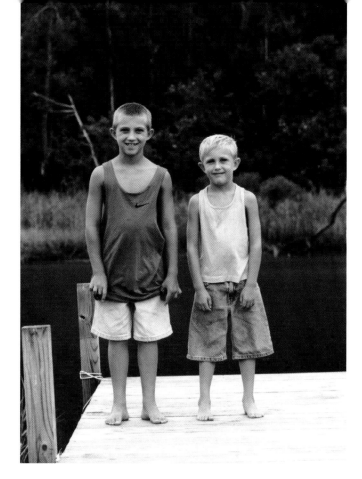

TRADITIONAL POSE

To cover the bases and help ensure my client's satisfaction, I do photograph children in traditional poses. Sometimes. That is what families often want. Notice how the tones of the clothing are reversed for each child—white shorts and dark shirt on Kyle, white shirt and darker shorts on Corey.

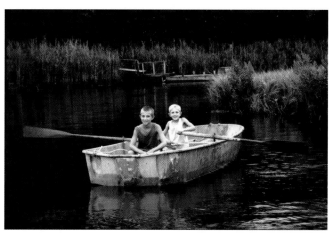

BOATING

Taking children out of their ordinary surroundings can lead to the magic that makes children's portraiture so special.

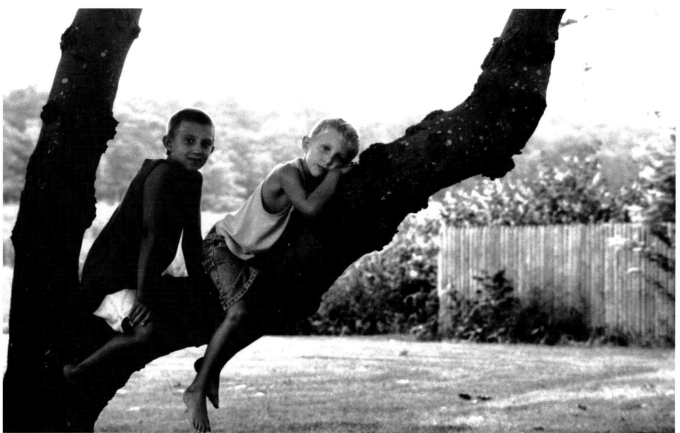

SITTING IN A TREE

Children love to climb trees. To finish our session, I suggested to the boys that they climb the tree for a different setting.

Photo Shoot:

At the Beach with Sarah & Rachel

Sarah and Rachel, the two beautiful young daughters of my friend Terry (proprietor of a wonderful old-style community bookstore that displays my fine art, organizes my summer workshops, and sells my books), were excited about this photo shoot. It was late July and we had planned the shoot weeks in advance, as the summer season is my busy time for portraits. We scheduled a 6:00 PM shoot. At 5:00 PM the gray clouds began to form a heavy blanket. I spend many of the summer months second-guessing the meteorologists and I thought it might just be alright. I did not call it off and met the girls at the beach. The surf was rough and the waves crashed against the shore, making beautiful fluted edgings on the shoreline. I tried to use the shapes in my composition. The lighting was tricky and changed constantly. The wind was howling, feeling like 30-mile-an-hour winds—not good hair weather. The girls did not have hair ties, and neither did I, so I had another obstacle to work with.

I photographed the girls by the beach, trying all the while to capture something different and special about the girls. We tried panning; we tried asking the sky when it was going to rain. We moved away from the surf, near the dunes. The wind thankfully cooperated and dropped about ten notches. I decided to try to create a painterly effect, which I am happy to say I accomplished. I used very fast film, Fuji ISO 1600, knowing that the exaggerated grain, a characteristic of fast film, would add colorful pixelation. The light was dimming rapidly; I lowered my shutter to 1/15 sec. and 1/8 sec. and held my breath, trying my hardest to brace against the wind and not blur the picture. While the images are soft focus, I think they say something poetic and special.

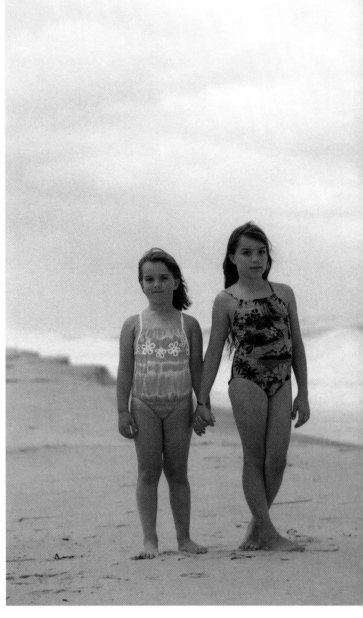

HOLDING HANDS

Having the subjects hold hands is a wonderful way to connect them psychologically and visually.

A PRIVATE MOMENT

Storytelling imagery is timeless and creates timeless pictures. To capture a shot like this, I watch the body language and wait for the expressive moment.

WHERE'S THE RAIN?

Asking children questions that anchor them in make-believe is an effective way to relate to children and create magic. We knew it was going to storm and almost called off the photo shoot; the waves were crashing, but, "Where's the rain?"

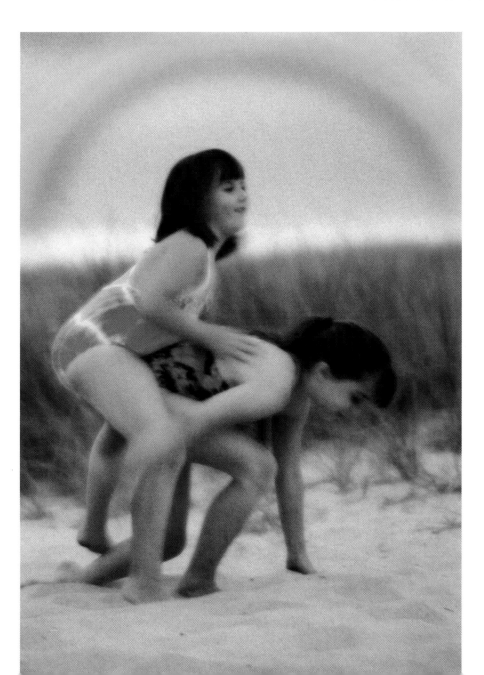

RAINBOW

Rainbows are magical and I was eager to add a rainbow to my photograph with Auto FX Mystical Lighting software. I love to hear viewers ask, "Wow, how did you capture that rainbow?" I think the goal of digital work is to make it look real.

Editing

With the photo session complete and the film processed (or digital files downloaded), we turn to the postproduction stages, including editing, sales presentation, printing, display, and storage.

The photo edit pulls the photo session together, creating a cohesive body of work that displays the child in the photographer's personal style. Some consider photo editing equally as important as the photo session itself. Editing requires a skillful eye and an unbiased touch.

Constant viewing of photographs—and lots of them—helps develop a discriminating eye.

Edit with the same tenacity as you would when creating a portfolio. Begin the edit with a quick "go-through," discarding pictures showing closed eyes and other assorted missed shots. Photo editing is not the place for sentiment; edit with an uncompromising eye. Less is best. One mediocre picture diminishes the integrity of five good ones; keep only the best.

CONTACT SHEET

Some photographers edit from proofs; I still like to edit first on a contact sheet. I look for images that bounce off the page, and then I continue with a closer inspection, using a loupe to see the expressions.

Presentation

Presentation is crucial to success. There are many mediums in which to display your work to a client, including paper proofs, contact sheets, slides, digital proofs, traditional chromes, or slide presentations on a computer. Regardless of the style of visual presentation, it is imperative to meet in person with the family. Personal contact and personal interactions are what the photographs are all about. Be gracious, kind, and openhearted. Plan to spend at least one hour reviewing the pictures. If possible, help the clients decide on selection while you are there. Leaving the proofs for subsequent review opens up the possibility that the clients will not be able to make up their minds, leading to procrastination. Maybe they will not even order prints.

PAPER PROOFS

Paper proofs are the traditional form in which to review images with clients, but they are somewhat costly and pose certain risks. If you leave without proofs and orders in hand, the chance of an order being placed is seriously jeopardized. Paper proofs also introduce the possibility of copyright infringement (a client could copy the proofs with a scanner). On the positive side, paper proofs are tangible. One of the many pleasures of photography is the ability to handle the picture. Photography is immediate, and paper proofs demonstrate this quality.

CONTACT SHEETS

With contact sheets, the photographer is in more control, but only a skilled eye can read a contact sheet. Images on a 35mm 8 x 10-inch proof sheet are tiny (36 x 24mm). One option is to enlarge the proof sheet to 11 x 14 inches, which increases the size of each image to 54 x 38mm. Medium-format contact proofs are even larger. When using a contact print, bring along a high-quality loupe (eye-magnification piece). When using contact sheets, it is often a good idea to schedule a follow-up meeting in which a small selection of paper proofs can be reviewed.

SLIDE PROJECTION

Slides are a popular presentation style. A slide presentation has a few advantages. First, the photographer can enlarge the image to any size, and facial expressions can be studied in detail. Second, a slide show is a fun method of presentation and carries a special aura. Third, elaborate productions can be created, such as using multiple slide projectors and soft mood music.

DIGITAL PROJECTION

Projecting photographs digitally—a personal favorite—is a popular trend, and there are many ways to accomplish this. You can bring your film to a lab and have it scanned to a disk. You can also scan the film or proofs yourself. Digital imaging cuts out the film-processing step.

Once the photos are in a digital format, you can arrange a meeting with the client at the studio or at their home to view the photo session on a laptop or desktop computer, or even on a digital projector. The Epson Powerlite S1 is on my wish list. There are many software options for creating digital slide shows. My personal favorite is Jasc Paint Shop Photo Album 5. It is user-friendly and allows you to control the transition style and time. Digital projection allows the photographer to choose the venue of presentation more easily than does slide projection, because you don't need a screen. Some photographers prefer to be on their home ground and have a room set up for reviewing the photos, while others feel it is more personal to visit the client's home.

Digital photography continues to open doors to new ways of conducting business. For example, Kodak's ProShot software provides templates for presentation. Photographers can easily create their own contact sheets with photo-editing software such as Adobe Photoshop CS and Jasc Paint Shop Pro 8. The photographer can also scan film and print ink-jet proofs. The possibilities are endless and will continue to expand.

FINAL PRESENTATION

Presentation is the photographer's calling card. If the final photographs look good on the initial glimpse, you are in; if not, the client will quickly become disappointed. Like on a blind date, what you first see makes an indelible impression. You should present only your best work, in a style that reflects your essence.

Each client I work with wants a different method of presentation. One of my clients orders 8 x 10-inch prints. She orders between twelve and twenty pictures with museum-quality matting and contained in a clamshell black box. I do like regal black for presentation.

Handpainted photographs are also popular with my clients. I print these images anywhere from 8 x 10 inches to 20 x 24 inches. The smaller pictures are usually part of a group. The larger images are appropriate for hanging over fireplaces and on large walls and can hang on their own depending upon the space. Smaller photographs require a few to look important.

Painting Photographs

THE ART OF HANDPAINTING photographs is as old as photography itself. Handpainting was formulated during the days of the daguerreotype as a way to soften the apparent harshness of photographs. To early patrons of photography, accustomed to the painter's tendency to obscure imperfections, the daguerreotype often needed a touch of paint to make it more palatable. Today, as photography advances along the digital highway, photo artists ironically look back for new ideas. The art of handpainting is more popular than ever, and software for photo manipulation opens up tremendous new possibilities for coloring photographs digitally. This chapter provides an overview of the various methods available for painting photographs.

Traditional Handpainting

Handpainting on black-and-white darkroom enlarging paper is a true art form. The luscious surface yields deep, rich tones, and the process of painting—choosing a palette, gliding paints across the surface of the paper, blending and mixing mediums—is second to none; I lose myself in the process.

The first step in creating a richly toned handpainted photograph is to make a quality black-and-white print. There are two types of photographic enlarging paper: resin-coated (RC) and fiber. Fiber is a traditional darkroom enlarging paper, and RC paper has a plastic coating. RC paper develops more quickly than fiber and dries flat. RC is also a stronger paper; unlike fiber paper, you do not have to worry about crimping it. RC paper and fiber paper are available in matte, semimatte (pearl), and glossy surfaces. As a general rule, matte or semimatte surfaces work better for handpainting prints. I prefer to handpaint on fiber paper, which, like a canvas, absorbs layers of colors and yields rich hues with subtle nuances. There are many fiber matte paper choices available, including Ilford Multigrade IV FB Fiber, Ilford Ilfobrom Galerie, Bergger Prestige Fine Art, Bergger Fine Art Silver Supreme, Kodak Professional PolyMax Fine Art, and Luminous Charcoal R.

After I have a black-and-white print ready, I fix imperfections with Spotone Liquid Dyes or Spotone Pens. The liquid dyes are available in sets of three (warm and neutral tones), and the pens are available in sets of ten pens (warm and neutral). I prefer using the liquid dyes because I can mix the color exactly. I then mask the borders with frisket, a clear tacky paper found in the drafting sections of art stores. To apply frisket, first cut four sections that are approximately the same length and width as the white borders on your photograph. Carefully remove the backing to expose the tacky side. Lay the frisket sticky side down along the borders of the photograph and run your fingers across the frisket surface to remove air bubbles. When finished handpainting, gently lift the tape, one side

JEFFREY, IAN, AND LIZA

The day was bright and the strong sun required an added +3 exposure compensation, which results in loss of detail in the background. Knowing I was going to handpaint the image, I did not worry. I added more exposure time (burning) when developing the background, while covering up (dodging) the subjects.

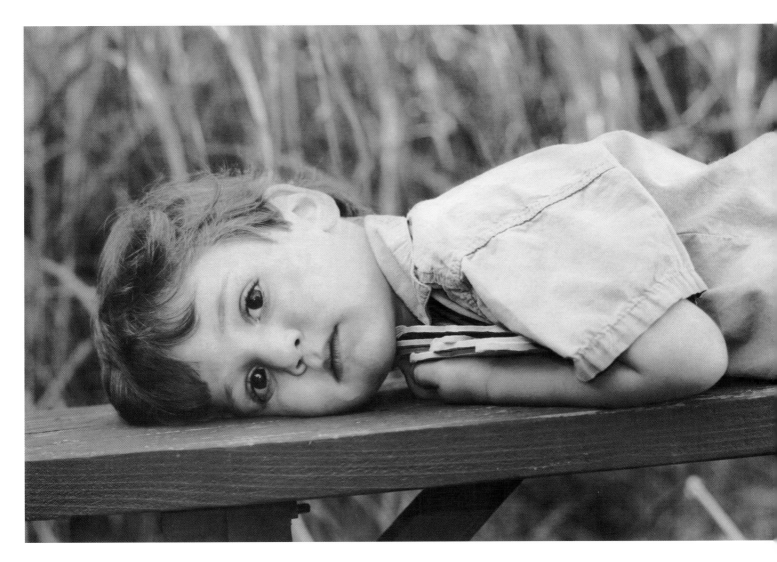

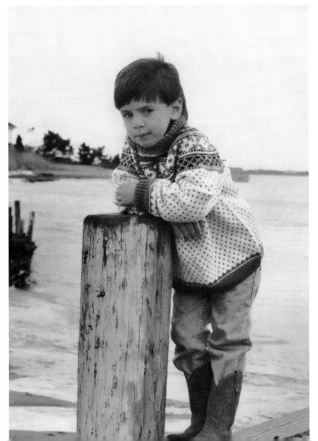

GRIFFIN

This is another example of my traditional approach to hand-painting. I often follow the children around, camera at eye level so I can catch a special moment. Tired from a long and hot photo session, Griffin rests.

LEE

Black-and-white photography has the power to create time-lessness. Lee is perched at the pier contemplating important questions (probably, how much longer is this photo session going to last?).

MIXING FLESH TONES

I always begin with the face when handpainting portraits, since this is the most important part of the picture. Marshall's has a premixed fleshcolor, but to achieve a natural flesh tone, it is better to mix your own colors rather than using the tube color. Experiment to find just the right mixture of colors. I usually start with three colors: lip, cadmium yellow, and Verona brown. I mix a dime-sized dollop each of lip and cadmium yellow, and about half that amount of Verona brown.

Place these colors next to each other on your palette and swirl with a skewer to blend. If the flesh tone is too red, add a little more Verona brown and yellow. If it is too brown, add a little more lip.

Here are some other recipes I have discovered for achieving flesh tones. As you can see, you only need a small number of colors to create any number of realistic flesh tones.

at a time, lifting the corner edge with your fingernail and then carefully pulling the frisket off. Clean white borders look crisp and professional, and it is worth taking the extra time to block the borders.

The next step is to prime with Marshall's PM Solution (a mixture of linseed oil and turpentine) in a well-ventilated room. The PM solution helps the paint move fluidly and evenly. Apply the solution with a clump of cotton and wipe off excess with a clean white tissue. To ensure a safe working environment, discard the used cotton and tissue in a baggie, seal the bag, and toss it at once in an outdoor garbage.

You will need at least ten skewers with which to apply the paint. Prepare skewers by rolling 100-percent pure cotton onto wooden sticks; use sticks about 4 inches high for large areas and toothpicks for fine details.

Many types of paints can be applied to photographs, but I prefer using Marshall's Photo Oil Colors. Unlike most oil paints, Marshall's oils are transparent, like watercolors, and are made especially for handpainting photographs. Because Marshall's oils are transparent, it is best to apply them as washes, building color in layers. The underlying tones of the photograph remain intact; therefore, beginning with a good-quality photograph is imperative. Like oil paints used on canvas, Marshall's oils will last a long time if covered tightly and stored in a cool place. I have had some of my paints for nearly fifteen years. In addition to the oil paints, you will need to use extender, which is to oil paints what water is to watercolors; it dilutes the tube strength of the paint and can be used to clean over washes of color.

I also keep a few boxes of pencils on my desk to serve as either color or tone enhancements, and I sometimes paint the entire photo using pencils. Marshall's manufactures a line of oil pencils. Prismacolor, Stabilo, and Conte colored pencils also work well on photographs.

Step-by-Step: Mara

Our session began at 5:30 on a July afternoon. Mara ate an early dinner so she would be full of spunk for the shoot. The use of a limited color palette adds to the soft tender moment. It is more challenging to use less color than it is to use more. I learned this truism through experience. When I first started handpainting, I used strong, bold colors, as if to make up for my insecurity in style. Slowly with time, I've found I prefer a softer muted palette, and still the color sings.

> ### REQUIRED MATERIALS
>
> Paper palette
> Roll of 100-percent pure cotton
> 4-inch wooden sticks
> Toothpicks
> Frisket
> Marshall's Photo Oil Colors (hobby size or larger)
> Marshall's Photo Oil Pencils
> Prismacolor pencils
> Extender

1. I begin with an 11 x 14-inch fiber matte print on Ilford Multigrade IV FB Fiber paper (matte), my paper of choice for over fifteen years. I learned to compose within the viewfinder, and when possible I print full frame and encase the photograph within a $^5/_{16}$-inch black border—part of my signature style. The border adds a professional element and is also useful when handpainting as it provides an obvious stopping point. However, I usually do not show the line when framing because the line, which is never exactly square, throws off the balance.

2. I first apply flesh tones to the face and then gently blend to produce a uniform wash. If the color is too light, I simply add another layer of the same color and blend. Once the face color is set, I move onto the body parts. Notice how I work the color in circular patterns. The color usually runs outside of the border, but this is not a problem. I simply clean the overrun in the sky with extender applied to a clean skewer. In this case, I don't worry about the overrun on the hair, because Mara's brown hair color will cover this. Mara's hair is dark brown, so I mix Verona brown with just a tiny bit of black (about seven parts brown to one part black). I do not use extender in this case since I want a dark brown and I already have an initial wash of the flesh overrun. Always applying paint in a circular motion, I begin at the middle of the head and delicately work my way to the edges; the circles get smaller as I move toward the edges.

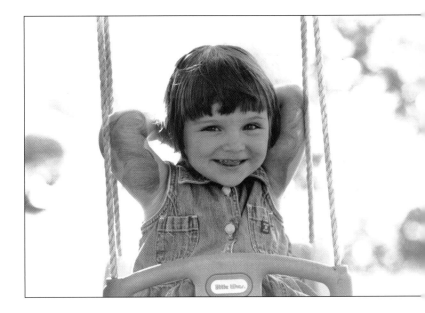

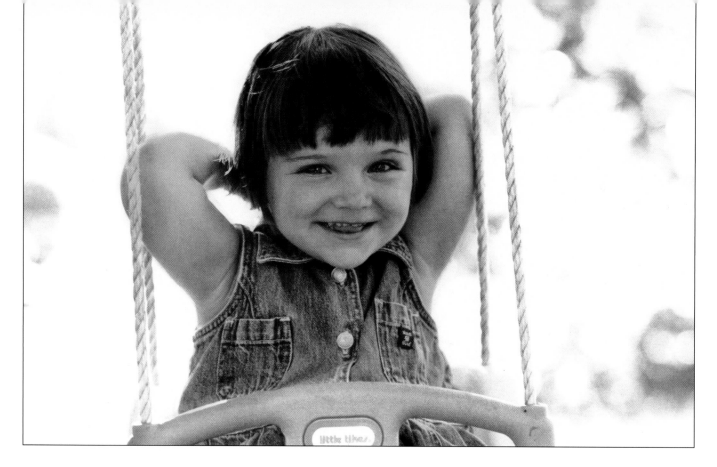

3. Chinese blue has a dash of iridescence and works well for coloring denim. I apply a dab of paint with the skewer and slowly work in the color. You could also use a colored pencil to color the overalls and wipe with gentle force to blend. I decide whether to paint with skewers or pencils by the size of the item. If it is a large area, I usually apply a wash of paint first and then add color with pencils in layers to accentuate depth, shadows, and highlights. Notice how the colors are applied and then all blended together with a wisp or a clump of cotton.

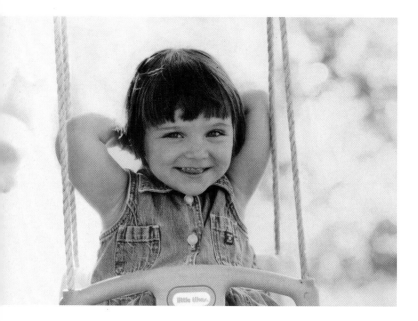

4. I then apply the background colors in sections, using the ropes of the swing as dividing lines. First I apply a thin wash of sky blue plus extender (three parts paint to one part extender). Using three new skewers, I apply tree green, violet, and navy in the shadows. I color the rope with a sepia-colored pencil. I gently wipe all color and check closely for minute overruns. When happy with the first section, I proceed to the other sections. I try many colors for the swing, working with light washes of blue, red, and yellow, and decide to use them all, layering the colors to create a "neutral" harmonizing tone that won't draw too much attention to it.

5. With the picture complete, I look at it closely to determine if the values are correct. I am looking for highlights and shadows that add definition but do not command too much attention. In this case, I add a touch—literally a pinpoint—of cadmium yellow heavily mixed with extender as highlights. I take into consideration the direction of the lighting to apply the highlights. Notice how the highlights in the swirls on the right cascade across the picture vertically as I try to mimic the sun. When I'm finished with a painting, I usually sign my name at the bottom right-hand corner of the picture with a navy Marshall's oil pencil.

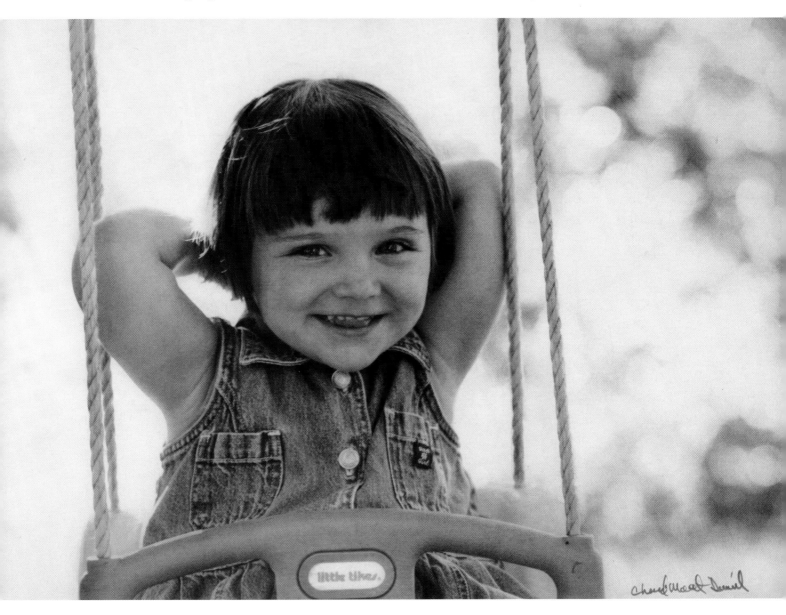

Handpainting a Digitized Print

With the ease of digital photo editing, many photographers and photo artists are digitizing their negatives and transparencies. Once your photos are digitized, you can print them on fine art paper and handpaint them. There is an abundance of specialized papers available and more on the horizon. Epson, Canon, Ilford, Kodak, Luminos/ Hahnemuhle, and Strathmore all have a wide variety of paper surfaces to choose from. Paper preference is a very personal matter, and many of the above manufacturers offer sampler packs to introduce you to the products. Consult their Web sites for detailed descriptions.

To handpaint the photograph of Brad at right, I digitized my black-and-white negative, scanning it at 1600 dpi, 48-bit depth, for a 6 x 8-inch print.

Working in Adobe Photoshop CS, I then cleaned the imperfections using the Band-Aid tool and a brush equal to the size of the imperfections. It is easier than spotting in the traditional darkroom manner because if you do not like the effect on the computer screen, you can undo it.

I adjusted the tonal range, particularly the midtones of the image, by using the Levels adjustment, and then fine-tuned the tones in Curves. Adobe Photoshop CS has a list of adjustments, and I suggest going through them in the order they appear to maximize the image quality. Jasc Paint Shop Pro 8 is an alternative software program, which is perhaps easier to use. Since I was planning to colorize the print, I wanted it to be lighter than normal.

I tested many paper surfaces to find the right one for this image. I selected Epson Heavyweight Matte Photo paper because I like its velvety smooth surface. I handpainted the print with various pastels, including Stabilo (my favorite), Conte, and Weber Costello Alphacolor pastel sticks, as well as Prismacolor pencils and Marshall's oil pencils. To blend the colors, I used my index finger, tortillons, and gray paper blending stumps (available in varying sizes at art supply stores).

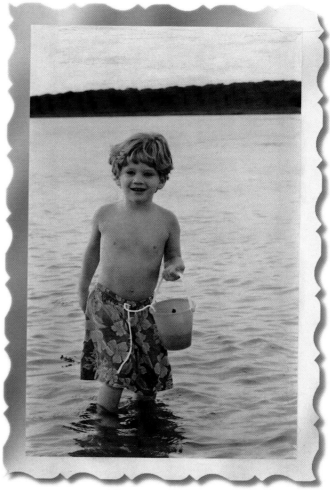

BRAD

With camera at eye level, I followed Brad into the water. The very fact that I went into the water with him created a bond between us, because Brad was impressed that I was willing to enter his world. I used Auto FX Dream Suite software to create the "wave" border.

Handtinting with
a Digital Brush

Handtinting selected areas of a photograph is popular in studio portraits, wedding pictures, and greeting cards. Applied correctly, handtinting adds a delicate touch of color. Some photographers apply a light wash of pastels, first grinding them into powder and then dry-brushing the color onto the print. Alternately, photo oils or pencils can be applied in specific areas.

Another method of handtinting certain areas of color is to work in a digital workflow, painting with a digital paintbrush. Digital photography is addictive. Once you have a handle on the tools, procedures that took an hour in the darkroom take no more than minutes on the computer. Fine-tuning the picture requires more time, but is still much quicker on a computer than in a darkroom.

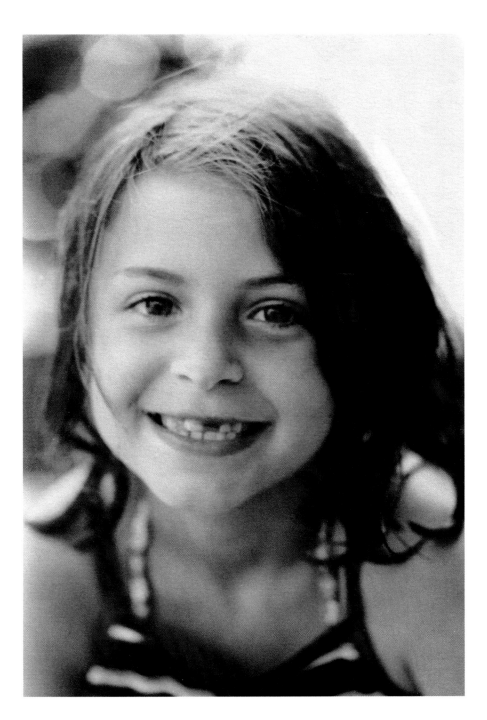

JOELLE

When children reach the milestone of losing their front teeth, their faces become even more endearing. While many parents rush to have a photo shoot before children lose their teeth, I suggest using this as a positive. I scanned the black-and-white image and handtinted it using Adobe Photoshop CS and Auto FX Mystical Lighting. Mystical Lighting is full of fun manipulations and can be installed as a stand-alone or as a tool in your preferred photo-editing software.

Step-by-Step:
Coley in Luau Costume

This picture-taking session was a lot of fun. I encouraged my daughter to dress up and then proceeded to photograph her. The image was shot with a Nikon N90S and a 105mm Nikkor lens in open shade on Ilford HP5 Plus film. I originally intended to handpaint the image, but I found that I couldn't create a color narrative that felt right. Instead, I digitized the image and handtinted it in Adobe Photoshop CS.

1. This photograph was originally a gelatin-silver print. I scan the image using SilverFast Ai 6 software. The file size is 38MB, large enough to work on without image degradation. I immediately duplicate the file and begin to touch it up with the Band-Aid tool. Spotting is necessary with a black background. Once the spotting is complete, I again duplicate the file, naming it "Luau spotted." Working on this copy, I use a new layer adjustment for Levels, Curves, and Brightness/Contrast and fine-tune the tonal values of the image.

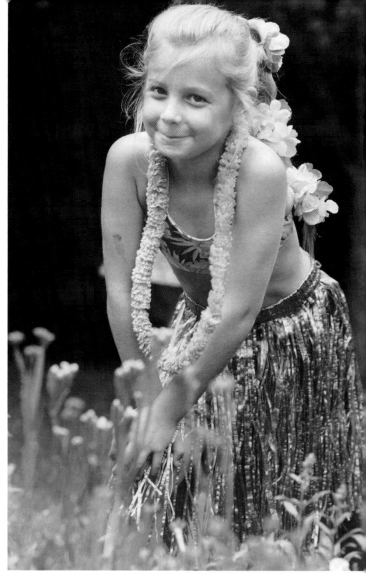

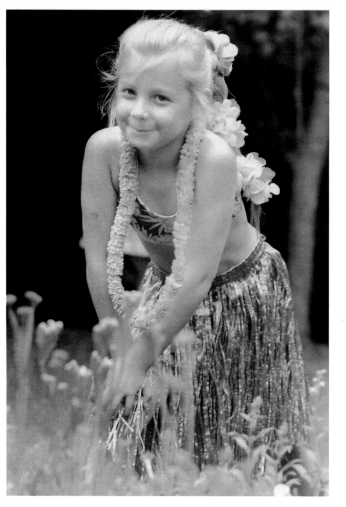

2. I save this file again, labeling it "Photo ready," and then begin on the colorization. I adjust the colors as an adjustment layer, first working with Color Balance. The goal is for a pink flesh tone. In this instance I have used the Color Balance at 53-percent opacity as follows:

MIDTONES:

RED +41%

HIGHLIGHTS:

RED + 31%

3. A second adjustment layer of Color Balance is necessary to adjust the background. I experiment again and find the following mix:

MIDTONES:

RED +23

MAGENTA -7

YELLOW -17

HIGHLIGHTS:

YELLOW -23

SHADOWS:

GREEN +41

Notice how the background turns green and the tree trunk the desired brown. A great feature in Photoshop CS is the ability to preview. Experiment by moving the sliders and when the image looks right, click "Ok."

4. I then use the Channel Mixer to pump up the color, intensifying the green background and the pink flesh tone. I create a layer adjustment, labeling it "Channel mixer," at 98-percent opacity as follows:

RED CHANNEL:	GREEN CHANNEL:	BLUE CHANNEL:
RED +108%	RED -2%	RED -6%
GREEN +8%	GREEN +100%	GREEN -4%
BLUE +6%	BLUE -6%	BLUE +100%
CONSTANT -4	CONSTANT +4	CONSTANT 0

5. Once satisfied with the base tones, I proceed to colorize the photograph. Most of my layers were blended in the normal mode at 25-percent opacity. I choose the brush size that best fits the specific area. I try to cover the area with few strokes, controlling the color by tweaking the opacity. I begin to work on details, slowly building color in washes. I select a color by using the color palette and the Eye Dropper tool. The intensity of the colors is controlled by the opacity.

6. Each color is added in a separate layer. For example, the lei is painted on a separate layer as is the bathing suit. I label each layer for later editing. I create a new layer, "Hair," and select opacity of 25 percent—I find this is a good starting point for creating a light wash of color. I then find a paintbrush size to cover the hair without going over onto the skin tones. Once the picture is complete, I save the file one more time as a PSD (Photoshop document) file. If I want to go back at a later date and adjust a layer, I can. I flatten all layers, save the image as a TIFF file, and proceed to printing.

Photo Restoration

Photo restoration is an obvious market for handpainting. Handpainting restored images helps conceal blemishes and can turn the original picture into a work of art.

There are printers and software available for photo restoration. Epson Stylus Photo RX600 (2400 x 4800 dpi, 48-bit color scanner) boasts of fixing faded torn pictures automatically.

Dust and scratch removal filters are available with some scanning software. Keeping in mind the philosophy, "The better the scan, the better the final picture," try scanning your photo using the dust and scratch removal filters and noise reduction filters before you work in photo-editing software. I use SilverFast Ai 6.0 scanning software for images that need a lot of work. I set the number of scans to eight or sixteen to eliminate noise, set the dust and scratch removal to auto, and then readjust as needed during preview. This takes a lot longer; a high-resolution scan can take up to ten minutes. As a general rule, I either scan at a high resolution and save the cleaning for Adobe Photoshop CS or, when scanning at the best optimum resolution is essential, with SilverFast .

If you are planning to handpaint your image after repairing damage digitally, keep in mind that the choices of color, hue, and saturation affect visual harmony. Try desaturating color at varying percentages to establish a base tone. Hue and color saturation are easily manipulated in Adobe Photoshop CS or Jasc Paint Shop Pro 8. I find that keeping the original flesh tone of the photograph instead of coloring it helps create a more realistic photopainting. To accomplish this, I mask the skin tones in Quick Mask and then desaturate everything else. I paint the image and leave the flesh tone the color that I see on the monitor.

TEST PRINTS

I calibrate my monitor once a week with Adobe Gamma, which comes with Adobe Photoshop CS. Calibrating your monitor helps ensure that what you see on the computer monitor will match what the printer produces—i.e., "What you see is what you get." There are many more advanced and costly software options for calibrating (Greytag, Monaco, Fujifilm, Color Vision, and Agfa) and they are often recommended by professionals. However, I have had good success with the Adobe Gamma and until that changes, I will stick with this free calibration option. To make certain that the print will look like it does on my monitor, I make test prints, either by selecting a certain portion and printing that segment or by reducing the size of the entire image and then printing that. If I make a correction, I make another test print and continue this process until I am completely satisfied.

I also like to make test prints on different papers. When selecting fine art paper, I touch and buy many brands to test for optimum color rendering based on the particular assignment. I prefer watercolor papers to pastel papers because I like the smoother surface for easier, more subtle blending. My studio has a supply of cold-pressed Arches, Lanaquarelle, and Strathmore Series 500 watercolor papers.

Step-by-Step:
Catching the Waves

I was so happy to find this old photograph in our family archives. Unfortunately, it had been abused over time by neglect. It looked like it was beyond repair, but I knew better.

1. I scan the image with my Epson 2450 at 300 dpi for an 8 x 10-inch print. I immediately duplicate the image once it comes onto my screen in Adobe Photoshop CS. If I make a mistake, I have another original digital file. I spot with the band aid or rubber stamp tool working at 200-percent magnification. Again, I duplicate the file naming it "Catching the Waves-spot," and continue working. If I make a mistake later on, I do not have to retouch again, I just revert back to my last saved copy.

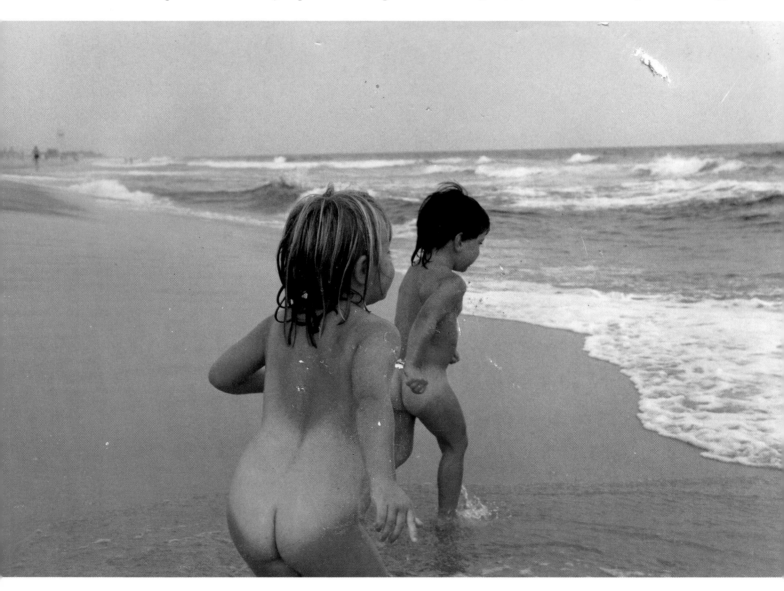

2. I am now ready to run through Adobe Photoshop CS adjustments in the order they are listed—Levels, Curves, Color Balance, Brightness/Contrast, and Hue/Saturation—each as a new layer adjustment. As you can see from the original picture, the digital retouching is quite an improvement and it is quick—maybe fifteen minutes. Imagine how long it would have taken a traditional (nondigital) photo retoucher to mend each imperfection with a paintbrush using dyes, eggs, paint, copy negatives, etc. A whole production is reduced to a 15-minute workflow. For fun, I create a border using Jasc Paint Shop Pro 8. This is an amazingly friendly software—a must-have for those intimidated by Adobe Photoshop CS.

3. I finish this job by determining the paper type. To create a memorable work, I use Strathmore Series 500 watercolor paper for its archival quality. After printing the image, I then work on enhancing it with pastels. Pastel painting is a wonderful art form. When I studied art at the New York Academy of Arts & Sciences, pastels quickly became my favorite medium. The luminosity and blending qualities of pastels are exceptional. I use Stabilo and Conte pencil pastels for the flesh tones and sand and Alphacolor pastel sticks for the sky. I layer the pastels until I find just the right tone.

GREAT ART IS THE OUTWARD EXPRESSION OF AN INNER LIFE IN THE ARTIST, AND HIS INNER LIFE WILL RESULT IN HIS PERSONAL VISION OF THE WORLD.

—Edward Hopper

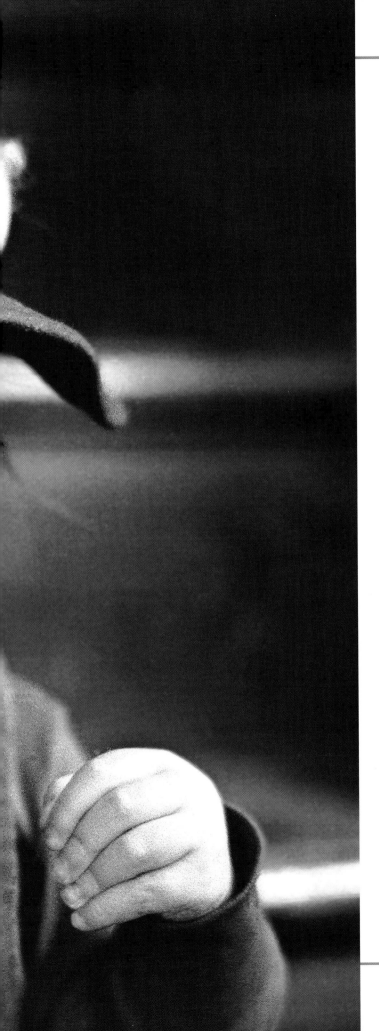

Photo Gallery

Throughout this book I have stressed the importance of studying the work of other photographers. We began with a look at the origins of children's photography and a survey of early photographers. Now we turn to the work of contemporary photographers who specialize in photographing children. The artists included in this gallery represent a cross section of photographers in the United States. To give a world perspective, I have included a photojournalist who works in Third World nations. While their approach and their personal styles vary—some construct elaborate sets in a studio, while others prefer to let the children explore their natural settings—they all share a love of children and a desire to convey their magical language through their photography.

"Catherine" by Tina Manley

Dani Blackwell

From her home state of Kansas, Dani Blackwell creates artful portraits that have been honored nationwide. Blackwell discovered photography at the age of twenty-four and found in it all the elements she had been looking for to express her creativity. Blackwell loves make-believe and the wonderful images that can emerge from its use and often uses digital imaging software to further create enchanted environments for her subjects. She shoots film 90 percent of the time, using a Mamiya 645 and a Bronica Sq1A, and uses a Fuji S1 Pro for digital work. Fuji NPH (400) film is her choice for color work. For black-and-white images she chooses Kodak T400 CN.

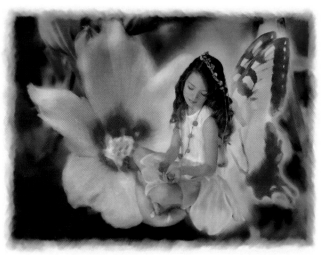

SOFT WONDER

A soft pastoral setting was perfect for a little girl who loves fairies. Captured with a Fuji S1 Pro, the final image is a composite created in Adobe Photoshop and printed on Epson watercolor paper.

BUT I'M NOT AN ANGEL!

After a session of beautiful smiles, this little angel soon grew weary. In the irony typical of children's portraiture *this* image was the client's favorite.

THE JOURNEY HOME

An unexpected snowfall and the subsequent "white wonderland" was the inspiration for this image. This photograph ultimately became a favorite of the child's mother for both its simplicity and the memory it brings of a little girl and her favorite doll. The image was originally printed on Kodak paper and selectively tinted with dye.

Ross Zanzucchi

Ross Zanzucchi and his wife, Juli, operate Total Image Photography, a portrait studio where children have so much fun playing and exploring the elaborate sets (designed by Juli) that they often don't realize they're being photographed. For his studio portraits, Zanzucchi uses a Mamiya medium-format camera with a 150mm telephoto lens and Konica Pro 160 film. After shooting the initial photographs on film, he often creates digital watercolor and selective-color images for his clients. To Zanzucchi, the methods used to create a portrait are not important. All that matters is capturing the emotions of the subject.

CATCHIN' THE BIG ONE

Using a mirror, moss, greens and several outdoor props gives this set a realistic look. Parents and kids alike love this scene.

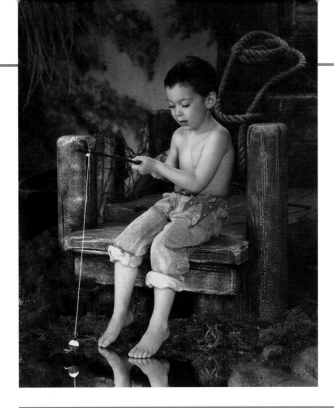

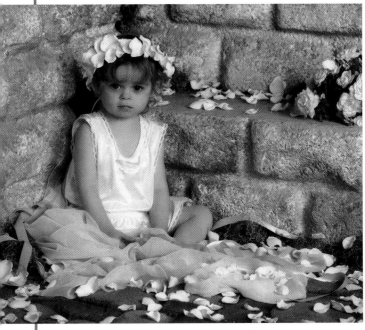

HE LOVES ME. HE LOVES ME NOT.

Having the child help scatter the petals was a great way to start interacting with her. She considered it playtime, making it easy to capture her varied expressions.

PERSONAL STYLE

As Arnold Newman says, "Style is a natural result, not an aim." The best way to develop a personal style is to take lots of photographs. Study art and photography. Stay current on trends in fashion and advertising. Join photography organizations, such as a local chapter of the Professional Photographers of America (PPA) and welcome critiques. Continually assess your portfolio, adding new images and taking away those that are stale.

■ INTERPRETATION: Push yourself to find the new angle to express yourself and create something fresh.

■ COMPOSITION: Composition is the place to formulate your intent. Some photographers shoot only in natural light at the beach, others manipulate in the computer, creating montages, and others shoot only high-contrast black-and-white images.

■ ATTITUDES: Your style becomes visible through the feelings you portray in your portraits, Mysterious, poignant, evocative, provocative, surreal, spiritual, and humorous are all examples of attitude.

■ APPROACH: How you physically approach taking a photograph, whether in a studio or a natural environment, whether formal or informal, becomes a characteristic of your style.

For the most part, personal style evolves from how you best communicate. It is this voice your admirers seek.

Jeff Marcotte

Jeff Marcotte's pursuit of photography began as a way to make a living but quickly became a passion. A resident of Vermont, Marcotte's sensitive style has won him recognition at state, regional, and national levels. Marcotte loves photographing children because of their innocence and inquisitiveness; he strives for a storytelling approach in his photographs. He believes that in order to capture truthful images of children you have to let them be. Never force a child to do what you want. Marcotte uses a Hasselblad medium-format 6 x 6cm camera with a 150mm lens or a Mamiya RB67 medium-format (6 x 7cm) camera with a 150mm soft-focus lens for a soft-looking photograph. He shoots exclusively on Kodak Portra 400VC film because of the rich colors the film yields.

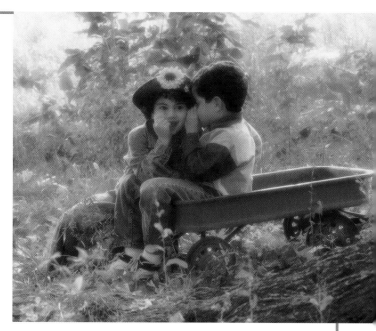

WHISPERS

In this sweet scene, brother and sister share a secret moment together. They both wore denim to create a split-complementary color scheme (a main color and the two colors on either side of its complement) of blue, yellow-orange, and red-orange.

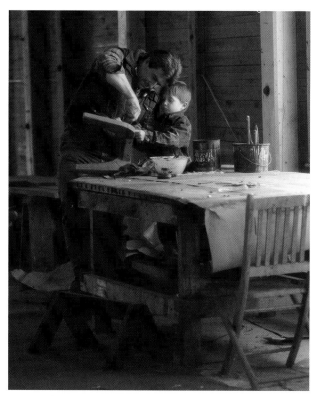

DAD'S APPRENTICE

Wait for just the right moment before tripping the shutter to capture magic. This image was printed on canvas for the look of an old master.

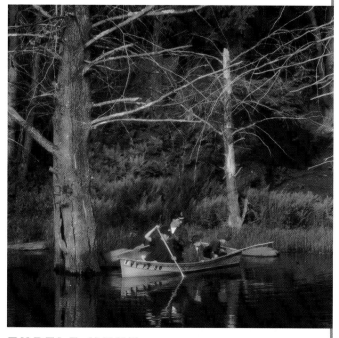

TURTLE HUNT

Soft light and willing subjects produce a timeless moment. The photograph was printed as a 16 x 20-inch custom print on Kodak paper.

Bruce Berg

Bruce Berg is an award-winning studio photographer from Oregon known for his fresh, romantic, and timeless portraits. His work has been featured in professional photography magazines and more than 100 books, calendars, and greeting cards. About 50 percent of his business is photographing teens, known in the industry as "seniors." In order to relate to this age group, Berg believes that you have to "think young" and be able to provide a wide variety of locations, styles, and backgrounds. Berg has recently made the switch from a Mamiya RB67 and Kodak film to a Canon D60 digital camera. For presentation, he projects his images via a laptop and digital projector in his viewing room; clients are able to see the images as large as 40 x 50 inches, allowing the children's expressions to really shine.

NEW EYES

Little ones, such as Leeanna, respond best to being photographed after a nap. Children younger than thirty months cannot be expected to "perform" or pose for a photographer, so the best thing is to schedule the session at one of their "better" times and just interact with them.

PRETTY IN PINK

Changing one's perspective to actually look up at a child can grab the viewer's attention. Try looking for different angles and compositions to spice up your portraits!

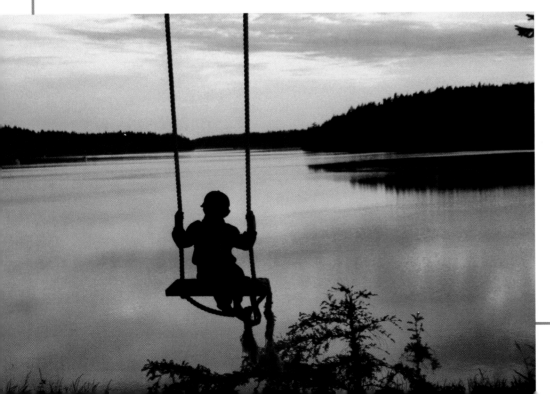

AS THE SUN GOES DOWN— SAN JUAN ISLAND

To get proper silhouettes, expose not for your subject, but for the sky, off-center from the lightest points. This photograph speaks volumes about childhood and the joys to be found in simple things.

Tina Manley

Tina Manley first became interested in photographing children when she started taking pictures of her own four children. Marketing her images to textbooks and magazines, she soon sold her first photograph (of her children) for use as a photographic book cover. In 1989 she traveled to Honduras and Guatemala with a mission group as a photographer and has returned every summer since. As a stock photographer, she travels the world, photographing in more than thirty-six countries; she sells the rights to use her images on her Web site and through several stock agencies. Manley feels that photography is a language that translates cultures, and she strives to convey the importance of personal relationships with her photography. She shoots with Leica rangefinder cameras and prefers black-and-white film to portray people and light without the distraction of color.

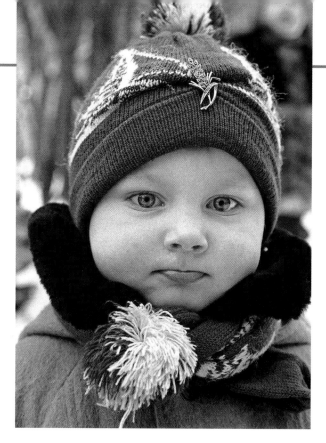

SASHA

Sasha was a three-year-old who attended kindergarten in her neighborhood school in Moscow from 7:00 in the morning until 5:00 at night! Her class was playing at recess in the snow, and Sasha was fascinated by the strange American woman. Manley used an 85mm/f/1.4 lens and knelt in the snow to photograph Sasha.

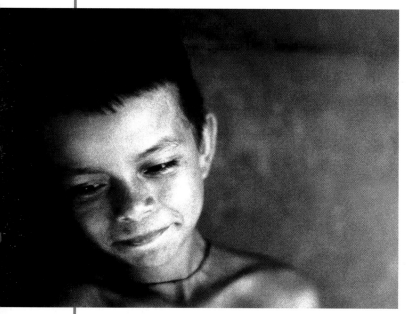

JULIAN

Julian is a Miskito Indian from the Mosquito Coast. This photograph was taken by firelight, using Tmax 3200 film and a Noctilux 50mm/f/1.0 lens. The film is very grainy, but it gives the photograph a dreamy look.

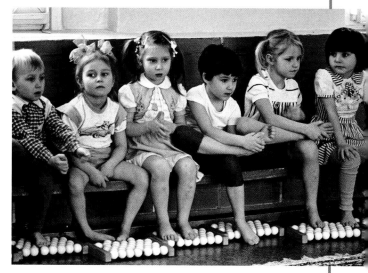

HEALTH KINDERGARTEN

This kindergarten in Moscow specialized in health and physical activity. The children would run barefoot in the snow every day and then come inside to massage their ears and feet. Despite the strange activity, Manley found the children's expressions very familiar.

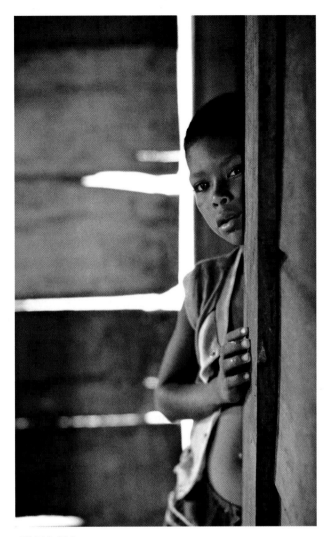

STREET CHILDREN

One of the organizations Manley works with in Honduras helps the street children by giving them a noon meal and a place to attend classes. These boys make a living by selling merchandise on the street. Perhaps the little boy looking up at them will have a better future. The intense sunlight and dark shadows made this photo difficult to print.

WELDI

Weldi is a Miskito Indian who lives in a house on stilts reachable only by canoe. Manley stayed with his family for a week so they would get used to her and forget that she was taking photographs. It was dark in the house, so Manley used a Noctilux 50mm lens wide open. The depth of field is very, very shallow at $f/1.0$.

SAMIRA AND MARYAM

These girls attended a mosque school in Baghdad to learn the Koran. They loved posing for their photos and were very welcoming to Manley, who wore a floor-length black veil with only her camera lens poking through the fabric.

Gayle Tiller

An artist who "paints with a camera," Gayle Tiller has an approach that is both elegant and simple. Whether in the studio or on location, Tiller combines natural light and scenery to create her pictures. In the studio she uses north window light to capture a soft, ethereal effect. Outside she photographs with natural light using as a backdrop the seashore or the bucolic surroundings of her home state of Virginia. Tiller uses both medium-format (Mamiya RZ67) and 35mm (Nikon F3) cameras.

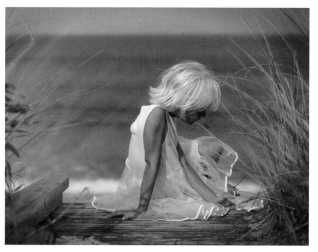

CHILD OF THE SEASHORE

This child was photographed in bright sun for a vibrant effect, and the brilliant color was captured on Fuji 400 film. The subject looking away from the camera creates a mood of a child in thought.

AUTUMN AFTERNOON

For this session, the client specifically requested a rustic location with autumn colors. The clothes the children wore came from Tiller's studio and were selected to complement the setting.

THE SISTERS

The blue steps were chosen to complement the girls' clothing. Their loving manner toward each other created a fun, lighthearted environment. The sisters were photographed in shaded sunlight with a shutter speed of 1/60 sec. and an aperture of *f*/4.5.

Bibliography

Adams, Ansel. *Artificial Light Photography*. Basic Photo Series. Boston: New York Graphic Society, 1956.

Adams, Ansel. *Natural Light Photography*. Basic Photo Series. Boston: New York Graphic Society, 1952.

Ang, Tom. *Digital Photographer's Handbook*. London: DK Publishing, 2002.

Ang, Tom. *The Tao of Photography*. New York: Amphoto Books/Watson-Guptill Publications, 2000.

The Art of Portraiture and the Nude. The Kodak Library of Creative Photography. Alexandria, VA: Time-Life Books. 1983.

Barthes, Roland. *The Camera Lucida*. New York: Hill and Wang, 1981.

Bidner, Jenni. *The Lighting Cookbook*. New York: Amphoto Books/Watson-Guptill Publications, 1997.

Cohen, Morton N. *Reflections in a Looking Glass: A Centennial Celebration of Lewis Carroll, Photographer*. New York: Aperture, 1998

Daly, Tim. *The Desktop Photographer*. New York: Amphoto Books/Watson-Guptill Publications, 2002.

Daly, Tim. *The Digital Printing Handbook*. New York: Amphoto Books/Watson-Guptill Publications, 2002.

Drager, Kerry. *Scenic Photography 101*. New York: Amphoto Books/Watson-Guptill Publications, 1999.

Flynt, Suzanne L. *The Allen Sisters*. Deerfield, MA: Pocumtuck Valley Memorial Association, 2002.

ALI RUNNING

This photo shoot took place on the shady side of a cornfield. It was hot and the children were cranky, so I separated them and focused on one child. I knew the other child would want to be reinvolved once he saw the fun we were having.

CLAMMING

This photograph began the photo shoot. The children were eager to find clams and would not wait till later, so I waited patiently and decided to capture some story-telling images. I looked for graceful body language and used the shoreline to create a leading diagonal line.

Frizot, Michel, ed. *A New History of Photography.* Cologne, Germany: Könemann, 1994.

Gair, Angela. *The Beginner's Guide: Pastels.* London: New Holland, 1997.

Harrison, Hazel. *Master Strokes: Pastel.* London: Quarto, 1999.

Hicks, Roger, and Frances Shultz. *Portraits: A Guide to Professional Lighting Techniques.* Hove, UK: RotoVision, 1996.

Johnson, William S., Mark Rice, and Carla Williams. *Photography from 1839 to Today: George Eastman House.* Cologne, Germany: Taschen, 2000.

Katchen, Carole. *Express Yourself! With Pastel.* Verdi, NV: International Artist Publishing, Inc., 2001.

Kodak Guide to 35mm Photography, Seventh Edition. Rochester, NY: Silver Pixel Press, 2001.

Light and Film. Life Library of Photography. Alexandria, VA: Time-Life Books, 1970.

London, Barbara, John Upton, Ken Kobre, and Betsy Brill. *Photography,* Seventh Edition. Upper Saddle River, NJ: Prentice Hall, 2001.

Long, Ben, *Complete Digital Photography.* Hingham, MA: Charles River Media, Inc., 2001.

Marien, Mary Warner. *Photography: A Cultural History.* Upper Saddle River, NJ: Prentice Hall, 2002.

McDonald, Tom. *The Business of Portrait Photography,* Revised Edition. New York: Amphoto Books/Watson-Guptill Publications, 2002.

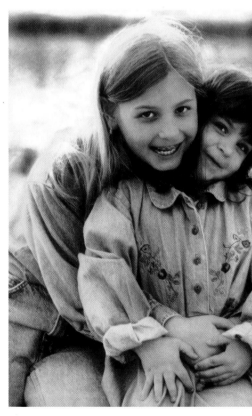

NICOLE AND JOELLE

I illustrated the bond between two sisters by encouraging physical connection.

Meehan, Les. *Digital Image Making.* New York: Amphoto Books/Watson-Guptill Publications, 2002.

Morra, Gilles. *A Guide to the Ideas, Movements, and Techniques of Photography: 1839 to the Present.* New York: Abbeville Press, 1998.

Newhall, Beaumont. *The History of Photography.* Boston: Bulfinch Press/ Little, Brown & Co., 1982.

Orenstein, Vik. *Creative Techniques for Photographing Children.* Cincinnati, OH: Writer's Digest Books, 1993.

Orvell, Miles. *American Photography.* Oxford, UK: Oxford University Press. 2003.

Peterson, Bryan. *People in Focus.* New York: Amphoto Books/Watson-Guptill Publications, 1993.

Photographing Children. Life Library of Photography. Alexandria, VA: Time-Life Books, 1983.

Rosenblum, Naomi. *A World History of Photography,* Third Edition. New York: Abbeville Press, 1997.

KIARA

Notice how the colors of Kiara's jacket repeat in the background and how the photograph is framed by three red pillars. Patterns are all around, waiting for the photographer to find them.

Schirmer, Lothar, ed. *Women Seeing Women.* New York: W. W. Norton & Co., 2003.

Seiling, Susan. "Top Photography Collections Inspire and Educate." *Art Business News.* March 2003, 104–106.

Sieveking, Anthea. *How to Photograph Babies and Children.* New York: Kodak Books, 1994.

Simmonds, Jackie. *Pastel Workbook.* Newton Abbot, UK: David & Charles, 1999.

Stone, Erika. *Pro Techniques of Photographing Children.* Tucson, AZ: HP Books, 1986.

Szasz, Susanne. *Photographing Children.* New York: Amphoto Books/ Watson-Guptill Publications, 1987.

Taylor, Maureen A. *Preserving Your Family Photographs.* Cincinnati, OH: Better Way Books, 2001.

Thwaites, Jeanne C. *Starting and Succeeding in Your Own Photography Business.* Cincinnati, OH: Writer's Digest Books, 1984.

Walker, Liz. *Photographing Children.* Point & Shoot Series. New York: Amphoto Books/Watson-Guptill Publications, 1995.

Willis-Braithwaite, Deborah. *VanDerZee: Photographer, 1886–1983.* New York: Harry N. Abrams, 1993.

Wolf, Sylvia. *Julia Margaret Cameron's Women.* New Haven, CT: Yale University Press, 1998.

Index